The Caporali Missal

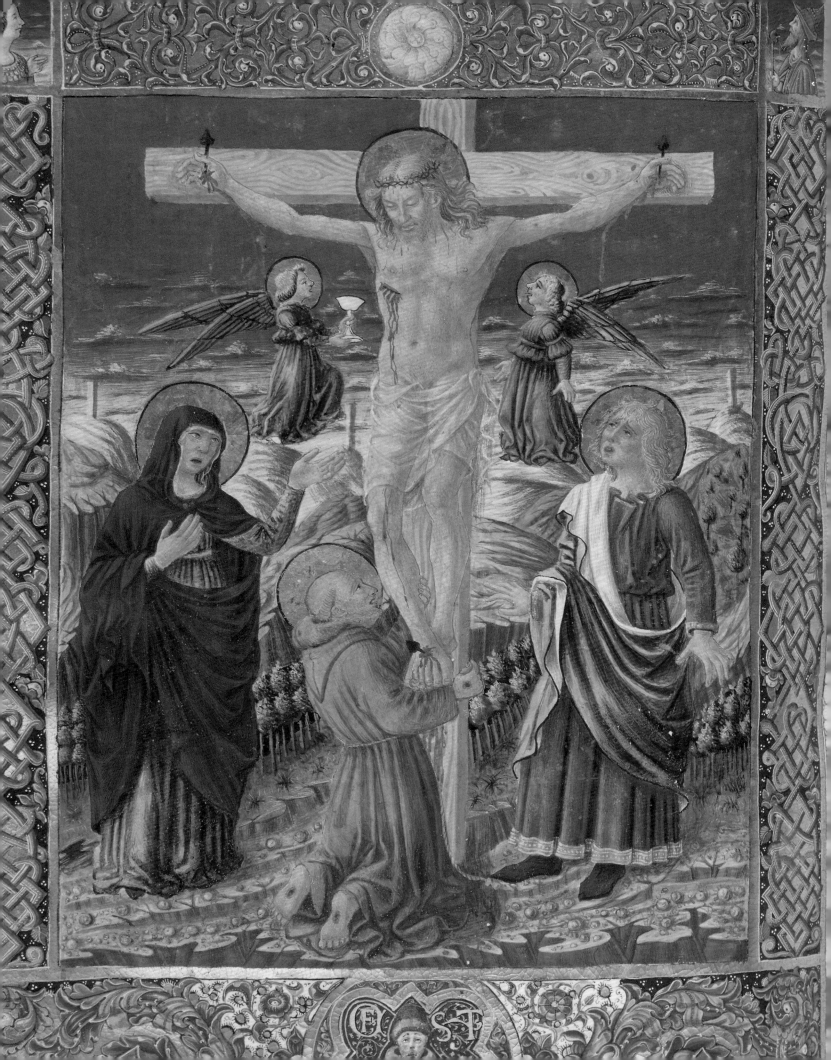

Stephen N. Fliegel

WITH CONTRIBUTIONS BY

Dilys Blum

Silvia Braconi

Virginia Brilliant

Jonathan Canning

Donal Cooper

Maria Rita Silvestrelli

The Caporali Missal

A MASTERPIECE OF RENAISSANCE ILLUMINATION

The Cleveland Museum of Art

DelMonico Books · Prestel Munich · London · New York

The Cleveland Museum of Art is grateful to Cleveland State University for its support of the Caporali Missal project from its inception in 2006. In particular, we thank Mr. John J. Boyle, vice president for Business Affairs and Finance, now retired; Dr. Michael J. Tevesz, then special assistant for cultural partnerships and former director of the Center for Sacred Landmarks in the Levin College of Urban Affairs; and Dr. Ronald Berkman, current president of Cleveland State University.

The Cleveland Museum of Art is generously funded by Cuyahoga County residents through Cuyahoga Arts and Culture. The Ohio Arts Council helped fund this exhibition with state tax dollars to encourage economic growth, educational excellence, and cultural enrichment for all Ohioans.

Published on the occasion of the exhibition *The Caporali Missal: A Masterpiece of Renaissance Illumination,* February 17–June 2, 2013, at the Cleveland Museum of Art.

Copyright © 2013 The Cleveland Museum of Art and Prestel Verlag, Munich·London·New York. All rights reserved. No part of this publication may be reproduced or transmitted in any form or by any means, electronic or mechanical, including photocopy, recording or any other information storage and retrieval system, without prior permission in writing from the Cleveland Museum of Art. The works of art themselves may also be protected by copyright in the United States of America and abroad and may not be reproduced in any form or medium without permission from the Cleveland Museum of Art.

Photography credits: Images of works of art in the exhibition were provided by the lenders, unless notes otherwise. Objects in the collection of the Cleveland Museum of Art were photographed by museum photographers Howard Agriesti and Gary Kirchenbauer. David Brichford and Bruce Shewitz assisted with preparation of the digital files, and Howard Agriesti supervised the color management. All works of art themselves may be protected by copyright in the United States or abroad and may not be reproduced in any form without permission from the copyright holders. Where provided, individual photographers and copyright holders are acknowledged in figure captions.

Published in 2013 by the Cleveland Museum of Art and DelMonico Books, an imprint of Prestel Publishing.

The Cleveland Museum of Art
11150 East Blvd.
Cleveland, OH 44106

www.ClevelandArt.org

Prestel, a member of Verlagsgruppe Random House GmbH

Prestel Verlag
Neumarkter Strasse 28
81673 Munich
Germany
Tel.: +49 (0)89 4136 0
Fax: +49 (0)89 4136 2335

Prestel Publishing Ltd.
4 Bloomsbury Place
London WC1A 2QA
United Kingdom
Tel.: +44 (0)20 7323 5004
Fax: +44 (0)20 7636 8004

Prestel Publishing
900 Broadway, Suite 603
New York, NY 10003
Tel.: 212 995 2720
Fax: 212 995 2733
E-mail: sales@prestel-usa.com

www.prestel.com

Library of Congress Control Number
2012949037

ISBN 978-3-7913-5271-8
(DelMonico Books, hardcover)

ISBN 978-1-935294-12-2
(The Cleveland Museum of Art, paperback)

Prepared by the Curatorial Publications Department of the Cleveland Museum of Art, Barbara J. Bradley, director

Edited by Jane Takac Panza

Proofread by Carrie Wicks

Map by Carolyn K. Lewis

Designed by and typeset in Arno and Fontin Sans by Susan E. Kelly for Marquand Books

Produced by Marquand Books, Inc., Seattle
www.marquand.com

Color management by iocolor, Seattle

Printed and bound in China by C&C Offset Printing Co.

Frontispiece: folio 185v (detail); p. 84: folio 208v (detail); p. 116: folio 22v (detail); tailpiece: folio 22 (detail)

Contents

Lenders to the Exhibition

Abbazia di San Pietro, Perugia

The Art Institute of Chicago

The Cleveland Museum of Art

Columbia University Library, Rare Book and Manuscript Library

Detroit Institute of Arts

Diocese of Perugia

Galleria Nazionale dell'Umbria, Perugia

Loyola University Museum of Art

Philadelphia Museum of Art

San Michele Arcangelo, Isola Maggiore del Trasimeno

Director's Foreword

THOUGH WORKING on a smaller scale than the great painters and sculptors of the Renaissance, the illuminators of books created works characterized by unrivaled standards of quality, materials, and design, often displaying imaginative symbolism and breathtaking creativity. John Ruskin called manuscript illumination "writing made beautiful," and medieval and Renaissance artists transformed the written page into exquisite treasures with their masterfully decorated initials, exquisite borders, and delicate miniatures.

The acquisition by the Cleveland Museum of Art in 2006 of the Caporali Missal—so named after Bartolomeo and Giapeco Caporali, the two artists who decorated its pages— brought to the museum's collections not only an important Renaissance work of art but also the opportunity to present the stunningly beautiful illuminated manuscript to our audiences. Given its historical significance, it also became both imperative and an obligation to undertake new, long overdue research. Though the whereabouts of the Caporali Missal can be traced back some two hundred years, the manuscript was largely forgotten and remained little known, save by a small group of specialist scholars. This exhibition and catalogue tells the story of this missal, reuniting it with the main corpus of important fifteenth-century Italian manuscripts. It presents the manuscript not in isolation but in context of its known genesis: a missal produced for the Franciscans of Montone in 1469 and painted by Bartolomeo and Giapeco Caporali, two Perugian artists virtually unknown in the English-speaking world. The exhibition importantly examines the manuscript against the backdrop of Franciscan liturgy and ritual and of fifteenth-century Umbrian painting.

The selection of works in this exhibition was made by Stephen N. Fliegel, the museum's curator of medieval art, who led a team of scholars on both sides of the Atlantic. My sincere thanks go to him and his colleagues who have produced important new scholarship. The exhibition would, of course, have been impossible without the collaboration and generosity of lenders in the United States and Italy. I extend my warmest thanks to them for their willingness to share their treasures. A particular note of thanks goes to the Soprintendenza in Perugia, to the Diocese of Perugia, and to the municipality and mayor of Montone. I also wish to thank Cleveland State University for its generous financial gift in support of the publication of this catalogue.

May all who experience *The Caporali Missal: A Masterpiece of Renaissance Illumination* take pleasure in viewing this beautiful book, an important link to the history of a medieval Italian town.

David Franklin, President and CEO
The Sarah S. and Alexander M. Cutler Director
The Cleveland Museum of Art

Preface and Acknowledgments

THE ACQUISITION of the Caporali Missal in 2006 provided an opportunity to research a beautiful and historically important illuminated manuscript that was little known except in small scholarly circles. Introducing the manuscript to the museum's audience proved challenging, however, as the museum had just launched an ambitious renovation of its facility. Displaying the Caporali Missal at the museum was therefore placed on hold, but it was included as part of the masterpieces exhibition *Sacred Gifts and Worldly Treasures,* which traveled to Munich, Los Angeles, and Nashville in 2007–8. These circumstances allowed for the organization of a small focus show that would endeavor to expand our knowledge of the Caporali Missal, place it in historical and liturgical context, draw conclusions about the genesis of its creation, and finally celebrate its acquisition.

Taking up the challenge of preparing a focus exhibition based on the Caporali Missal, which was encouraged by then director Timothy Rub, required investigating the historical place that once housed the manuscript, the church of San Francesco, Montone, near Perugia, in the verdant hills of Umbria. Also important was establishing the types of loans that would make sense and would enhance our understanding of both the missal's history and its purported illuminators: Bartolomeo and Giapeco Caporali. Fortuitously, the missal's colophon identifies its scribe, the date of its completion, and its commission for the Franciscan community at San Francesco, Montone. While the core information about the manuscript's origins was in hand—a rare luxury for manuscript scholars—several basic questions remained: Did the church of San Francesco still stand in Montone, and if so, might it still house archival evidence relating to the presence of the missal there? Who was the missal's patron: Stefano di Cambio, mentioned in the colophon as guardian father of the church of San Francesco, or was there someone else? And, as a point of scholarly curiosity, would establishing when and under what circumstances the missal left Montone be possible? Questions also lingered about the production of the missal and the role of the Caporali brothers, an attribution first made by Mario Salmi in 1933. Was the missal produced in Montone, or more likely in Perugia, where the Caporali had their workshop? Myriad related issues convinced me that a focus exhibition and accompanying catalogue could offer answers to some—perhaps most—of these queries.

Such an exhibition and catalogue would require the input of specialists who worked on aspects germane to understanding the missal: the Franciscans, local history of Montone, fifteenth-century Umbrian painting, and the like. In 2007, when discussion of a possible focus exhibition was ongoing, I received much encouragement from Virginia Brilliant, then a Mellon Fellow in medieval art at the Cleveland Museum of Art and now curator of European art at the Ringling Museum of Art in Sarasota, Florida, and a contributor to this catalogue. I am grateful for her profound interest in the manuscript and the concept of the exhibition at a very early stage.

My warmest gratitude goes to Michael J. Tevesz for his solid enthusiasm for this exhibition. Upon hearing of the acquisition, Dr. Tevesz, then director of the Center for Sacred Landmarks in the Levin College of Urban Affairs at Cleveland State University, showed considerable interest in the educational and scholarly possibilities posed by a focus show. On a planned trip to Italy in 2007, Dr. Tevesz, joined by friends Beth Singer and Anthony Zaccardelli, visited Montone and returned to share with me dozens of valuable photographs of the church's interior and exterior. This accelerated my interest in organizing the exhibition and in visiting Montone and Perugia myself. I joined the three friends on two subsequent visits to the region, and we made up an informal research team known as the "Merry Quartet." On these research trips, we established contacts with local officials and visited churches throughout Umbria to find paintings and frescoes by Bartolomeo Caporali in Deruta, Montelabate, Isola Maggiore in Lake Trasimeno, and others. Largely because of these trips, the form the exhibition might take and the works of art that might be included became clearer: the show would feature works that would visually inform the Caporali Missal as both a work of art and an object of ritual.

Through Dr. Tevesz I met other faculty and officers at CSU who shared his interest, and gradually a partnership with the university evolved. For our discussions concerning the educational opportunities presented by the exhibition, my thanks to Matt Jackson-McCabe, chairperson and associate professor in the Department of Religious Studies, and Gregory M. Sadlek, dean and professor in the College of Liberal Arts and Social Sciences. I am grateful to Marian Bleeke, assistant professor of art history; Laura Wertheimer, associate professor of history; and Elizabeth A. Lehfeldt, professor and chair of the Department of History, for their subsequent contributions to the educational component. Finally, I must thank John J. Boyle, vice president for Business Affairs and Finance, now retired, for sharing in this interest and through whose good offices a generous financial contribution was made by CSU to cover some of the production costs of this catalogue.

The decision to lend rare, often fragile, and certainly irreplaceable works of art to an exhibition in another city or country is never easy. Such generosity results in the advancement of scholarship, and for their gracious collegiality and goodwill I thank the following lenders to the exhibition. In Perugia, I am indebted to Soprintendente Dott. Fabio De Chirico, Soprintendenza per i Beni Storici Artistici ed Etnoantropologici dell'Umbria; Direttore-arch. Francesco Scoppola, Direzione Regionale per i Beni Culturali e Paesaggistici dell'Umbria; retired Soprintendente-Dott.ssa Vittoria Garibaldi, Soprintendenza per i Beni Storici Artistici ed Etnoantropologici dell'Umbria; and Federica Zalabra, art historian in the Soprintendenza per i Beni Storici Artistici ed Etnoantropologici dell'Umbria. The Diocese of Perugia was very supportive of the exhibition, for which I am grateful to Mons. Pierluigi Rosa, vicario giudiziale, Arcidiocesi di Perigua; Francesco d'Ameli,

direttore, Ufficio Diocesano Beni Culturali Ecclesiastici; Dr. Elena Pottini; and Don Giustino Farnedi, abate di San Pietro di Perugia. In Montone, I thank Mirco Rinaldi, vice sindaco assessore alla cultura; Cristina Venturini, responsabile ufficio cultura; and Rebecca Bacchetti, Aries Property Management. Further, Maurizio Michelozzi, a conservator in Florence, generously provided translation services and frequently intervened with Italian lenders on behalf of the Cleveland Museum of Art. In the United States, I thank Martha Wolff, the Art Institute of Chicago; Pamela Ambrose and Jonathan Canning, Loyola University Museum of Art, Chicago; James G. Neal and Consuelo Dutschke, Columbia University Library, Rare Book and Manuscript Library, New York; Graham W. J. Beale and Salvador Salort-Pons, Detroit Institute of Arts; and Timothy Rub and Dilys Blum, Philadelphia Museum of Art.

My gratitude to the scholars whose work is published here cannot adequately be expressed. When invited to participate in this catalogue, each contributor, without exception, not only endorsed the project but enthusiastically shared his or her knowledge. I thank Donal Cooper, University of Warwick, UK; Maria Rita Silvestrelli, Università per Stanieri di Perugia; Silvia Braconi, independent historian, Umbertide; Virginia Brilliant, Ringling Museum of Art, Sarasota; Jonathan Canning, Loyola University Museum of Art, Chicago; and Dilys Blum, Philadelphia Museum of Art. I would like to thank Rev. David A. Novak of Sts. Robert and William Parish, Euclid, Ohio, for generously sharing his liturgical knowledge of the Roman missal, and Tom Henry, Courtauld Institute of Art, London, for his advice, suggestions, and enthusiastic support. I am also grateful to Professor Leofranc Holford-Strevens, Oxford, UK, for his assistance with Latin translations.

Finally, I must thank my colleagues at the Cleveland Museum of Art. David Franklin, director, and C. Griffith Mann, deputy director and chief curator, have offered warm support throughout. I thank Heidi Strean, director of exhibitions, and Sheri Walter, exhibitions specialist; Barbara J. Bradley, director of curatorial publications, and particular thanks to Jane Takac Panza, editor of this volume; Mary Suzor, director of collections management, and Kimberly Cook, assistant registrar; and Caroline Goeser, director of education and interpretation. Finally, I must single out special praise for the unflinching work of Amanda Mikolic, curatorial assistant in medieval art; her problem-solving and research skills as well as image procurement abilities have benefitted this exhibition and its catalogue enormously.

Stephen N. Fliegel
Curator of Medieval Art
The Cleveland Museum of Art

Città di Castello

Montone

Gubbio

Umbertide

U M B R I A

Lake
Trasimeno

PERUGIA

Assisi

Deruta

Foligno

Montefalco

Tiber

Spoleto

Nera

Orvieto

Terni

Narni

ITALY

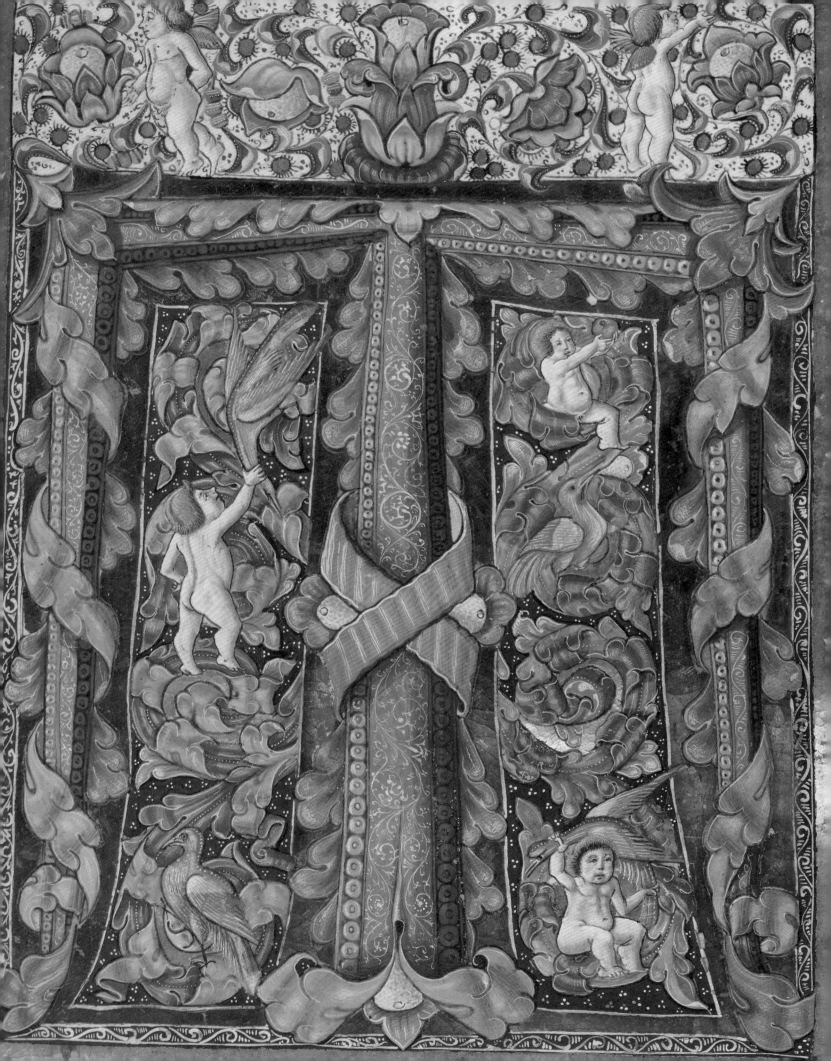

STEPHEN N. FLIEGEL

The Caporali Missal: A Masterpiece of Renaissance Illumination

IN 2006 the Cleveland Museum of Art acquired a sumptuous and historically important manuscript missal known today as the Caporali Missal. Its illuminations have been attributed to the brothers Bartolomeo and Giapeco Caporali, artists active in Perugia during the second half of the fifteenth century. The missal is well preserved and in excellent condition (cat. 1), surviving in its entirety with the exception of its binding, which was replaced in the early nineteenth century. The missal can be localized and dated with great precision. While it is possible to deduce from the style of the manuscript's decoration that it was produced in Perugia, the presence of a colophon provides us with additional information about the commission, destined use, and date of production, securely placing it with the Franciscans of Montone in 1469. Evidence of its connections to the Franciscans is apparent throughout given the large number of visual and scribal references to that order.

The copying of texts and the making of books has always been requisite to the practice of the Christian faith. Without books no services could be conducted, no laws codified and promulgated, and no doctrine espoused. Above all, without books the written word—the teachings and commandments of God himself, as conveyed in the Gospels and biblical texts—could not be made available to the faithful. From the earliest days of the church, the copying of books went on continuously in scriptoria scattered throughout Christendom. Throughout medieval Christendom, the embellishment of books was just as important in the visual projection of the sacred word as were sumptuous vestments and liturgical vessels. From an early date these books often contained decoration—enlarged initials, pictures, elaborate borders—that we know as illuminations. Gifted illuminators often found commissions in wealthy abbeys or cathedral chapters seeking to produce stunning service books for their altars. Frequently, at least through the thirteenth century, such scribes and illuminators were often talented members of the religious orders. Others were lay, sometimes itinerant artists and scribes who traveled where the commissions were to be found; to eke out a living in the service of the church, many gravitated to the most important production centers located in Italy's great cathedral cities like Florence, Siena, Milan, or Perugia. Natives of Perugia, the Caporali brothers shared a workshop and rose to prominent positions in their town.

The Caporali Missal, like all missals, was a service book intended for use at the altar by an ordained priest for the celebration of the Mass. During the early Middle Ages, there had been many books for the Mass. The principal book had been the sacramentary, which contained all the texts of orations and prayers needed by the celebrant—whether a parish priest, a bishop, or the pope—for every day of the liturgical year. This material comprised an unchanging part (the canon of the Mass) and a part that varied from day to day (the

Detail of *Initial T[e igitur]*, folio 186 from the Caporali Missal.

formularies of the Temporale and Sanctorale cycles as well as votive masses). From the twelfth century onward, these had become amalgamated into a single book: the missal. The missal was introduced during the Carolingian period and by the thirteenth century had completely replaced the older sacramentary.

The missal gradually evolved into the principle service book for the priest containing the texts recited or sung by him at the altar and necessary for the performance of the Mass. These included the prayers, invocations, readings, biblical passages, chants, and ceremonial instructions. Some of these texts are used in the same form throughout the liturgical year while others change from one day to the next to celebrate, for example, different saints' feast days or special feast days in the Temporale. Every priest, therefore, required a missal. Every missal was produced for the exclusive use of a priest at the altar. However, not every church throughout medieval Europe could afford to own a magnificently decorated missal, as such books represented a significant cost. Lavish illuminated examples from the Middle Ages or Renaissance, many of which survive today in libraries and museums, tended to be produced for wealthy monastic foundations, large cathedral churches, and, in some instances, for private chapels where their production costs were borne by a private benefactor. In the case of the Caporali Missal, internal evidence suggests that the book was funded by such a benefactor.

Illuminated missals were not only functional but also provided status to those churches in which they were used. Along with other liturgical objects, they would have been highly regarded as representative of the importance and dignity of a church or a religious order. Every church required essential liturgical objects and furnishings in order to support the celebration of the Mass and, if a monastic or conventual church, the singing of the offices. Such objects included the chalice and paten, ciboria, pyxes, Eucharistic doves, altar crosses, and cruets—that is, objects used in the consecration of the Eucharistic bread and wine or for the containment of the reserved Sacrament. To these we might also include candlesticks and processional crosses, vestments for the priest, and, of course, books for the altar, such as missals and gospel lectionaries. The production of such objects kept thousands of illuminators, painters, goldsmiths, metalworkers, and other craftsmen employed across Christian Europe.

The process of making a single codex (or book)—from the preparation of the parchment to the mixing of inks and paints to the final binding of the completed book—was expensive and laborious. Before a scribe could begin to write a book, he needed an original copy of the same text, called an exemplar. This corrected text then served as a model for the new manuscript. One monastery or cathedral often loaned books to another for this purpose, and on other occasions, scribes and illuminators were likely sent to the host church to copy a book on-site. These activities account for the transmission of styles in book illumination. Lay workshops also emerged in large cities, especially after the thirteenth century, for the production of books for ecclesiastical and secular clients. The

Caporali Missal most likely was not produced at the convent of San Francesco, Montone, which did not support a scriptorium. Undoubtedly, the missal was produced in Perugia, which supported a university at the time and would have had a substantial community of scholars, scribes, and illuminators who could have been tapped to produce the texts and illuminations on consignment for the Franciscans. The colophon in the missal records that its scribe was Heinrich Haring, who identifies himself as German. It would not be unusual for foreign academics, clerics, scholars, or scribes to be present in Perugia during the mid-fifteenth century, and some would have no doubt accepted such commissions in order to eke out a living.[1] To date, no archival evidence has been found to expand our knowledge of Haring, this commission, or his possible connection to the Franciscans at Montone or the Caporali brothers themselves.

A fundamental distinction in the services of the late medieval church exists between the Mass and the daily offices. These were completely different in function and outward form. The Mass is the Communion service or Eucharist, one of the most solemn and important sacraments of the church. It was celebrated at the altar, and its service books were the sacramentary, missal, and gospel lectionary. The musical counterpart to the service books for the Mass was the choral book known as the gradual, usually made as a multivolume set to cover the entire liturgical year. The Mass should not be confused with the daily offices performed in the choir. The daily offices (or divine office) are the series of services for the hours of prayer. They are not sacramental services but are basically prayers and anthems in honor and praise of Christ and the saints, either sung or recited at the eight canonical hours: matins, lauds, prime, terce, sext, none, vespers, and compline. Their service book was the breviary, read privately by the clergy, especially in smaller parish churches. The musical form of the breviary was the antiphonal, a large multivolume choral book used for services in the choir by religious orders as well as in cathedrals, collegiate churches, and perhaps large urban parish churches with the means to commission them.

It should be remembered that the church year is based on two simultaneous cycles of services. The first of these is the Temporale, or Proper of the Time, which observes Sundays and festivals commemorating the life of Christ. It opens with the first Sunday in Advent (the Sunday closest to November 30) and continues with Christmas, Lent, Paschal Time (from Easter to Ascension eve), and the season of Ascension (which includes Pentecost, Trinity Sunday, Corpus Christi, and the Sundays after Pentecost). The second quite distinct cycle of services is the Sanctorale, or Proper of the Saints. This latter celebrates the feast days of saints, including those of the Virgin Mary, and it opens with Saint Andrew's Day (November 30). A different saint's name could be assigned to every day of the year. Local observances varied from place to place, and the calendars in liturgical manuscripts classified or graded saints' days according to the importance to be given them: ordinary days, important or *semi-duplex,* and of exceptional importance or *totem duplex.* The Sanctorale and the Temporale were kept distinct in medieval service

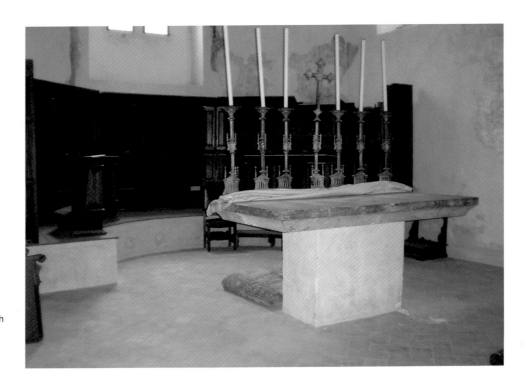

FIGURE 1 High altar of the church of San Francesco, Montone, where the Caporali Missal was likely used. Photograph: Michael J. Tevesz.

books and sometimes even formed separate volumes. The clergy would have easily distinguished between them.

The church of San Francesco, Montone, like other churches, would therefore have possessed a variety of manuscripts in addition to the Caporali Missal to support the religious life of the Franciscan community there, and the missal would have very likely not been the only manuscript missal available to the friars. Other missals, perhaps more ordinary in terms of decoration and comparatively modest and utilitarian, would have been present for use on a daily basis or upon the church's small side altars. Subjected to the stresses and strains of daily handling, they would have been extremely vulnerable to damage. Given its lavish and extensive decoration, the Caporali Missal would have most likely been used on the church's high altar (fig. 1) or reserved for use on specific feast days or special occasions. The excellent condition of the missal is suggestive of infrequent or reserved use and careful storage. When not in use, liturgical manuscripts, along with liturgical vessels and vestments, would have been stored in the small sacristy at San Francesco. Apart from the Caporali Missal, no other liturgical manuscripts from Montone dating to the fifteenth century are known to have survived or have yet been identified.

History and Contents of the Manuscript

According to the colophon on folio 400, the Caporali Missal was executed for the Franciscan convent of San Francesco, Montone near Perugia in Italy's Umbria region; the buildings of this male convent are still extant (fig. 2). Though the existing archives in Montone do not provide evidence of the presence of the missal at San Francesco, the manuscript's colophon affirms this commission (fig. 3).[2] The colophon provides the name of the German scribe, Henricus Haring (Heinrich Haring), and the precise date of completion, October 4, 1469. Also identified are the names of San Francesco's guardian at the time,

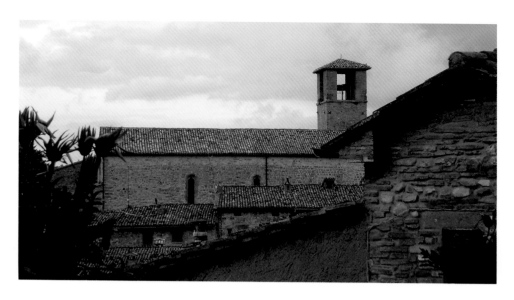

FIGURE 2 The church of San Francesco, Montone. Begun c. 1300. Photograph: Michael J. Tevesz.

Presbiter Frater Stephanus Cambi (Stefano di Cambio), and of its two procurators, Franciscus Ser Johannis de Ciurellis (Francesco di Ser Giovanni de'Cirelli) and Petrus Paulus de Miraculis (Pierpaolo de'Miraculi); these individuals may, or may not, be portrayed within the borders of the canon illustration on folio 185v, though their pictorial representation here is unclear. Such internal evidence concerning the date, place, commission, and scribe of a manuscript is exceptionally rare.

FIGURE 3 Colophon, folio 400 from the Caporali Missal.

When and under what circumstances the missal left the church of San Francesco, Montone is unknown.[3] Our first inkling of the whereabouts of the manuscript following Montone is suggested by the armorial binding stamp that bears the motto "carpe diem." This same stamp appears on the bindings of at least eight other manuscripts and a printed book documented as passing through the sales rooms during the late nineteenth century and early twentieth century. While puzzling to cataloguers for more than a century, recent research strongly suggests that the owner of the carpe diem armorial stamp was John Webster (1751–1826), a London lawyer and bibliophile. *The Gentleman's Magazine* for 1826 records that Webster died on January 5, 1826, and was resident at Upper Mall, Hammersmith, and Queen Street in Cheapside.[4] Webster, like many of his era, had cultivated an interest in medieval and Renaissance manuscripts, but unlike many of his contemporaries, he is not known to have dismembered manuscripts. Indeed, those manuscripts passing through his collection were carefully rebound and inscribed with his armorial stamp.

It is not recorded how or precisely when Webster acquired the Caporali Missal. However, Webster's life dates and known collecting activities coincide with the

Napoleonic incursions into Italy. Napoleon's armies, which were in Perugia and Montone, may have been the catalyst for bringing the Caporali Missal to the London art market. In 1796 Napoleon assumed command of the Army of Italy and soon defeated the Piedmontese and then the Austrians in northern Italy. His immediate plan was to press on to Vienna, but he first needed to secure his southern flank. He therefore occupied the papal legations of Ferrara and Bologna and marched on Ravenna. The Austrians managed to hold Mantua for a period and Pope Pius VI wrongly calculated that this would provide the springboard for a counterattack. The pope delayed making the agreed reparations, a decision that proved to be disastrous when Mantua fell to the French early in 1797. French troops swept through the Marches and then occupied both Perugia and Foligno. This occupation ended after only a month with the signing of the Treaty of Tolentino (1797), under the terms of which Pius VI was required to pay even higher reparations. He was also forced to concede both Ferrara and Bologna to the French. In June 1797 all the territory held by the French in northern Italy was consolidated as the Cisalpine Republic.

Although many citizens in Umbria welcomed the French and enthusiastically erected trees of liberty, others supported the church. The number in the latter camp increased as the exactions of the French became clearer, leading to a number of revolts, one of the most serious of which occurred at Città di Castello in April 1798. A trigger for the revolt seems to have been the illegal seizure of Raphael's painting *Marriage of the Virgin*. A steady stream of booty, both of money and art, made its way back to France in 1797–98. Indeed, the Sistine Chapel was sacked by Napoleon's troops in 1798 and lost many of its manuscripts. Some of these were eventually acquired by the Englishman William Ottley (1771–1836), who dismembered them.[5] The archives of San Francesco, Montone were also sacked by Napoleonic troops and are today incomplete as a result. Thus, it is tempting, though so far not provable, to believe the Caporali Missal left Montone at this time, perhaps ultimately finding its way to the English market and Webster's library. In this scenario, the vicissitudes of history have been kind, and our missal was not dismembered like so many other illuminated manuscripts that departed Italy under similar circumstances.

Though we cannot account fully for the whereabouts of the Caporali Missal during the past two hundred years, we do know much about its provenance history. Following Webster's death in 1826, his library, including the missal, was apparently purchased by Thomas Edwards (1762–1834), a bookseller in Halifax, West Yorkshire. From Edwards the missal subsequently passed into the collection of Philip Augustus Hanrott (1776–1856) before resurfacing on the London art market in December 1893, when it was sold by the antiquarian bookseller Bernard Quaritch.[6] The Caporali Missal then appeared in the collections of Leo S. Olschki of Florence and Count Paolo Gerli di Villagaeta of Milan (whose ex libris is on the flyleaf) before eventually being acquired by an unidentified Swiss private collector.[7] Dr. Jörn Günther, a rare book dealer in Hamburg, finally procured it, selling it, in turn, to the Cleveland Museum of Art in 2006.

As it survives today, the missal is remarkably complete with all of its four hundred folios. The manuscript opens with the hymn Kyrie (fols. 1–3v), followed by the calendar (fols. 3–8v) in which are listed the feast days to be commemorated during the course of the coming liturgical year. The most important feast days are identified in red, the remainder in black; prominent feast days are marked "duplex." Scribal and visual references to the Franciscan use of the missal appear throughout, as saints venerated by the Franciscans—Bartholomew, John the Baptist, Anthony of Padua, and, of course, Francis—are listed prominently. The colophon on folio 400 states that the manuscript was completed on October 4, 1469—not coincidentally, the Feast of Saint Francis. Whether the book was actually completed on this day or somewhat close in time cannot, of course, be established independently. Does this date refer only to the completion of the texts alone or to the completion of the bound and decorated book? The former seems the more probable. Whatever the answer, the Feast of Saint Francis was deemed significant enough for the scribe to mention it as the date the book was finished. This suggests that Haring was well aware that the missal was destined for the Franciscans at Montone and may also suggest that he himself was a Franciscan.

The manuscript's calendar precedes the Proper of the Time, or Temporale, which covers the first Sunday in Advent to the twenty-fourth Sunday after Trinity (fols. 9–258v) and provides the variable parts of the Mass, including Gospel readings and collects, for the year's seasonal feasts associated with the life of Christ. In the middle of the Temporale cycle, divided at the Easter vigil, appears the ordinary of the Mass with the various Prefaces, the Sanctus and Gloria, canon, Communion rite, and last Gospel. The Proper of the Saints, or Sanctorale (fols. 259–326v), which commemorates the saints and the life of the Virgin throughout the liturgical year, follows the Temporale. The Commune Sanctorum (fols. 327–360v) comes next, then a mass for the consecration of a church and several votive masses (fols. 360v–387v) as well as the mass for the dead. The Proper of the Saints gives the variant readings and prayers for the saints' days included in the calendar while the Common of the Saints provides general texts appropriate to the feast days of different categories of saints.

The most prominent decoration of the missal is assigned to three full-page illuminations. The first of these appears on the opening page of the Temporale on folio 9 (fig. 4); the rubric begins "Incipit Ordo missalis Fratrum Minorum," thus announcing the beginning of the Mass formularies for use of the Friars Minor, or Franciscans.[8] Below follows Psalm 24, which opens the introit of the Mass for the first Sunday in Advent: "Ad te levavi animam meam, Deus meus, in te confide."[9] The page's text is sumptuously framed by a luxurious border composed of abundant and rich foliage decoration. Within the foliage appear animated, clambering putti, who wear red rosaries or beads around their necks, and naturalistically drawn animals. Above, a green grasshopper faces a roundel featuring a large cat, perhaps a cheetah, wearing a collar. In the *bas-de-page* are two colorful birds,

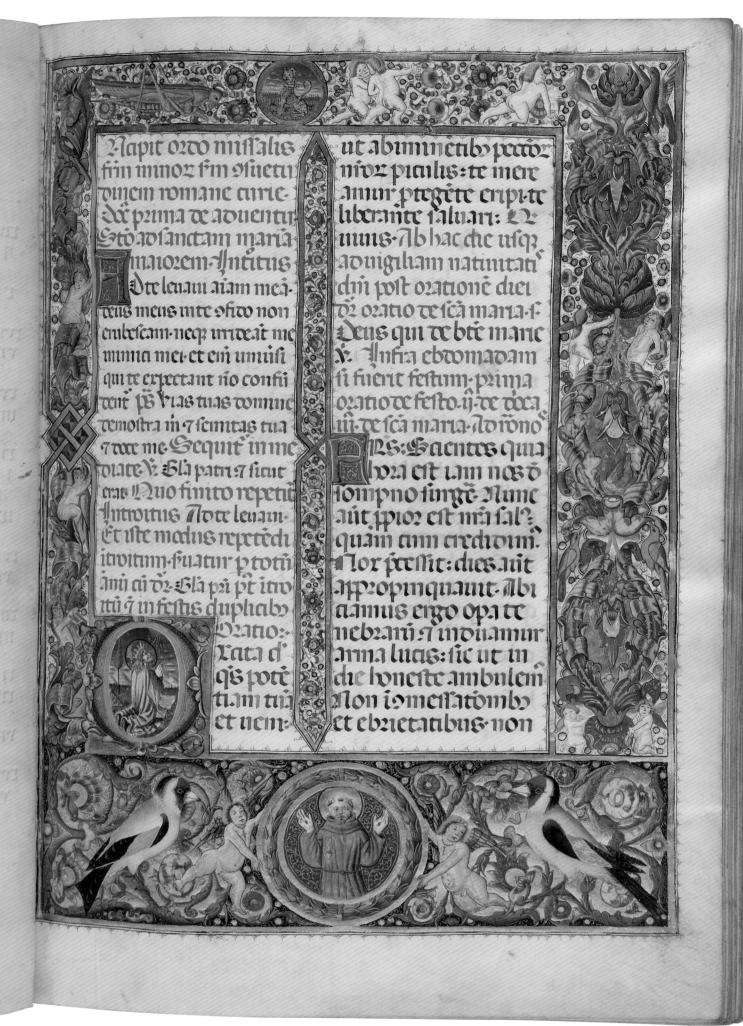

Incipit ordo missalis
fm minor sm institu-
dinem romane curie
dns prima de aduentu
Sto ad sanctam maria
maiorem. Introitus
Ad te leuaui aiam mea-
deus meus in te confido non
erubescam. neq irrideat me
inimici mei. et enim uniuisi
qui te expectant no confi-
dentur. Vias tuas dominc
demostra michi 7 semitas tua
7 doce me. Sequit in me-
diate v. Gla patri 7 sicut
erat. Quo finito repetit
Introitus Ad te leuaui-
Et iste modus repetedi
introitum. seruatur p totu
anu cu dr Gla pa pt itro-
itu 7 in festis duplicib;
Oratio:
Erata q
qs pote
tiam tua
et uem:

ut ab imminentib; peccato-
nior piculis: te mere-
amur ptegete eripi. te
liberante saluari: Ore-
mus. Ab hac die usq
ad uigiliam natiuitat'
chri post orationem diei
dr oratio de sca maria. F.
Deus qui de bte marie
V. Infra ebdomadam
si fuerit festum. prima
oratio de festo. ij. de doca
iij. de sca maria. Ad dnos
L.S.: Scientes quia
hora est iam nos d
sompno surge. Nunc
aut ppior est nra sal'
quam cum credidim'.
Nox pcessit: dies aut
appropinquauit. Abi-
ciamus ergo opa te-
nebrarum 7 induamur
arma lucis: sic ut in
die honeste ambulem'
Non in comessationib;
et ebrietatibus: non

probably finches, that symmetrically face a roundel at the center. This roundel, framed in garland, contains the nimbed three-quarter-length figure of Saint Francis, his hands raised to display his stigmata, a motif known as the *alter Christus*. A small initial in the lower left corner of the text block depicts King David in prayer, a subject traditionally associated with the Psalms.

Though there are many conspicuous exceptions, most manuscript missals from the fifteenth century were modestly decorated. The canon of the Mass, however, usually bore some decoration. In the Caporali Missal, the canon illustration (fols. 185v–186) is truly spectacular (fig. 5; see also cat. 1). A full-page miniature of the Crucifixion (fol. 185v) appears before the canon text—an image normally found in missals at this location—and depicts the crucified Christ with the Virgin and Saint John the Evangelist on the right and left, respectively. The figure of Saint Francis with stigmata kneels at the foot of the cross, which he embraces. Above, two hovering angels flank the figure of Christ, one of which holds a chalice to collect the blood issuing from the wound on Christ's right side—a reference to the Eucharist. Such a composition is a well-established symbol for the consecration of the body and blood of Christ under the species of bread and wine. Indeed, the altars in most churches were embellished with a sculpted or painted crucifix that was either placed directly on or suspended above the altar. In this way, the image of Christ on the cross was a constant reminder to the beholder of his sacrifice as the event was re-created at the altar during Mass. In the Caporali Missal, this Calvary scene would have been primarily visible only to the priest at the altar and perhaps occasionally to the other friars from afar. The scene is set in a hilly landscape with a rocky foreground; the verdant hills with topiary-like trees are perhaps suggestive of the lush Umbrian countryside. Above, punctuated with regularly spaced and delineated clouds, the blue sky is rendered in deep cobalt blue that lightens closer to the horizon. This beautiful and sumptuous scene is reminiscent of a large panel painting reduced in scale to fit the format of the parchment page.

The Crucifixion miniature is set within an elaborately decorated frame comprising scrolling acanthus leaves and other foliage as well as interlacing ribbons rendered in vivid pinks, blues, and greens. Burnished gold adds to the already luxurious decoration. The lower portion of the frame features the half-length figure of a Franciscan friar, his hands clasped in prayer, within a gold pierced quatrefoil that, in turn, is rendered within a gold roundel (fig. 6). The figure is clearly the guardian father of San Francesco, Montone, Stefano di Cambio, as indicated by the monogram FC ST within the quatrefoil. Father Stefano is also mentioned in the colophon on folio 400 as "guardianus conventus . . . presbiter Frater Stephanus Cambi." This, along with the reference to Montone, leaves no doubt as to the provenance of the missal.

In the corners of the upper frame are bust-length portraits of two figures set within squares and facing the center or, more likely, facing each other. These somewhat enigmatic figures have been interpreted as two males, an older bearded man on the right who sports

FIGURE 4 Introit for the first Sunday in Advent, folio 9 from the Caporali Missal.

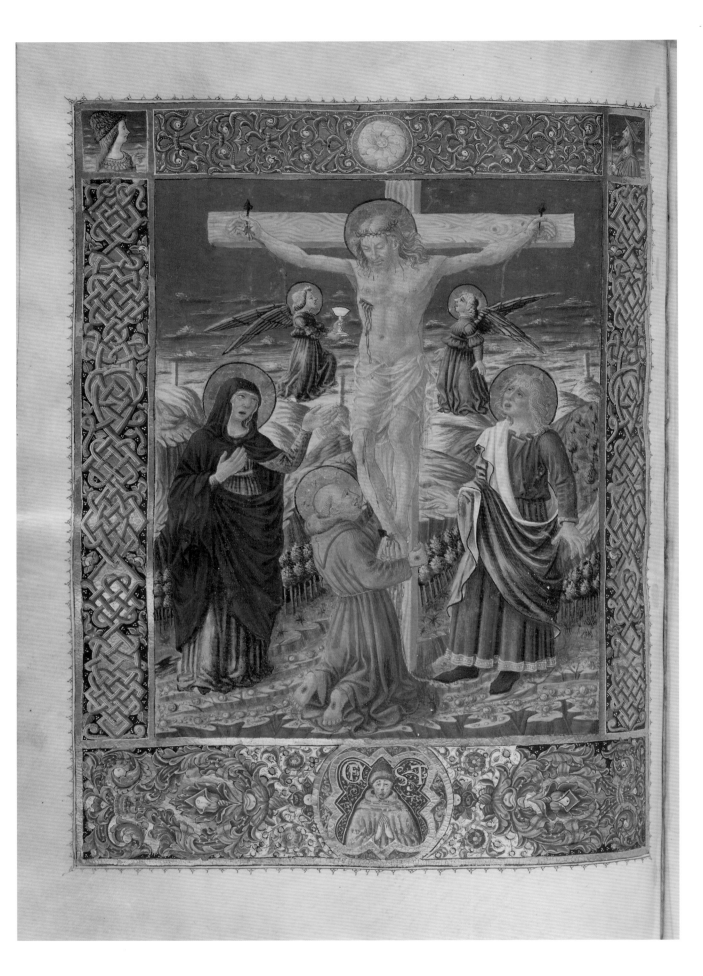

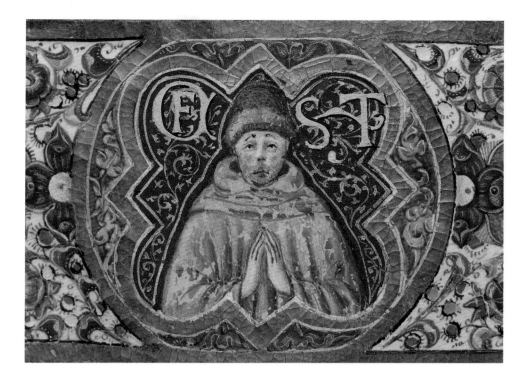

a red hat with a green brim and a younger beardless man on the left with a long coiffure and a conical brown hat. Additionally, these diminutive portraits have been suggested as representing the two procurators of San Francesco mentioned in the colophon: Francesco di Ser Giovanni de'Ciurelli and Pierpaolo de'Miraculi.[10] It has been further speculated that these individuals—lay persons connected to the friars at San Francesco in Montone who likely dealt with the provisioning of goods and services for the community—may have commissioned the missal. Such a scenario would presume that the procurators paid the scribe and the illuminators on behalf of the friars. The colophon in fact refers to the procurators as "honorabili uiri . . . qui incipere et finire fecerunt sollempniter·presens opus."[11] Little is known of these two individuals; however, the family names were certainly known in Montone at the time of the missal. One Franciscus Miraculi is listed among the Domini Sex, or Council of Six, who governed Montone in 1469, and the name *de Ciurellis* relates to Vittorio Cirelli (Victorius de Ciurellis), a painter documented in Montone between 1532 and 1552 and probably a descendant of Francesco di Ser Giovanni de'Ciurelli.[12]

Given the mention of Ciurelli and Miraculi in the colophon, and given the prevalence of the family names in Montone, there is no doubt that the two maintained an important role in the Franciscan community at San Francesco. However, the interpretation of the two portraits as depicting these specific individuals is not without problems and is not entirely clear. The most apparent problem is the gender of the individuals in the portraits. The bearded figure on the right is obviously male, but the gender of the figure in the upper left corner is less clear and may in fact represent a female and not a youthful male.[13] If we accept this latter interpretation, we must assume this male and female were prominent individuals who had some major role in the genesis of the missal or the patronage of the church of San Francesco in order to warrant their portraits' placement in such a prestigious location in the manuscript. A more tenable interpretation of the two portraits

FACING PAGE

FIGURE 5 *The Crucifixion*, folio 185v from the Caporali Missal.

ABOVE

FIGURE 6 Detail of Stefano di Cambio, guardian father of San Francesco, Montone, from *The Crucifixion*.

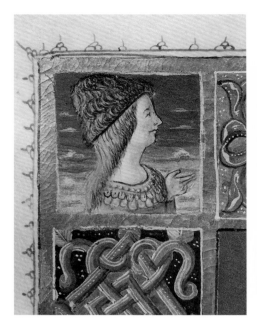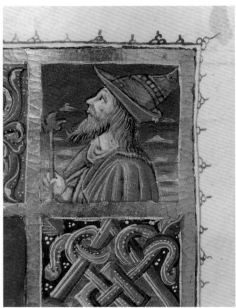

FIGURE 7 Detail of Margherita Malatesta, wife of Carlo Fortebracci, Count of Montone, from *The Crucifixion.*

FIGURE 8 Detail of Carlo Fortebracci, Count of Montone, from *The Crucifixion.*

is that they represent Margherita Malatesta (fig. 7) and her husband, Carlo Fortebracci, Count of Montone (fig. 8). Fortebracci and his wife have a documented history with San Francesco. They commissioned the construction of a sculpted altar at the north wall of the church on the occasion of the birth of their male heir. The altar bears both of their coats of arms as well as those of the counts of Montone. In 1491 Bernardino Fortebracci, their son, commissioned Bartolomeo Caporali to paint a fresco above the altar. The Fortebracci family, counts of Montone from 1414 to 1477, used the church of San Francesco as their private family chapel. If the two portraits on the Crucifixion page are of Carlo and Margherita, we can infer that their role in the church was patronal and that the missal was funded at their expense—though organized by the procurators—and gifted by them to the Franciscans of Montone.[14]

However, the role of Father Stefano, guardian father of San Francesco, should not be underestimated, as he also had a significant history in the embellishments of his church during his tenure. His image in the lower margin of the Crucifixion page, a prestigious location, may simply point to the manuscript's production during his tenure, but it may also suggest that the friar had a more active role in the missal's production. It is reasonable to assume that Father Stefano would have made certain choices regarding both the contents and decoration of a manuscript missal that was clearly destined for the high altar of his church.

Facing the Crucifixion is a luxurious full-page initial *T[e igitur]* (fol. 186) that introduces the text of the canon of the Mass (fig. 9; see also cat. 1). The border consists of garland ornament. Within this elaborate border, the letter *T* is enveloped and enriched by acanthus leaves and other floral elements that incorporate clambering putti and birds. The page is dominated by vibrant acid greens, mauves, and cobalt blues. This sumptuous and elaborate initial must be one of the most spectacular to survive from the Renaissance. Beneath the ornate initial, the prayer continues in alternating red and blue letters.

The canon is the fundamental part of the Mass, coming between the offertory and Communion and representing the most solemn part of all masses: the consecration by

FACING PAGE

FIGURE 9 *Initial T[e igitur],* folio 186 from the Caporali Missal.

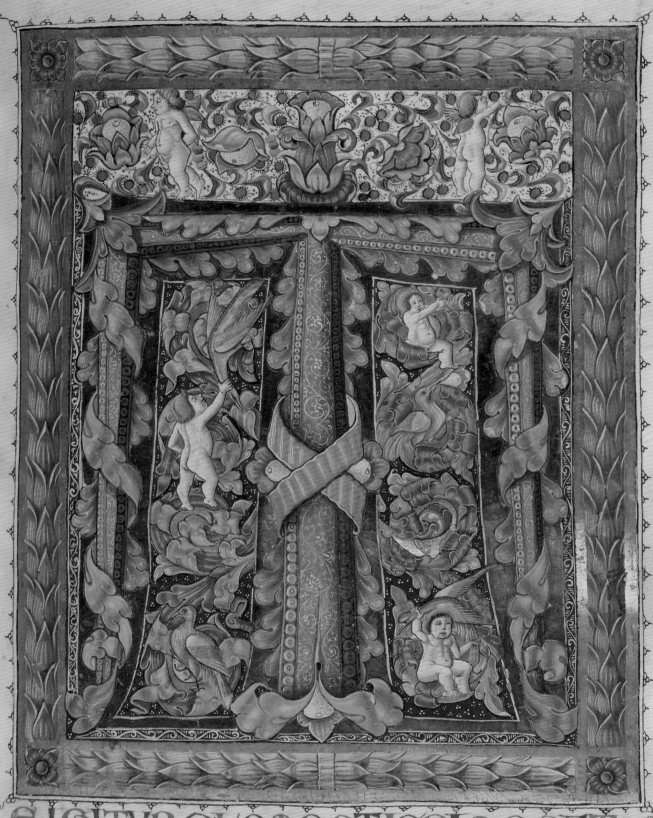

IGITVR CLEMENTISSIME PATER
PER IH E S V M X P M F I L I V M T V V

LEFT

FIGURE 10 *The Annunciation*, folio 275v from the Caporali Missal.

RIGHT

FIGURE 11 *Assumption of the Virgin*, folio 306 from the Caporali Missal.

the priest of the Eucharistic bread and wine into the body and blood of Christ, an event known as transubstantiation. The canon has remained unchanged in the Roman missal since the time of Pope Gregory the Great (590–604), generally regarded as the great organizer of the Roman liturgy and to whom tradition ascribes the final revision and arrangement.[15] The canon is therefore an already ancient consecration prayer that appears in countless manuscript missals throughout Christendom. At this moment in the Mass, the priest bends low and kisses the open page of the missal bearing the image of the crucified Christ. He makes three signs of the cross over the bread and wine to bless it and silently begins to pray these words:[16] "Te igitur clementissime Pater, per Jesum Christum Filium tuum Dominum nostrum, supplices rogamus ac petimus, uti accepta habeas, et benedicas haec, sancta sacrificial illibata."[17] In 1469, at the time of the Caporali Missal's production, the canon had reigned unquestioned and unchanged for centuries as the expression of the most sacred rite of the church. Contemporary interpreters simply took this holy text as it stood and conceived mystic and allegorical reasons for its divisions, expressions, rites, and even for the letter *T* of the Te igitur, which resembled the cross on which Christ died.

An unbroken line of script was difficult for the human eye to read unless relieved by a visual cue. The decorated initial, therefore, emerged as an accentuated or emphasized first letter of script. Its function was aesthetic as well as utilitarian, providing a marker for the reader's eye, noting the beginning of a book or chapter, and in this way, offering a visual gateway into the more important parts of a book's text—especially in an era when books contained no page numbers. Such initials became the focus of exceptional decoration to draw attention to and help classify the priorities of the text. Familiar images within the decoration of an initial (called a historiated initial) further assisted in explaining the text graphically to the user. Large decorated letters also bestowed upon a manuscript a look of great luxury, often sought by the book's owner.

In addition to the three full-page illuminations just described, the Caporali Missal includes thirty-one small illuminations, often with elaborate ascenders or descenders, that introduce important texts (figs. 10–11). Such historiated initials frequently appear in medieval and Renaissance missals at the beginning of the main feast days of the Temporale and Sanctorale and the beginning of the Common of the Saints.[18]

The Style and Attribution of the Caporali Missal

The Caporali Missal was first published in 1933 by Mario Salmi.[19] It was Salmi who initially attributed the missal's decoration to Bartolomeo and Giapeco Caporali on the basis of style. We unfortunately know little if anything of the workshop practices of either brother. However, sufficient works attributable to Bartolomeo—largely panel paintings and frescos—survive to provide evidence of his painterly style.[20] Similarly, a small number of illuminations attributable to Giapeco are preserved and provide visual comparanda for the decoration of the present missal. There is also the circumstantial evidence, the survival of two works at San Francesco, Montone: the gonfalon dated 1482 (cat. 6) and a fresco dated 1491 and signed by Bartolomeo (fig. 12). Both of these strongly suggest an existing relationship between the Franciscans at Montone and Bartolomeo. It is also conceivable that the Fortebracci family may have commissioned the missal from Bartolomeo since they supported other embellishments at San Francesco. Perugian nobles and local condottiere-princes, unlike other Italian communes, tended to emphasize local patronage, and the Fortebracci's choice of Bartolomeo would attest to their recognition that he was a well-known and respected artist in the region.[21] In return, the artists themselves seem to have been political supporters of the governing oligarchy. It is probably no coincidence that Bartolomeo, Fiorenzo di Lorenzo, Perugino, and Pintoricchio all served on the priorate, the highest political office in Perugia.[22]

To date no documentation—neither contracts nor payment records—has been discovered linking the Caporali brothers with the embellishments of our missal. However, the stylistic and technical evidence would seem to support Salmi's assertion that the

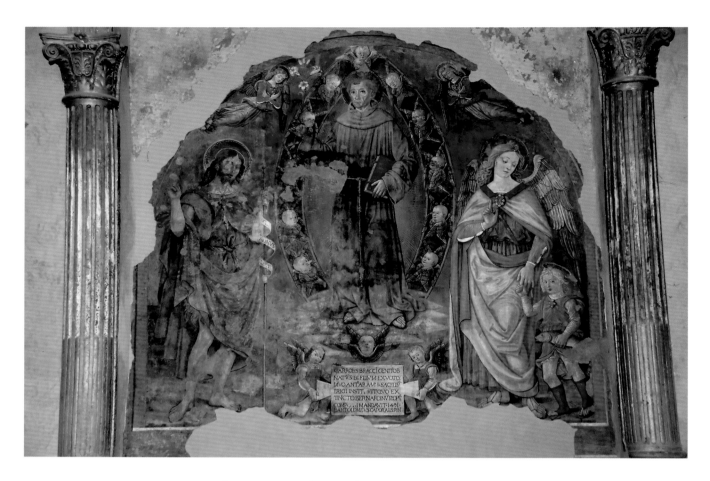

FIGURE 12 *Saint Anthony of Padua between Four Angels, Saint John the Baptist, Archangel Raphael, and Tobias,* 1491, from altar commissioned by Carlo Fortebracci in 1476. Bartolomeo Caporali (Italian, c. 1420–c. 1505). Fresco. San Francesco, Montone. Photograph: Michael J. Tevesz.

Calvary miniature (fol. 185v) was painted largely by Bartolomeo and that Giapeco painted the balance of the decoration, including the elaborate borders and thirty-one decorated initials. Bartolomeo's work as a miniaturist is unclear; no extant miniatures have been documented by him.[23] Nevertheless, it would not be unusual for Bartolomeo to work in the medium of book illumination from time to time. Many Renaissance painters worked across these media as needed in order to eke out a living. It was also not unusual for established painters to take commissions painting coats of arms, furniture and banners, and other ephemera. For example, in 1471 Bartolomeo was paid 60 florins for painting the arms of Sixtus IV on the Palazzo Pubblico and on the city gates of Perugia, and in 1472 he was paid a sum for painting trumpet banners.[24] The fact that Giapeco was a documented miniaturist who served as treasurer of the miniaturists' guild in Perugia would make tenable such a working relationship between the brothers on the decoration of a manuscript. Indeed, upon Giapeco's death in 1476, Bartolomeo was appointed to complete the former's term, which might suggest that Bartolomeo was himself an occasional illuminator of books or certainly recognized as being capable of doing so. In 1470 Bartolomeo and Giapeco purchased land and a house together in the parish of San Fortunato, where they may have had their workshop.[25]

The most compelling comparandum to the Crucifixion miniature in our missal is the large painted crucifix that hangs over the high altar of the church of San Michele on Isola Maggiore in Lake Trasimeno (cat. 7). The corpus of Christ on the Trasimeno crucifix, probably painted in the 1460s, would seem close enough in terms of its style, modeling, and chromaticism to suggest it was an antecedent to the version in the missal. Both

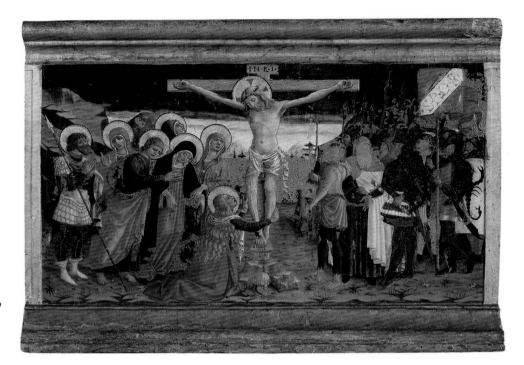

FIGURE 13 *The Crucifixion,* predella from *Altarpiece of the Adoration of the Magi.* Bartolomeo Caporali (Italian, c. 1420–c. 1505). Galleria Nazionale dell'Umbria, Perugia, inv. 141.

treatments demonstrate near identical features, including the rendering of the Redeemer's hair and crown of thorns, the musculature of the torso, the position of the legs, and similar attention to the hands and crucifixion nails. Likewise, the blood issuing from the five wounds forms nearly matching patterns, as Bartolomeo followed an idiosyncratic convention in which the blood flowing from the wound in Christ's side drips along the right, beneath the perizonium, and then continues along the right leg. Even the treatment of the wooden beams of the cross is similar in that Bartolomeo vividly depicted the grain and knots in the wood. These same features are also apparent in the predella of the *Altarpiece of the Adoration of the Magi* painted by Bartolomeo (fig. 13).[26]

The corpus of Christ in the missal is painted in subtle shades of ochre, pale yellow, and brown, much like the aforementioned examples, and the precise rendering of the musculature suggests Bartolomeo's powers of anatomical observation. The body of Christ and the flanking figures of the Virgin and Saint John, as well as the kneeling figure of Saint Francis at the foot of the cross, possess a monumentality indicative of the artist's experience as a painter of large-scale panel paintings and frescoes. Their draperies and especially their somewhat large hands demonstrate Bartolomeo's stylistic approach. The treatment of his female figures bears a striking similarity in the color and arrangement of their veils. But the two flanking angels in the missal's Crucifixion miniature are of a different character, suggesting they were painted by another hand, perhaps a workshop assistant, but more likely by Giapeco, who also authored the border decoration and vignettes of this folio.

Recent scholarship has begun to shed light on Giapeco's oeuvre and style.[27] The frontispiece page, the facing page to the canon bearing the decorated *T,* and the thirty-one small decorated letters can all be assigned to his hand. In these illuminations Giapeco

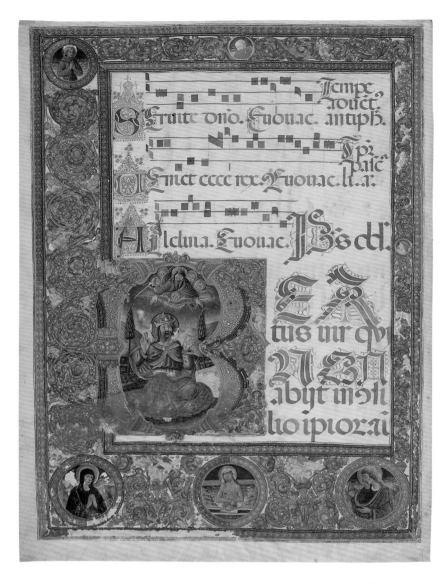

FIGURE 14 *Bifolium from a Choir Psalter: Initial B with King David in Prayer*, c. 1475–76. Attributed to Giapeco Caporali (Italian, died 1476). Ink, tempera, and gold on vellum; 58.6 × 43 cm. Worcester Art Museum 1921.157.

revealed himself to be an experienced and talented illuminator with a predilection for sophisticated decoration. Salmi was the first to note two distinct styles in the illuminations of the missal and commented on Giapeco's technique and palette.[28] While assigning the primary miniature—the Crucifixion—to Bartolomeo, Salmi suggests that Giapeco may have had a hand in painting the sky and landscape in the scene.

Giapeco's work as an illuminator has been under study in recent years and is primarily known through his hand in at least three volumes from a set of antiphonals—of which four survive—made for the Benedictine abbey of San Pietro in Perugia.[29] We are fortunate in possessing payment records that document the date, the scribe, and the miniaturists of the antiphonals. The antiphonal was copied by Don Alvise (or Alvige), and one of the illuminators was Giapeco, recorded as working on the antiphonals between 1472 and 1476. Another documented source of Giapeco's hand is to be found in the *Annali Decemvirali* of 1474, now in the Archivio di Stato in Perugia, which contains a miniature signed by him featuring the griffin of Perugia and elaborate foliate ornamentation.[30]

A bifolium from a choir psalter now in the Worcester Art Museum, Massachusetts, seems, on the basis of Giapeco's known style, to be convincingly attributable to his hand (fig. 14).[31] This bifolium of unknown provenance is made sumptuous by its highly ornate frontispiece that introduces the first psalm. A large initial *B* marks the opening words of that psalm: "Beatus vir qui non abiit in consilio impiorum."[32] As is traditional with the decoration of the first psalm, King David, the biblical king of Judea and presumed author of the Psalms, is prominently represented, the main focus of the initial. David is shown seated on the ground with his hands raised in prayer. His psaltery, a stringed instrument commonly associated with him, is placed on the ground nearby. David tilts his crowned head back and gazes upward toward heaven. Above, God the Father, surrounded by fiery cherubim, looks down toward the king, whom he blesses. This bifolium was once part of a rich and impressive large-format psalter known as a choir psalter. Choir psalters were choral books intended for the singing of the Psalms, probably by a monastic community.

The Worcester bifolium would have functioned as the frontispiece to the first volume of a larger set.

Stylistically, the decoration of the frontispiece strongly points to the work of Giapeco. The most compelling comparanda for this bifolium are the antiphonaries made for the abbey of San Pietro in Perugia (cats. 2, 3), for which payment records to Giapeco exist, and also the missal made for the Franciscans of Montone (cat. 1). The apparent hallmarks of Giapeco's style appear here: lavish borders with scrolling acanthus leaves, flowers, and highly animated putti as well as a vivid palette with bright cobalt blues, acid greens, pinks, reds, and orange. His love of figure roundels is also reflected in the borders. Below, Christ as Man of Sorrows appears in the central roundel; he is flanked to the left and right by the Virgin and Saint John the Evangelist, respectively. Other roundels depict Saint Francis in the upper left and an unknown tonsured and bearded monk in the center of the upper portion of the border. The large initial with King David reveals a receding verdant landscape with topiary-like trees and distant blue mountains and skies—not far removed from the decoration of the manuscripts cited. Finally, the colorful garland borders that outline the text block and the figure roundels are common features of Giapeco's work.

Since the Worcester bifolium is unprovenanced, it is difficult to date the work precisely. The roundels at the upper left and at the center of the upper border may suggest a provenance that is yet to be determined. It seems unlikely that the choir psalter was related to the San Pietro commission, as the abbey of San Pietro in Perugia was a Benedictine house, reinforced by the representation of Saint Benedict wearing the Benedictine habit on folio 1 of the Columbia volume (cat. 2). Instead, the presence of the founder of the Franciscan order seems to indicate that the Worcester bifolium was made for a foundation of that order; the unknown monk represented in the upper central roundel also appears to be wearing the Franciscan habit. In general, the maturity and sophistication of the painting of this leaf, seen especially in the large initial *B*, may imply the work was completed toward the end of Giapeco's career.

A missal in the Morgan Library & Museum in New York offers further evidence of Giapeco's hand (fig. 15).[33] The dimensions of the Morgan missal are nearly identical to the Caporali Missal, though it has fewer leaves and historiated initials. The Morgan missal,

FIGURE 15 *Missal*, folio 7r, introit for the first Sunday in Advent, 1470s? Giapeco Caporali (Italian, died 1476), with canon miniature by Fiorenzo di Lorenzo (Italian, c. 1445–c. 1525). Ink, tempera, and gold on vellum; 34 × 24 cm. Morgan Library & Museum, New York, MS M472.

however, does bear much in common with the Caporali both stylistically and decoratively. The opening of the introit for the first Sunday in Advent in the Morgan manuscript (fol. 7) is extremely similar to its counterpart in the Caporali Missal (fol. 9) in terms of the design, layout, and decorative vocabulary of its margins. Like the Caporali, the Morgan manuscript features Giapeco's hallmark floriate ornament, clambering putti wearing red rosaries around their necks, birds, garlands, and even the curious use of grasshoppers in the upper margin. The Morgan's seventeen historiated initials are also similar in design to those found in the Caporali. The large Calvary miniature is by a different hand, but the palette of the Morgan missal finds affinity with the Caporali as well as with the San Pietro antiphonals, which are documented to Giapeco's hand.[34]

The Morgan missal would seem to be largely the work of Giapeco, probably dating to the 1470s, just prior to his death from the plague in 1476. The missal is made according to Augustinian use, which suggests that it may have been produced for an Augustinian conventual house in the region. The church of Sant'Agostino in Perugia may be a possibility or another of the convents in the region, such as Sant'Agostino in Città di Castello.

In all of these manuscripts, the criteria of page layout, border decoration, vocabulary of ornamentation, and palette retain a striking consistency that logically point to a single artist. There is a strong predilection for floriated borders with acanthus spirals, flowers, and leaves, seemingly Giapeco's stock-in-trade. Within the ornate foliage of the borders are numerous lively and animated putti who engage with each other, sometimes tussling or otherwise frolicking with animals or playing musical instruments. Another aspect of Giapeco's work is his love of garland that both frames the page and the roundels he likes to feature in the bas-de-page. All of these elements appear within the folios of the Caporali Missal. While Giapeco's work has correctly been described as somewhat old-fashioned and dependent upon Florentine prototypes, he was clearly a skilled and experienced artist with an eye for chromaticism and elaborate design.[35]

The Caporali Missal represents a little-known and newly discovered book that may now be added to the corpus of published Renaissance manuscripts. Its sumptuous decoration makes it visually compelling and art historically significant, but its true importance is revealed through its colophon. Separated in time from the book's genesis by five and a half centuries, we, the modern observers, have the luxury of placing this book in time and place with rare precision. It is through this contextual knowledge that the real impact of the Caporali Missal may be appreciated for its place in Umbrian art of the Quattrocento.

NOTES

1 Perugia's university achieved considerable fame during the fourteenth century, and the presence of foreigners there is well documented. According to the city statutes of 1342, university professors were required to be foreigners. For a discussion of the socioeconomic conditions in Perugia during the fourteenth and fifteenth centuries, see Sarah R. Blanshei, "Population, Wealth, and Patronage in Medieval and Renaissance Perugia," *Journal of Interdisciplinary History* 9, no. 4 (Spring 1979): pp. 597–619.

2 See transcription and English translation in appendix B, p. 125. The author is grateful to Professor Leofranc Holford-Strevens, Oxford, UK, for providing these.

3 Efforts to trace the presence or to find any mention of the manuscript at the church of San Francesco through documentary sources in the Municipal Archives of Montone have not yielded results. Though there are mentions of Stefano di Cambio, guardian father of San Francesco at the time of the manuscript's creation, there is no documentation found to date linking him directly to the commission. The archives from San Francesco are not complete today, having been ransacked by Napoleonic troops, and such documentation, if it once existed, may simply have been lost. See "San Francesco, Montone," pp. 69–83.

4 *The Gentleman's Magazine* 1 (1826): p. 186. For a fuller discussion of this attribution, see Anthony Hobson and Thomas Woodcock, "The Owners of the 'Carpe Diem' Armorial Binding Stamp," *Book Collector* 54 (2005): pp. 539–42.

5 See William Young Ottley (1771–1836) sale, Sotheby's, London, May 11–12, 1838.

6 See sale, Quaritch, December 1893, cat. 138, lot 95. For a more detailed listing of the known provenance history of the manuscript, see catalogue 1.

7 The Swiss owner of the missal has chosen to remain anonymous and has asked Jörn Günther, who purchased the manuscript, not to divulge his identity. They have been simply described to me as "an old Swiss family."

8 "Here begins the order of the missal of the brothers minor [i.e., the Franciscans]."

9 "To thee, O Lord, have I lifted up my soul. In thee, O my God, I put my trust."

10 This interpretation was proposed in the description of the missal produced by Jörn Günther prior to its sale to the Cleveland Museum of Art.

11 "the honorable men . . . who solemnly caused the present work to be begun and ended."

12 I am indebted to Silvia Braconi for providing this information.

13 This possibility was first suggested to me by Maria Rita Silvestrelli who concurs that the likely identity is Carlo Fortebracci and Margherita Malatesta. The male figure (right) seems to hold a scepter or flower. The female figure (left) raises her hand to her spouse in a gesture of acknowledgment or acceptance. The presence of a leopard with an ornate collar on folio 9 has also been suggested by Silvestrelli as indicating a connection to Fortebracci; see "Bartolomeo and Giapeco Caporali," p. 41.

14 The Caporali Missal is mentioned in the catalogue of the Museo di San Francesco, Montone, where it is referred to as a work by the two Caporali brothers and a donation of the Count of Montone, Carlo Fortebracci, and his wife, Margherita Malatesta, but no archival sources are mentioned.

15 See *The Catholic Encyclopedia,* vol. 3 (New York: Encyclopedia Press, 1913), pp. 255–67.

16 In the modern Catholic liturgy, the priest no longer kisses the open missal or the altar at the opening of the canon.

17 "Therefore, we humbly pray and beseech Thee, most merciful Father, through Jesus Christ, Thy Son, Our Lord, to receive and bless these gifts, these presents, these holy unspotted sacrifices."

18 See appendix A, pp. 118–23, for a complete list of illuminations within the Caporali Missal. For further discussion of the internal divisions of the Roman missal and common locations for the placement of decorated initials, see Nigel Morgan, "The Liturgy and the Offices," in *The Cambridge Illuminations: Ten Centuries of Book Production in the Medieval West,* eds. Paul Binski and Stella Panayotova (London: Harvey Miller, 2005), pp. 118–23.

19 Mario Salmi, "Bartolomeo Caporali a Firenze," *Rivista d'arte* 15 (1933): pp. 253–72.

20 See "Bartolomeo and Giapeco Caporali," pp. 35–49, for a more cogent summary of his career and oeuvre. Until now, Bartolomeo has remained little studied, especially by non-Italian scholars, and there currently is no consensus regarding his extant body of work.

21 By 1469, the year the Caporali Missal was completed, Bartolomeo had already held prominent positions in Perugia. In 1457–58 he had served as treasurer of the painters' guild, and in 1462 he was elected a civic prior for March and April.

22 See Blanshei, "Population, Wealth, and Patronage," p. 618.

23 Five excised miniatures depicting the gates of Perugia and once illustrating the *Matricola,* now in the Archivio di Stato in Perugia, were formerly attributed in part or entirely (Salmi) to Bartolomeo. Recent scholarship has now more cogently assigned these works to other artists active in Perugia. See J. J. G. Alexander, "The City Gates of Perugia and Umbrian Manuscript Illumination of the Fifteenth Century," in *The Medieval Book: Glosses from Friends & Colleagues of Christopher de Hamel,* eds. Richard A. Linenthal, James H. Marrow, and William Noel (Houten, Netherlands: Hes & De Graaf, 2010), pp. 109–16.

24 Stanley Lothrop, "Bartolomeo Caporali," in *Memoirs of the American Academy in Rome,* vol. 1 (Bergamo, Italy: Istituto Italiano d'Arti Grafiche, 1917), p. 88.

25 Ibid.

26 Galleria Nazionale dell'Umbria, Perugia, inv. 141.

27 J. J. G. Alexander, ed., *The Painted Page: Italian Renaissance Book Illumination 1450–1550,* exh. cat. (Munich and New York: Prestel, 1994), cat. 124, pp. 232–33; Vittoria Garibaldi and Francesco Federico Mancini, eds., *Pintoricchio,* exh. cat. (Milan: Silvana, 2008), cat. 6, pp. 178–79. David Acton, *Master Drawings from the Worcester Art Museum* (New York: Hudson Hills Press; Worcester Art Museum, 1998), cat. 3, pp. 22–23; Alexander, "The City Gates of Perugia," in Linenthal, Marrow, and Noel, *The Medieval Book,* p. 113.

28 Salmi, "Bartolomeo Caporali a Firenze," pp. 270–72.

29 MSS I, L, and M are still in Perugia at the abbey of San Pietro. One of the volumes, the former MS K, is today preserved in the Rare Book Library of Columbia University, New York (Plimpton MS 41). See Alexander, *The Painted Page,* cat. 124, pp. 232–33; Garibaldi and Mancini, *Pintoricchio,* cat. 6, pp. 178–79; and here, catalogue 2, 3. See also Mario Salmi, *Italian Miniatures* (London: Collins, 1957), p. 56, in which the author notes Giapeco's indebtedness to Florentine Illumination.

30 MS 108. Ibid.

31 1921.157. Acton, *Master Drawings,* cat. 3, pp. 22–23.

32 "Blessed is the man who has not walked in the counsel of the ungodly."

33 *Missal,* 1470s? Giapeco Caporali (Italian, died 1476), with canon miniature by Fiorenzo di Lorenzo (Italian, c. 1445–c. 1525). Ink, tempera, and gold on vellum; 286 leaves, text in 2 columns, 27 lines; 34 × 24 cm. Morgan Library & Museum, New York, MS M472.

34 The Morgan Library & Museum attributes the large canon miniature to Fiorenzo di Lorenzo with the remaining marginal decoration and historiated initials by a follower of Giapeco.

35 Alexander, "The City Gates of Perugia," in Linenthal, Marrow, and Noel, *The Medieval Book,* p. 113.

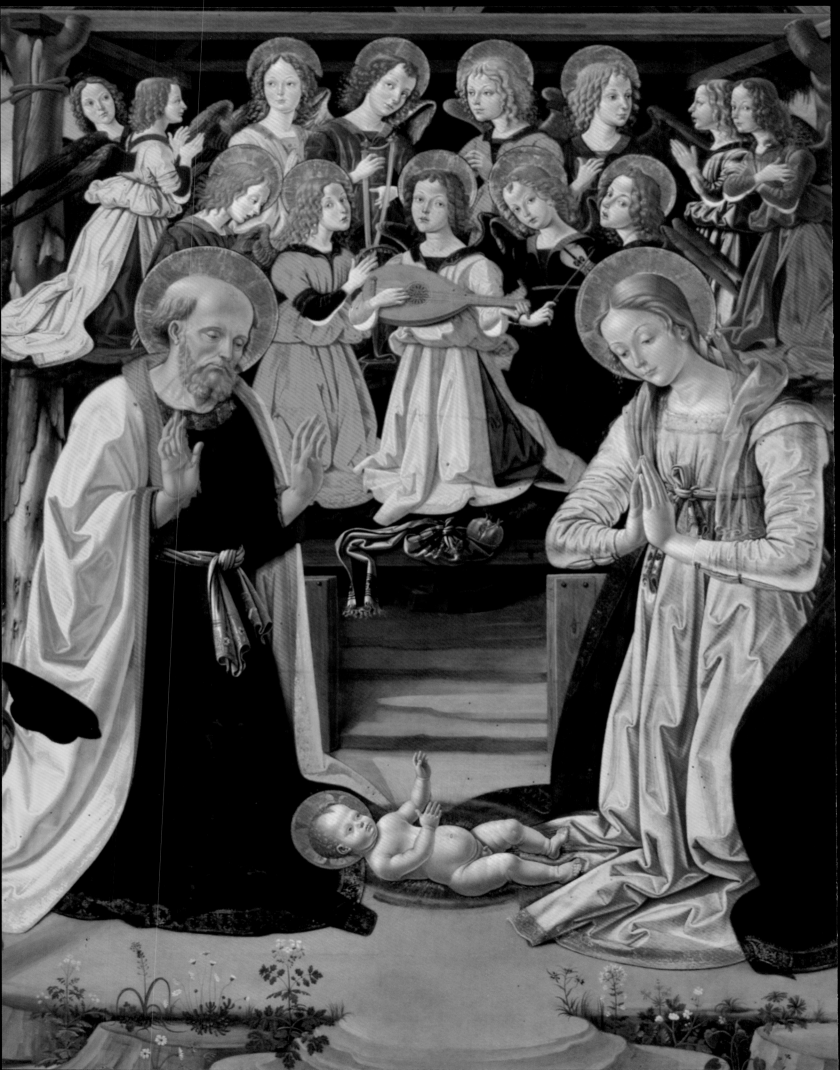

Bartolomeo and Giapeco Caporali

SEGNOLO DI GIOVANNI, known as "Il Caporale," was a military man whose descendants made important contributions to the arts in Perugia for more than a century.[1] Originally from Massa Lombarda in Romagna, Segnolo most likely arrived in Perugia as part of the retinue of Braccio Fortebracci[2] and by 1417 was already the castellan of the cassero di Sant'Antonio, a strategic military garrison in the city.[3]

His sons would follow a very different path: Bartolomeo, the elder of the two, became a member of the painters' guild in 1442 while Giapeco joined the miniaturists' guild.[4] The earliest known information about Bartolomeo stems from his enrollment in the painters' guild; however, no specific work by the artist has been identified with this period, nor is there any precise knowledge about his early training.[5]

Critics have long recognized his close relationship with the painter Benozzo Gozzoli, an association now confirmed by a document dating to July 1451, when the decoration for the new chapel at the Palazzo dei Priori was being planned and carried out, the ceiling having already been richly decorated by the preceding generation of late-Gothic Perugian masters. When the final commission was awarded by Ottaviano di Lorenzo and Mariano d'Antonio, a certain Bartolomeo, who clearly can be identified as Caporali, and a Benozzo, who can be none other than Gozzoli, appeared to be involved: "Item ei dicti Giovagnie et Liupardo deggano pagare Binoçco et Bartolomeo de la rata ne toccha a loro per pentura del dicto lavorio."[6] Their presence should not be surprising if one considers the type of ornamentation that this ceiling required: gilding and silver-plating with alternating panels featuring a griffin and a burnished-gold star, all of which had to harmonize with large bands depicting festoons and faces of putti that were painted later by Benedetto Bonfigli in the portion below. In much the same way as had been done in the chapel of San Brizio in Orvieto, here, too, an updated decorative scheme was proposed, adapted to a site that, more than any other, was intended to be the principal and exemplary space of the entire palazzo.[7]

Following their father's death, which occurred prior to October 1452, the Caporali brothers renounced their inheritance and moved to Porta Eburnea, in the parish of Santa Maria della Valle. Bartolomeo was the first to appear in the new land registry, but it was Giapeco who illuminated the initials with a simple decoration in pen and ink from which a winged and flaxen-haired putto emerges (cat. 4).[8] We have no other information about him during this period, as he probably worked in the shadow of his older brother who, in December of that year, was asked to paint a *maestà* and a *pietà* in the headquarters of the powerful shoemakers' guild, still located within the Palazzo dei Priori—an official commission for which he was paid 5 florins and that resulted in his attaining the status of an independent and highly regarded master.[9]

Detail of *Adoration of the Shepherds*, 1477–79. Bartolomeo Caporali (Italian, c. 1420–c. 1505). Galleria Nazionale dell'Umbria, Perugia.

FIGURE 1 *Fanciullata Aedicule*, 1459. Bartolomeo Caporali (Italian, c. 1420–c. 1505). Deruta (environs). Photograph: Maria Rita Silvestrelli.

The aedicule that Bartolomeo painted in 1459 in Fanciullata (fig. 1), where he also owned land, is rather typical of this early period.[10] The entire layout of the wall painting has characteristics that are very similar to Gozzoli's style in his frescoes in Montefalco. In particular, Bartolomeo's architecture of the side niches that feature the figures of Saints James and Anthony Abbot demonstrates a refined rethinking of the small monochrome heads (fig. 2) previously utilized by Gozzoli in the fragmentary fresco of San Fortunato in Montefalco (fig. 3), which also served as a model for the angel playing a tambourine (fig. 4); the typology of the Virgin's face, however, is informed by another work by Gozzoli in Perugia, the *Sapienza Nova Altarpiece* of 1456.

In the Fanciullata fresco, two different expressive modalities—if not two different hands—can be identified: one, closely linked to Gozzoli's style, was perhaps more appreciated by the patron, but a second artist's manner is evident thoughout the entire painting, one that was strongly marked by the "painting of light" associated with Florentine masters, from Domenico Veneziano—who was active in Perugia as early as 1438—to Fra Angelico and Filippo Lippi. These latter two painters would influence the "shining Caporali" throughout his career, motivating him to continuously innovate in his work. The face of Saint James, especially, is comparable to the face of the crucified Christ that Bartolomeo executed in the church of San Michele Arcangelo on Isola Maggiore in Lake Trasimeno—a masterpiece of the artist's early period painted perhaps slightly before the Fanciullata fresco.[11] Here, Christ's deeply hollowed eye sockets, lined face, the hair stuck to his skull, and the drops of coagulated blood translate Gozzoli's more controlled language of

FIGURE 2 Detail of small monochrome head, 1459, from *Fanciullata Aedicule*.

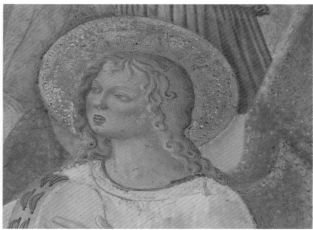

FIGURE 3 *Madonna and Child Enthroned*, 1450. Benozzo Gozzoli (Italian, c. 1421–1497). San Fortunato, Montefalco. Photograph: Maria Rita Silvestrelli.

FIGURE 4 Detail of angel playing the tambourine, 1459, from *Fanciullata Aedicule*.

the Crucifixion in the chapel of San Gerolamo in Montefalco into the expressive and moody language favored by the Umbrian tradition. The large skull of Adam, which has its origins in the work of Fra Angelico, also has a strong emotional impact, screaming before the cross that rises above a bleak lake landscape—an unreal perspectival view—between the figures of a praying Saint Francis and a prostate Mary Magdalene (cat. 7).

One might think that Bartolomeo found it difficult to receive major civic commissions, which tended to be awarded to celebrated artists from outside the city, such as Giovanni Boccati from Camerino, who had numerous sojourns in Perugia, or more successful masters like Benedetto Bonfigli. Bartolomeo collaborated on a variety of projects with Giapeco, attempting to find interesting commissions particularly in the surrounding Perugian region. In his continuous quest for innovation and new techniques, he skillfully developed an accessible and captivating language that imitated illustrious models and aligned with the dominant taste in Perugia and its environs. Moreover, he sought to adjust to a demanding but broader market, all the while carefully managing his longstanding and flourishing entrepreneurial activity. The result was numerous connections and various civic posts that enhanced his professional life.[12]

The works that are ascribed to him and that belong to this early period are not documented and thus have aroused a great deal of critical controversy.[13] While the paintings

in this series may have a similar stylistic origin, there are obvious differences in execution, revealing a wide range in a workshop where, alongside a single mind, there were different collaborators with whom Bartolomeo was associated from time to time; these individuals are not always recorded or clearly identifiable, but they remain quite evident throughout his career. It seems that he worked in the company of other painters whose personalities are still difficult to pinpoint but to whom he allowed broad freedom of execution, maintaining a high level of workmanship without insisting on a rigorously uniform style. The *Annunciation* in Avignon, which, more than any other work, declares a closeness to the art of Gozzoli;[14] the *Madonna and Child with Two Angels,* now in Berlin, which is almost a collage of influences; the *Madonna with Child, Angels, and Saints* (1465) from the Strossmayer collection and now in Zagreb; and the *Madonna and Angels* in the Uffizi all belong to this stylistic period.[15]

During the second half of the 1460s, Bartolomeo seems to have consolidated his role in the city, as suggested by the existence of more documentary evidence and an increasing number of his works that have been preserved from this period. In May 1467 his presence is noted in Rome, where he sold 1,300 sheets of gold that were to be utilized "pro supercelio ecclesia sancti Marci."[16] This reference associates him with one of the principal worksites in Rome at that time, the Palazzo Venezia. Here, he executed work similar to what he had already achieved with the decoration of the vault in the chapel of the Palazzo dei Priori, focusing his attention on careful craftsmanship and continually varying the gilded portions of the paintings—to which Giapeco may have made a considerable contribution. Bartolomeo widely used his brother for other pieces produced by the workshop but known to us only through documents. Indeed, for years Bartolomeo provided the municipality of Perugia and the abbey of San Pietro with painted and gilded objects, an activity that guaranteed continuous work and high revenues.[17]

A panel such as *Madonna with Child and Six Angels,* now in the Galleria Nazionale dell'Umbria, is particularly significant because of its controversial critical interpretation. It likely was executed for the Eucharistic altar in Monteluce and given to the nuns by Fioravante di Giovanni di Luca (known as "Fioravante dei Matti") in 1465.[18] The painting reveals a careful study of luminous effects through the skillful distribution of gilding highlighted by color. Bartolomeo experimented with a technique that mixed oil with tempera and introduced contrasting colors in the angels' clothing, thereby turning the panel into a precious object that almost resembles enamel and was thus suitable for veneration by the nuns.[19] Works from the next decade, such as the *Triptych of Justice* (fig. 5) and the fragmentary *Monaldi Polyptych,* now in the National Gallery in London, are also characterized by this focus and research into new techniques. Despite these paintings' stylistic innovation, the gold background is still intricately worked with gilded fabrics featuring complicated designs—elements that comply with a persistent, old-fashioned taste in the city with which Piero della Francesca also had to contend in his *Saint Anthony Polyptych.*

FIGURE 5 Detail of *Trittico della Giustizia,* 1475. Bartolomeo Caporali (Italian, c. 1420–c. 1505). Galleria Nazionale dell'Umbria, Perugia. Photograph: Maria Rita Silvestrelli.

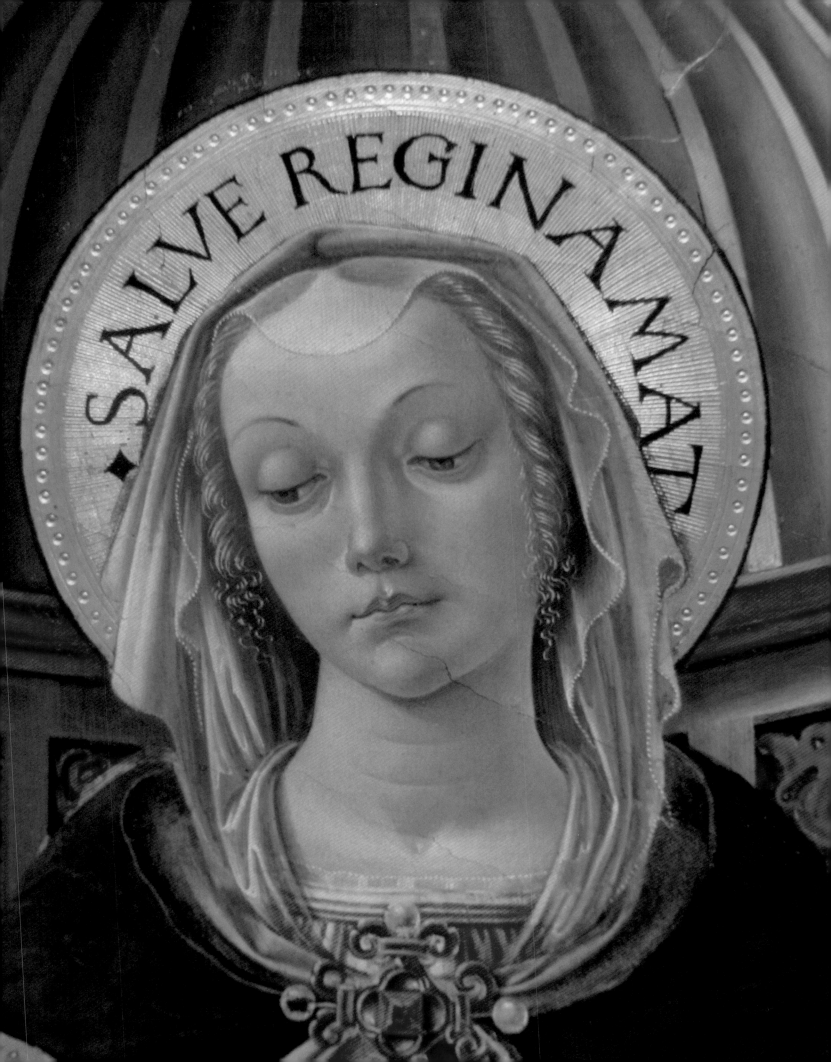

FIGURE 6 *Assumption of the Virgin,*
1469. Bartolomeo Caporali (Italian,
c. 1420–c. 1505). Monastery of Santa
Giuliana, Perugia. Photograph: Maria
Rita Silvestrelli.

Benedetto Bonfigli was in close contact with Bartolomeo; they collaborated on the
Lancilotto di Ludovico Altarpiece for the church of San Domenico.[20] In a work as complex
as *Adoration of the Magi* (c. 1466), also for San Domenico, one can already note the pres-
ence of a composite culture where several different artists are painting "in the style of
Bonfigli and better than Bonfigli" but who are also tied to the style of Bartolomeo, as can
be seen in the predella's Crucifixion scene, executed by a painter very sensitive to the rep-
resentation of perspectival landscape.[21] Bonfigli, the more renowned Perugian painter at
this time, does not seem to have had a workshop and, when required, perhaps called upon
the shop of Mariano d'Antonio. Bonfigli died in 1468, and the following year Bartolomeo
was practicing his profession in the work space of Angelo Baldeschi on a street occupied
by shoemakers, which was still close to the base of the city's main piazza, a focal point
where workshops of various painters had long been concentrated.[22]

This period also saw increased activity at the monastery of Santa Giuliana, exemplified
by a monumental fresco featuring the *Assumption of the Virgin,* a remnant of a broader
decoration executed in 1469 in the nuns' parlatory (fig. 6). This work, recently restored
and relocated to its original setting, reveals refined compositional archaisms in harmony
with the older decorations of the site and, thus, was destined for certain success. Note, in
particular, the Byzantine-style mandorla that encloses the Virgin and Child; the four sym-
metrical angels in flight who hold up scrolls; and the base painted in variegated marble
designs in which half figures of saints inside polylobate dividers appear in the upper band.
It is a composition characterized by light tones distinguished by a new formal elegance
due in large part to the rich fabrics, the angels' garments, and the Virgin's mantle with its
mother-of-pearl tones (fig. 7).[23]

FIGURE 7 Detail of *Assumption of the Virgin.*

The missal for the church of San Francesco, Montone bears the same date and is a work that scholars believe Bartolomeo executed mostly in collaboration with his brother, Giapeco. The presence of the gilded leopard (fol. 9), one of the emblems of the Fortebracci family, suggests that the missal was created with their financial support.[24] The artists' familial ties with the lords of Montone—which date back to the time of their father Segnolo "il Caporale," who became a Perugian citizen thanks specifically to a decree issued by the great Braccio Fortebracci's son Oddone—thus seem to surface in various ways.[25]

The Fortebracci's admiration for and faith in Bartolomeo continued. In 1491 Carlo Fortebracci's son Bernardino entrusted him with the creation of a celebrative fresco in the family chapel, still in San Francesco, Montone. The work depicts Saint Anthony of Padua between Saint John the Baptist and Tobias and an angel.[26] The friar Stefano di Cambio clearly played a significant role in these commissions; he had long been the guardian father of the convent and had earlier been depicted in prayer within a tondo in the decorative band at the base of the Crucifixion in the missal of San Francesco, Montone (fol. 185v). In 1482 Bartolomeo painted for him and for the convent (OPUS HUIUS CONVENTUS)[27] the gonfalon featuring the Madonna of Mercy (cat. 6), where the friar is again portrayed, but this time in profile, his hands joined in prayer, presented to the Virgin by Saint Sebastian.[28] On the back wall inside the church of San Francesco, Bartolomeo created a now very fragmentary Saint Sebastian, dated 1490, which can be related to a private patron who was probably once again "guided" by the convent's same guardian father.[29]

It is precisely at this time that Giapeco emerges in the documentation noted thus far. He was still in close contact with his brother, with whom he acquired a house in May 1469 in Porta Sant'Angelo in the parish of San Fortunato, where he would live with his wife,

Maddalena di Giovanni di Costanzo di Paolo, after marrying her the following year.[30] There is scant information about his activity as a miniaturist, which, as far as we know, seems to have begun precisely with the Montone missal, for which he is thought to have created much of the exuberant decoration.[31]

Between 1471 and 1473, the powerful abbey of San Pietro refurbished its liturgical books, a commission entrusted to Giapeco, who had established a workshop near the Colle Landone, one of the principal spaces in the city, in a "chamber" owned by Angela di Acquaviva.[32] The names that emerge from the accounting records of the Benedictine abbey cast some light on the artists who worked there and, thus, the illuminators active in the circle of Giapeco at this time.[33] Two principal groups are identified: one including Giapeco—who is specifically named but who certainly worked alongside collaborators— and the other related to Pierantonio di Nicolò di Pocciolo[34] and his "helper" Berardino Iuliani magistri Angeli.[35] They shared a workshop located beneath the episcopate palace, next to the audience chamber for the blacksmiths and herbalists at the end of the piazza.[36] Pierantonio was paid in November 1471 "per iminiatura di doie lettere grande le quali sono principio de lantifonario novo,"[37] and in November 1472 for having decorated "uno principio di uno antifonario de ladvento,"[38] i.e., the breviary of the time (choir books I and L). Choir books K and M, containing the office of the saints, can be assigned to Giapeco, who in June 1472 received payment "for the rest of the second book," namely, the Sanctorale that constitutes the second part of the daily office.[39] Another curious figure, Tommaso di Mascio Scarafone, also worked on this project, and information has recently been unearthed about his playful though modest artistic identity; along with Ercolano di Pietro da Mugnano, he was paid for the execution of 669 illuminated letters.[40]

Only Giapeco is again mentioned in May 1473, when he received 5½ florins for illuminating a missal written by Maestro Mattia di Guglielmo for the confraternity of San Francesco.[41] It was while he held the post of prior for a two-month period in May–June 1474 that he executed the illuminated initial *I* of the *Annali Decemvirali*,[42] giving it the form of a griffin crowned with a serpent's tail. It is a clear, elegant homage to the Baglioni seigniory, whose crest, as various figurative sources attest, and as the humanist Francesco Maturanzio recalls, had a half griffin terminating with a serpent's tail (fig. 8).[43] Giapeco was not compensated for this work, as, with ironic cheerfulness, he mentioned in a handwritten notation: "Non guardare a tal lavoro / che Giapeco del Caporale magnifico priore / el fe et non è costo denaio al notaro loro."[44]

His last known illuminated work seems to be a missal now in the Morgan Library & Museum in New York. This codex came from the convent of San Agostino in Perugia and was created during the final phase of Giapeco's activity.[45] Here, he is responsible for the large, elaborate illumination with an initial letter featuring a representation of David conversing with God (fol. 7). The plant volutes and symbolic animals, such as the grasshopper and the pelican, are comparable to the same figures in the Montone missal. This

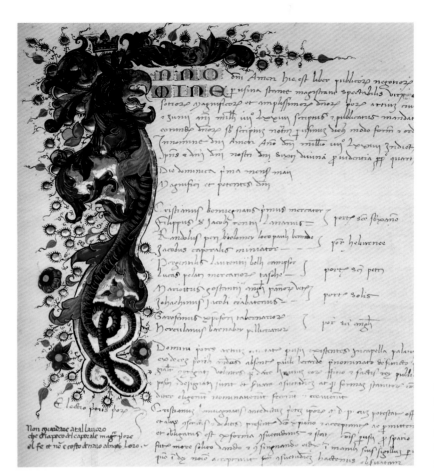

FIGURE 8 *Illuminated Initial I in the Form of a Griffin with a Serpent's Tail*, 1474. Giapeco Caporali (Italian, died 1476). Archivio di Stato, Perugia, Consigli e Riformanze. Photograph: Maria Rita Silvestrelli.

illumination and others attributed to Giapeco convey his skill as a decorator and color-ist. Other initial letters in this same codex appear weaker in workmanship and may have been the product of his workshop.[46] As for the illumination that appears in folio 131, only the frame that delimits the Crucifixion and the putti that hold the coat of arms of Saint Nicola da Tolentino can be assigned to Giapeco; the page was completed with a Crucifix-ion by another hand.[47] In 1476 he was again paid for work executed for the monastery of San Pietro, but his activity was interrupted, and he died from the plague that very year, leaving behind his little son, Vincenzo, who died shortly thereafter at some time before February 1477.

Bartolomeo would later compile in his own hand an inventory of all the assets and objects in the workshop at the time of his brother's death. This albeit scant information describes a certain detachment between the two brothers beginning in the early 1470s,[48] a time when Bartolomeo's workshop seemed to become the favored meeting place for exchanges, encounters, and visits by various artists. Through a subtle network of acquain-tances who still remain elusive, Bartolomeo emerged as a leading figure in the artistic world of Perugia, and it was perhaps in the early 1470s that the youngest protagonists of Umbrian painting, from Perugino to Pintoricchio, began to rely on him. In fact, an example of the sort of work that emerged from Bartolomeo's circle—though clearly not the result of his refined ideas—are the San Bernardino panels, one of the most thoroughly investigated series in Perugian painting, influenced by the latest stylistic trends emerg-ing from Verrocchio's Florentine studio. Here, the transparent view of architecture and

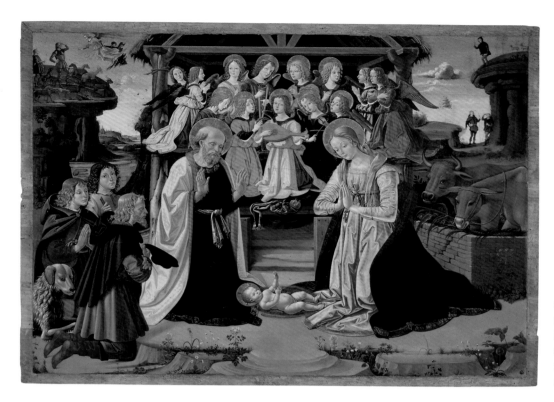

FIGURE 9 *Adoration of the Shepherds,* 1477–79. Bartolomeo Caporali (Italian, c. 1420–c. 1505). Galleria Nazionale dell'Umbria, Perugia.

landscape prevails over the representation of the narrated facts. Today this is a singular example of the complexity of the artistic environment in Perugia, as most of the fresco decorations that must have covered the walls of the houses of the Baglioni and other notable Perugian families have been completely lost.[49]

There is documentary evidence that Sante di Apollonio del Celandro, Bartolomeo's most talented disciple, worked alongside him on "the griffin and other things" for the confraternity of Santi Andrea and Bernardino della Giustizia.[50] Their efforts must have been well received, for two years later they were given a commission to execute an altar panel, the *Triptych of Justice,* a work much debated by critics, in which the younger artist's contribution is considerable and easily recognizable.[51] Well suited *ad depingendum*—as the older master seems to have recommended—Sante would also receive another important commission, the *Decemviri Altarpiece* for the Palazzo dei Priori chapel.[52] After Sante's death the commission was reassigned to Perugino, who in 1493 went to Bartolomeo's house to retrieve the molding that had been painted for the work.[53]

The *Triptych of Justice* is a painting that should be considered in close association with *The Virgin and Child with Saints* altarpiece currently in the National Gallery in London and previously part of the Monaldi collection in Perugia. The arrangement of the central panel, *Madonna and Child with Angels between Saint Francis and Saint Bernardino,* hints at earlier models by Gozzoli, as seen in its reinterpretation by Nicolò di Liberatore in the older Deruta altarpiece. For Bartolomeo's work we still do not know the identity of the patron presented to the Virgin, but the piece should be dated in close proximity to the *Triptych of Justice* and not far from *Adoration of the Shepherds* for Monteluce (fig. 9). At this same time Bartolomeo was granted another important commission: a *pietà* for the Cappella del Verde in the cathedral in Perugia. The work is known only from documents

but clearly demonstrates how the artist was a dominant presence in the city's principal spaces at this point.[54]

These paintings by Bartolomeo not only exhibit similarities to new models, such as Perugino's *Adoration of the Magi,* but they also affirm experiments attempted earlier and now carried out with greater certainty. In his *Adoration of the Shepherds* (1477–79),[55] the use of oil paint allowed the artist to dwell on new calligraphic elements, as he paid greater attention to details that he meticulously described in a manner evoking Bernardino Pintoricchio—who is presumed to have spent time in Bartolomeo's workshop and who would work in Monteluce only a few years later, in 1484, creating a fresco decoration around the tabernacle for the Eucharist.[56]

The early 1480s marked a new direction for Bartolomeo, who updated his expressive language toward that of the "gentle style" developed by Perugino on the walls of the Sistine Chapel and by his Umbrian collaborators. This is clearly seen in *Madonna of the Windowsill* (1484), a work commissioned by the Alessandri family, Perugian jurists, and now in the Museo di Capodimonte in Naples.[57]

A *pietà* on panel, now in the Museo Capitolare in Perugia and dated 1486,[58] closely relates to the beautiful detached fresco of the same subject, originally in Santa Giuliana,[59] where the central group inserted in a landscape is similar to an earlier version by Perugino, *Pietà del Farneto,* an extremely symmetrical composition. Adaptations of the ancient theme of the *Vesperbild* were favored for devotional painting, and in 1479 Boccati also addressed this subject, creating a much more dramatic variant.[60]

Thanks to drawings left by Giovan Battista Cavalcaselle, it is also possible, theoretically, to reconstruct the *Altarpiece of the Hunters* in Castiglione del Lago. The central panel in the painting features a Virgin and Child adored by angels and, in the side panels, Saint Sebastian and Mary Magdalene on one side and Saints Anthony Abbot and Roch on the other. It bore an inscription with a signature and date (1487) but is now known only through five fragments that still reveal an intense, successfully rendered expressiveness.[61] Here, too, Bartolomeo once again presented the Virgin holding the Christ Child in a standing position on her knee. This compositional scheme, introduced in the 1480s in the workshop of Verrocchio, found new success in Umbria in the mid-1480s; Piermatteo da Amelia utilized it for his *Altarpiece of the Franciscans* in Terni, and it was employed numerous times within the Caporali workshop and more generally in Perugian circles.[62] The motif appears again in a fresco with the Virgin and Child enthroned between Saints Anthony and Jerome, commissioned by Evangelista di Francesco de'Rossi for the church of Rocca Sant'Angelo, near Assisi.[63] These works all seem to come from the same stylistic phase and continue to demonstrate Bartolomeo's chameleon-like ability to absorb current fashions. His documented assistant at this time was Lattanzio di Giovanni, who worked alongside him during the period when he created the aforementioned fresco with

Saint Anthony in a mandorla between Tobias and the angel and Saint John the Baptist, in Montone.[64]

The arrival in Perugia of the Virgin's wedding ring, stolen in Chiusi in 1473 by a German monk, led to the founding in 1487 of the Compagnia di San Giuseppe, a confraternity that, a few years earlier, had obtained a chapel dedicated to Saint Bernardino in the cathedral, and where the revered relic was meant to be placed. A committee of five men was assigned the task of arranging for the execution of a painting depicting the betrothal of Saint Joseph and the Blessed Virgin, and Bartolomeo was among the first signatories of the confraternity. The work was entrusted to Pintoricchio, who named Bartolomeo his proxy to negotiate the most suitable compensation and also to collect it.[65] It was an important sign; the now elderly Bartolomeo had every advantage to guarantee good relationships with the young, celebrated artist, who then welcomed into the large work sites in Rome a new generation of Umbrian painters, which included Giovanni Battista, the most versatile of Bartolomeo's sons.[66]

NOTES

I would like to thank Stephen Fliegel, Brigadier General Gianfranco Di Luzio, the Army Foreign Language School, Perugia, and Sheri Shaneyfelt.

1 Bartolomeo's direct descendants include Giampaolo, a goldsmith, and Giovanni Battista, a painter, architect, and erudite commentator of Vitruvius's *De Architectura*. Giovanni Battista's son, Giulio, was also an architect and a painter; see appendix C, p. 126. See *Allgemeines Künstlerlexikon* (Munich: K. G. Saur, 1997), s.v. "ad vocem."

2 Braccio Fortebracci had become lord of the city in 1416.

3 Going by the nickname "Caporale," Segnolo is recorded as holding this post in documentation regarding his acquisition of hides. See Romano Pierotti, "Aspetti del mercato e della produzione a Perugia tra la fine del secolo XIV e la prima metà del XV. La bottega di cuoiame di Niccolò di Martino cuoiaio," *Bollettino della Deputazione di Storia Patria dell'Umbria* 70 (1975): pp. 79–185. His wife Maddalena is named in a dispute connected to an inheritance in which another of Segnolo's sons, Michelangelo, is also mentioned. See Archivio di Stato, Perugia (hereafter referred to as ASP), Notarile, Bastardelli, 254, fols. 83–83v.

4 The registry for the painters' guild can be found at the Biblioteca Augusta in Perugia, MS 961. The registry for the miniaturists' guild is known only through a transcription by Annibale Mariotti of MS 1928 from the Biblioteca Augusta in *Spoglio delle matricole del Collegio delle Arti a Perugia* 1 (1786), fol. 260. Other observations with documentary additions are in Adamo Rossi, "L'arte dei miniatori a Perugia," *Giornale di Erudizione Artistica* 2 (1873): pp. 305–27.

5 Mario Salmi proposes that he trained in Florence; see "Bartolomeo Caporali a Firenze," *Rivista d'arte* 15 (1933): pp. 253–72. The hypothesis has been developed recently by Laura Teza; see "Percorsi fiorentini di Bartolomeo Caporali e indagini su Ludovico d'Angelo Mattioli," in *Invisibile agli occhi. Atti della giornata di studio in ricordo di Lisa Venturini*, ed. Nicoletta Baldini (Florence: Service, 2007), pp. 109–31.

6 "I called upon Giovanni and Leopardo to pay Benozzo and Bartolomeo the price for painting this work." The painters are Giovanni di Tommaso Crivelli, Melchiorre di Matteo, and Leopardo Raggi. See ASP, Notarile, Bastardelli, 328, fol. 66. Mariano d'Antonio, a former student of Pellegrino di Giovanni, had one of the most important workshops in the city. For other observations, see Maria Rita Silvestrelli, "Vite di artisti a Perugia al tempo della formazione di Pintoricchio," in *Pintoricchio*, exh. cat., eds. Vittoria Garibaldi and Francesco

Federico Mancini (Milan: Silvana, 2008), pp. 27–37, esp. pp. 28–29. It should be noted that in 1564 Giulio Caporali, son of Giovanni Battista, was brought in to repaint this ceiling. See Umberto Gnoli, *Pittori e miniatori dell'Umbria* (Spoleto: C. Argentieri, 1923), p. 171.

7 In 1450 the chapel was called the "principale membrum dicti palatii et locus precipuus et singularis, decus, ornamentum et speculus dicti palatii" (main part of the palace and a unique and singular place of honor and majesty and a mirror of that palace). See Francesco Federico Mancini, "La residenza dei Priori: uso e decorazioni degli spazi interni dal XIV al XVIII secolo," in *Il Palazzo dei Priori di Perugia* (Perugia: Quattroemme, 1997), pp. 279–325, esp. p. 283. Thus, it is possible to place more correctly *Totila's Siege of Perugia* (Florence, Gabinetto Disegni e Stampe degli Uffizi, 333 E), the well-known drawing that Gozzoli submitted to a competition for a commission for the entire decoration. In this drawing, the representation of the city in the background was too vague, and the story of the city's protector, Saint Herculanus—flung from the Etruscan walls, flayed, and then decapitated—did not correspond to what the ten *priori delle arti*, heads of the guilds, had envisioned during their long sessions, and the commission undoubtedly went to Bonfigli, who was considered the best interpreter of the citizenry's aspirations.

8 The following year Bartolomeo acquired, again alone, a house in the Conca quarter. See ASP, Notarile, Protocolli, 130, fol. 904.

9 ASP, Archivio storico Comune di Perugia (hereafter referred to as ASCPg), Cappella dei Priori, 2, fol. 68.

10 For historical information on the site, see Ugolino Nicolini, "La Madonna del Fanciullo," in *Il Paese dell'arte civile* (Perugia: Arnaud, 1997), pp. 100–103. The painting was restored in May 1485, when 2 florins were paid to Filippo domini Benedicti "superstite super reparatione Maestatis site in pertinentis castri Dirute in loco dicto San Cassiano" (for the imminent repair of the *maestà* located in the castle of Deruta). See ASP, ASCPg, Depositario tesoriere, fol. 153. The land registry reveals that Bartolomeo also owned land in Sant'Angelo di Celle specifically.

11 Fra' Leonardo Nicolutii of Isola Maggiore, "Custode della Custodia di Perugia" (guardian of the custody of Perugia) (1456) and on more than one occasion the guardian father of the convent of San Francesco al Prato, could be connected in some manner to the commissioning of the work. This might explain the presence of Saint Leonard at the top of the cross.

12 Beginning in 1464 he was the *camerario* (administrator) of the painters' guild several times; prior in

1462 and again in 1480; and elector of the Capitano del Popolo in 1469 and 1476 as well as the Fancello dei Massari in 1483 and 1485. In 1487 he was one of the signatories to the new Compagnia di San Giuseppe, formed at the behest of Bernardino da Feltre, and in 1497 he was the *revisore dei conti* (auditor) for the confraternity of San Pietro Martire.

13 Following the discovery of documents related to the *Giustizia Triptych,* Bartolomeo's early phase of activity—tied to Fra Angelico and filtered through Gozzoli—was questioned; however here, these relationships are reaffirmed on the basis of the document associated with the decoration of the ceiling of the Cappella dei Priori.

14 Michel Laclotte and Esther Moench, *Peinture Italienne. Musée du Petit Palais, Avignon* (Paris: Réunion des musées nationaux, 2005), pp. 85–86. For Luciano Bellosi, it can be ascribed to Gozzoli himself, but Andrea De Marchi feels it was executed following a drawing by Gozzoli. See Keith Christiansen et al., ed., *Fra Carnevale. Un artista rinascimentale da Filippo Lippo a Piero della Francesca,* exh. cat. (Milan: Edizioni Olivares, 2004), p. 70.

15 For a catalogue of the works of Bartolomeo and his workshop, see Filippo Todini, *La pittura umbra: dal Duecento al primo Cinquecento* (Milan: Longanesi, 1989), 1: pp. 49–52.

16 "for the ceiling of the church of San Marco." Rome, Biblioteca Vallicelliana, Spogli Corvisieri, case 14, booklet D. Umberto Gnoli, "Bartolomeo Caporali a Roma," *Rivista d'arte* 16 (1934): p. 97. Laura Teza, ed., *Per Fiorenzo di Lorenzo pittore e scultore* (Perugia: Quattroemme, 2003), p. 22, no. 55. The painter and miniaturist Giuliano Amidei was also working here in the autumn. Teza, "Percorsi fiorentini di Bartolomeo Caporali," in Baldini, *Invisibile agli occhi,* p. 112. Andrea De Marchi, "Identità di Giuliano Amadei miniatore," *Bollettino d'arte* 93/94 (1995–96): pp. 119–58.

17 In late June 1471 he and Bonfigli received 60 florins for providing "pro pennonibus tubarum palatii Magnifici Domini Priores" (for the pennons of the Palace of the Magnificent Priors). See ASP, Notarile, Protocolli, 266, fol. 61.

18 Alberto Maria Sartore, "Bartolomeo Caporali. Cedola autografa," in Garibaldi and Mancini, *Pintoricchio,* pp. 204–5. In all likelihood this corresponds to the work commissioned from the painter by Fioravante dei Matti in 1465, a date that is also suitable in terms of style for the Zagreb panel and other works from this period.

19 Pietro Scarpellini believes the painting should be attributed to the "Maestro dagli occhi sottili," who was active within Bartolomeo's workshop and with whom this work and others, including

the Zagreb panel, should be associated. See Pietro Scarpellini and Maria Rita Silvestrelli, *Pintoricchio* (Milan: Federico Motta Editore, 2003), pp. 35–36; Paola Mercurelli Salari, "Maestro dagli occhi sottili," in Garibaldi and Mancini, *Pintoricchio*, pp. 216–17; Sartore, "Bartolomeo Caporali. Cedola autografa," in Garibaldi and Mancini, *Pintoricchio*, pp. 204–5.

20 This is the well-known contract of July 1467. The commission refers to a polyptych that has been the subject of consistent discussion and whose pieces are now in the Galleria Nazionale dell'Umbria. See Andrea De Marchi, "Pittori a Camerino nel Quattrocento: le ombre di Gentile e la luce di Piero," in *Pittori a Camerino nel Quattrocento* (Milan: Motta, 2002), pp. 24–99, esp. p. 95.

21 The painting was executed for Gaspare di Nicolò di Lello. Piero Nottiani, "Riflessioni sulle tecniche pittoriche nell'epoca e nell'ambiente di Benedetto Bonfigli: dipinti su tavola e su tela," in *Un pittore e la sua città. Benedetto Bonfigli e Perugia*, ed. Vittoria Garibaldi (Milan: Electa, 1996), pp. 120–23, esp. p. 123.

22 This important urban space was radically transformed at the time of the construction of the Rocca Paolina, resulting in the destruction of the entire Baglioni quarter. In 1481 the workshop of Giovanni di Tommaso di Angelo di Paolo, known as "Giovagnolo," was also located here. See ASP, Notarile, Bastardelli, 593, fol. 247v.

23 For this fresco and for a balanced assessment of Bartolomeo's stylistic language, see Bruno Toscano, "La pittura in Umbria nel Quattrocento," in *La pittura in Italia. Il Quattrocento*, ed. Federico Zeri (Milan: Electa, 1987), 2: pp. 355–83, esp. p. 369.

24 Emilia Perrott, "Un messale umbro del Quattrocento," *Bibliofilia* 36 (1934): pp. 173–84. Elvio Lunghi, "Per la miniatura umbra del Quattrocento," in *Atti Accademia Properziana del Subasio—Assisi* (Assisi: Atti Accademia Properziana del Subasio, 1984), 6: pp. 149–97, esp. p. 162, no. 8. Maria Grazia Ciardi Duprè Dal Poggetto, Fausta Gualdi Sabatini, and Sara Giacomelli, *Miniatura umbra del Rinascimento*, Storia della miniatura: studi e documenti 9–10 (Florence: Società internazionale di studi di storia della miniatura, 2005–6), pp. 7–69.

25 ASP, ASCPg, Catasti, 1, 17, fol. 331.

26 Maria Rita Silvestrelli, "Bartolomeo Caporali," in *Museo Comunale di San Francesco a Montone*, ed. Giovanna Sapori (Milan: Electa, 1997), pp. 94–96.

27 "work of this convent"

28 Silvestrelli, "Vite di artisti a Perugia," in Garibaldi and Mancini, *Pintoricchio*, p. 31.

29 Maria Rita Silvestrelli, "Appunti sulla storia e l'architettura della chiesa di San Francesco," in Sapori, *Museo Comunale*, pp. 23–29, esp. p. 25. Paola

Mercurelli Salari, "Pittore perugino della fine del XV secolo," in Sapori, *Museo Comunale*, p. 37.

30 He and Maddalena would have a son, Vincenzo, who would die by February 14, 1477, when Bartolomeo mentioned these events in conjunction with a dowry earlier assigned by the two brothers to a nephew. See ASP, Notarile, Protocolli, 209, fols. 49v–50v.

31 See "The Caporali Missal: A Masterpiece of Renaissance Illumination," pp. 13–33.

32 Angela di Acquaviva, wife of Galeotto Baglioni, was the mother of the more well-known Atalanta Baglioni, who commissioned Raphael to paint the *Borghese Deposition*. Information about the existence of this workshop, mentioned in an inventory compiled after the death of the miniaturist, was revealed by Alberto Sartore, "Giapeco Caporali. Lettera 'I' iniziale miniata," in Garibaldi and Mancini, *Pintoricchio*, pp. 176–77.

33 See Ciardi Duprè Dal Poggetto, "Perugino e la miniatura," pp. 7–69, for new, but not always acceptable, suggestions.

34 Pierantonio was the son of Nicolaus Poccioli Conciator, a tanner of wool and hides from Porta Sant'Angelo. See ASP, ASCP, Officii, 9, fol. 55.

35 It was probably he who also illuminated four breviaries for the Benedictines. In 1474 he was present at an assembly of painters. See Biblioteca Augusta Perugia, MS 961, fol. 23v.

36 Sartore, "Giapeco Caporali. Lettera 'I' iniziale miniata," in Garibaldi and Mancini, *Pintoricchio*, p. 176.

37 "to illuminate two large letters at the beginning of the new antiphon"

38 "the beginning of an advent antiphon"

39 J. J. G. Alexander, "Antiphonary of San Pietro, Perugia," in *The Painted Page: Italian Renaissance Book Illumination, 1450–1550*, ed. J. J. G. Alexander (London: Royal Academy of Arts; Munich: Prestel, 1994), p. 232.

40 Ercolano di Pietro da Mugnano was the brother of the miniaturist Benedetto di Pietro da Mugnano, already working for the abbey of San Pietro; he was killed in an ambush in 1469. His father was a master stone and wood carver active in the most important building sites in the city.

41 Confraternity of San Francesco, general ledger, B IV, 424, fol. 48. Payment to the miniaturist was made on May 4. Maestro Mattia di Guglielmo Tedesco, instead, was the writer entrusted with the task of writing the missal in September 1471, since the one previously there had been stolen. J. J. G. Alexander, "The City Gates of Perugia and Umbrian Manuscript Illumination of the Fifteenth Century," in *The Medieval Book: Glosses from Friends & Colleagues of Christopher de Hamel*, eds.

Richard A. Linenthal, James H. Marrow, and William Noel (Houten, Netherlands: Hes & De Graff, 2010), pp. 109–16.

42 ASP, ASCPg, Consigli e Riformanze, 110, fol. 58. The illumination has been extensively studied and reproduced. See Ciardi Duprè Dal Poggetto, Gualdi Sabatini, and Giacomelli, *Miniatura umbra del Rinascimento*, p. 146, with bibliography, to which Sartore, "Giapeco Caporali. Lettera 'I' iniziale miniata," in Garibaldi and Mancini, *Pintoricchio*, pp. 176–77, should be added.

43 Biblioteca Augusta Perugia, MS 715, fols. 114v–115: "Et per loro insegna portavano uno scudo azzurro cum una sbarra in mezzo a traverso doro cum lo cimiero di sopra mezzo grifone et de drieto pendeva una coda de serpente" (and for their insignia they carried a blue shield with a gold band across the middle with a crest above with a half griffin and a serpent's tail hanging down behind).

44 "Don't look at this work / since Giapeco del Caporale, magnificent prior / did it and it cost them nothing."

45 It is very likely that Giapeco was buried in this church, which he frequently attended and which was not far from his residence. In 1470, when he asked for his wife's dowry from his father-in-law, the notarial deed extended into the cloister of this convent. See ASP, Notarile, Protocolli, fol. 203. As the will of Bartolomeo's wife, Brigida Cartolari, notes, this is also the site of the tomb of her husband, alongside whom she wished to be buried. See ASP, Notarile, Protocolli, 762, fol. 201v.

46 See Pietro Scarpellini's entry in *Dizionario Biografico degli italiani*, vol. 18 (Rome: Istituto della Enciclopedia Italiana, 1975), s.v. "Giapeco Caporali."

47 Meta Harrsen and George K. Boyce, *Italian Manuscripts in the Pierpont Morgan Library* (New York: Pierpont Morgan Library, 1953), p. 74. It might have been brought to completion by some coworkers after his death. It has been variously attributed to Bartolomeo, to the circle of Fiorenzo di Lorenzo, and, most recently, to Sante di Apollonio. See Ciardi Duprè Dal Poggetto, Gualdi Sabatini, and Giacomelli, *Miniatura umbra del Rinascimento*, pp. 41–42.

48 They are also mentioned together in March 1471 for unspecified projects in Tordandrea, in the vicinity of Assisi. See ASP, ASCPg, Sussidio Focolare, 154, fol. 11v.

49 Laura Teza, "Una nuova storia per le tavolette di San Bernardino," in *Pietro Vannucci, il Perugino*, Proceedings of the Convegno Internazionale di studio (October 25–28, 2000), ed. Laura Teza (Perugia: Volumnia, 2004), pp. 247–305.

50 Son of Polonio (Apollonio) di Cecchino del Cilandro, a mattress maker.

51 Maria Rita Silvestrelli, "Genealogia di Bernardino di Betto. Perugia tra il 1450 e il 1480," in *Pintoricchio,* eds. Pietro Scarpellini and Maria Rita Silvestrelli (Milan: Federico Motta Editore, 2003), p. 33, no. 79. For documentation related to the *Giustizia Triptych* and the subsequent revision to the catalogue of Bartolomeo's work, see Michael Bury, "Bartolomeo Caporali: a new document and its implications," *Burlington Magazine* 132 (1990): pp. 469–75; Pietro Scarpellini, "Bartolomeo Caporali," in *Galleria Nazionale dell'Umbria. Dipinti sculture e ceramiche: studi e restauri,* eds. Caterina Bon Valsassina and Vittoria Garibaldi (Florence: Arnaud, 1994), pp. 235–38. Luciano Bellosi does not accept the documentary link; see "Considerazioni sulla Mostra del Perugino. I," *Prospettiva* 125 (2007): pp. 67–87, esp. pp. 78–84.

52 On December 31, 1483, he received a commission to paint the *Decemviri Altarpiece* for the chapel of the priori, which Perugino had left unfinished. In the subsequent fifteen days, he immediately painted the magistrates then holding office and their notary. The compensation—100 florins—was quite considerable.

53 October 5, 1493: "adì 5 a uno albanese portò da casa de Bartolomeo del Caporale al Palazzo uno certo quadro dipicto per le mani già de M. Sancte depinctore, qual va sopra la tavola dell'altare" (on day 5 an Albanian was paid to carry to the Palazzo dei Priori from the house of Bartolomeo Caporali a picture already painted by the hand of the master Sante di Apollonio that goes above the altar table [in the chapel of the priors]). See Fiorenzo Canuti, *Il Perugino* (Siena: Editrice d'arte la Diana, 1893), 2: p. 174.

54 Walter Bombe, *Geschichte der Peruginer Malerei bis zu Perugino und Pinturicchio: auf Grund des Nachlasses Adamo Rossis und eigener archivalischer Forschungen* (Berlin: B. Cassirer, 1912), pp. 324–26.

55 Scarpellini, "Bartolomeo Caporali," pp. 235–38.

56 Maria Rita Silvestrelli, "Pintoricchio tra Roma e Perugia (1484–1495)," in Scarpellini and Silvestrelli, *Pintoricchio,* pp. 97–98.

57 Tommaso Mozzati, "Bartolomeo Caporali," in *Piermatteo da Amelia e il Rinascimento nell'Umbria meridionale,* exh. cat., eds. Vittoria Garibaldi and Francesco Federico Mancini (Milan: Silvana, 2009), pp. 120–21.

58 Attributed to Bartolomeo by Stanley Lothrop, "Bartolomeo Caporali," *Memoirs of the American Academy in Rome* 1 (1917): pp. 87–102.

59 Today in the storage facility of the Galleria Nazionale dell'Umbria (inv. N.221). See Francesco Santi, *Galleria Nazionale dell'Umbria. Dipinti, sculture e oggetti dei secoli XV–XVI* (Rome: Poligrafico e Zecca dello Stato-Archivi di Stato, 1985), pp. 55–56.

60 See Mauro Minardi, "Giovanni di Piermatteo Boccati," in *Pittori a Camerino nel Quattrocento,* ed. Andrea De Marchi (Milan: Federico Motta, 2002), pp. 206–91, esp. pp. 289–91.

61 Elizabeth E. Gardner, "I disegni di G.B. Cavalcaselle e la Pala di Bartolomeo Caporali a Castiglion del Lago," *Quaderni di Emblema* 2 (1973): pp. 47–49. The work, ruined by humidity, was cut down into nine pieces, only five of which are known to have survived: in the Galleria Nazionale dell'Umbria, the Magdalene and an angel; in the Pinacoteca in Udine, a Saint Anthony Abbot and an angel; and in the Zeri collection, a Saint Sebastian. See Mirko Santanicchia, "Pittura nell'area del lago Trasimeno tra medioevo e Rinascimento," in *Storie di pittori tra Perugia e il suo lago,* eds. Francesco Piagnani and Mirko Santanicchia (Morbio Inferiore: Selective Art, 2008), pp. 15–74, esp. pp. 65–67.

62 See, for example, the five illuminations in the register of the Misericordia between 1486 and 1488; Alexander, "The City Gates of Perugia," in Linenthal, Marrow, and Noel, *The Medieval Book,* pp. 109–16.

63 Elvio Lunghi, "La decorazione della Chiesa di S. Maria in Arce a Rocca S. Angelo," in *Atti dell'Accademia Properziana del Subasio* (Assisi: Tipografia Porziuncola, 1983), 6: no. 7, pp. 113–42, esp. pp. 119–21.

64 See figure 12 in "The Caporali Missal: A Masterpiece of Renaissance Illumination," p. 28.

65 Silvestrelli, "Pintoricchio tra Roma e Perugia," in Scarpellini and Silvestrelli, *Pintoricchio,* p. 99.

66 Pietro Scarpellini, "Ancora sulla figura di Gianbattista Caporali e sulla sua collaborazione col Pintoricchio," in *I Lunedì della Galleria. Pietro Vannucci e i pittori perugini del primo Cinquecento,* ed. Paola Mercurelli Salari (Perugia: Quattroemme, 2005), pp. 73–90.

The Franciscan Context

Let the brothers not make anything their own, neither house, nor place, nor anything at all.
—THE FRANCISCAN RULE, 1223

The clergy should hold as precious the chalices, corporals, appointments of the altar, and everything that pertains to the sacrifice [of the Eucharist].
—THE FIRST LETTER TO THE CUSTODIANS, 1220

Celebrate only one Mass a day according to the rite of the Holy Church in those places where the brothers dwell. But if there is more than one priest there, let the other be content, for the love of charity, at hearing the celebration of the other priest.
—A LETTER TO THE FRANCISCAN ORDER, 1225–26

THESE THREE PASSAGES from Francis's writings reflect the ambiguous, even contra-dictory legacy that the saint bequeathed to his young order at his death in 1226. Poverty was the movement's foundational principle. At the same time, however, Francis held the Eucharist in great veneration and urged his followers to receive Communion and keep the consecrated Host "in precious places."[1] The vessels and vestments of the Mass should reflect the sanctity of the sacrament and were apparently exempt from the poverty that governed other aspects of Franciscan life. The saint's declared reverence for "our Lord's most holy names and written words" implies that his attitude toward the Mass and its material apparatus also extended to liturgical books.[2]

But for Francis the excessive celebration of Mass broke with the poor and humble life he envisioned for his new order. The saint's concern suggests that the growing number of priests joining the nascent Franciscan movement was already affecting the character of its liturgy. This phenomenon would only accelerate after his death, and within sixty years the Franciscan order had emerged as the dominant liturgical force in Christendom. In 1273 a report prepared for the church council at Lyons rebuked the Franciscans for saying "missas usque ad horam terciam non cessando, preter unam autem, quam dicunt sollempniter in conventu, legendo breviter continuant plures missas; et quoniam gaudent brevitate moderni, populus querit pocius missas illas, conventualibus et parrochialibus ecclesiis pretermissis."[3]

The order's liturgical development required the production and acquisition of large numbers of liturgical books for Franciscan communities. Francis had instructed his friars to follow the rite of the papal curia, and in the 1240s the movement's fifth minister general,

Detail of *Madonna of Humility with Saints Francis and Bernardino and Fra Jacopo Mattioli*, c. 1452. Benozzo Gozzoli (Italian, c. 1421–1497). Tempera and gold on panel. Kunsthistorisches Museum, Vienna.

Haymo of Faversham, revised the Franciscan liturgy to suit the needs of the expanding order. These reforms codified the missal as the liturgical book we know today, and the order's prodigious growth cemented the missal's status as the standard Mass book across late medieval Europe.[4] The missal consolidated into one volume the various texts needed for the Mass, hitherto divided between several books. Among other benefits, this rationalization permitted a single, unaccompanied priest to say a simplified and shortened Mass, known as a private or Low Mass, as it was spoken and not sung.[5] The resulting economies of time and personnel allowed Franciscan communities to keep pace with their burgeoning liturgical commitments, in particular the numerous votive masses requested by the laity in return for testamentary bequests.[6]

The ownership of books remained a difficult issue for the Franciscans. The order legislated extensively to prevent individual friars from hoarding books for their own personal use or from selling or pawning them for money.[7] The order was over 250 years old when the Caporali Missal was commissioned around 1469, but the manuscript still betrays the accommodations that the friars had to make with the ideals of their founder. Franciscans were forbidden by their rule from handling money, and each convent was obliged to appoint laymen as procurators to conduct their business affairs, disbursing expenditure and collecting money owed. These officials could sometimes exercise considerable influence over artistic commissions, and the success of major patronage initiatives called for close collaboration between Franciscan communities and their lay procurators. So it is no accident that the two lay procurators of San Francesco in Montone are named alongside the guardian father Stefano di Cambio in the manuscript's colophon.[8]

At the same time the Caporali Missal also reflects the mature state of Franciscan artistic patronage in the fifteenth century, especially among the unreformed conventual houses like Montone. By this date the artistic patronage of Franciscan conventual houses was not readily distinguishable in kind from that of other wealthy ecclesiastical institutions. Richly illuminated liturgical books were not regarded as contrary to the official observance of poverty, nor were silver crosses, gilded chalices, or precious textiles. This relatively lax interpretation of the Franciscan Rule was opposed by the more ascetic Observant movement within the order. The Observants enjoyed strong support in Umbria but focused their reforming efforts on a new network of convents separate from the established conventual houses.[9]

This essay explores the broader Franciscan context for the Caporali Missal. How would the book have been used? What resonances did the illuminations carry for their Franciscan audience? How did senior friars like Father Stefano emerge as artistic patrons, shaping the decoration and furnishing of their churches? When addressing these questions, we should remember that the missal was commissioned and made in the order's Umbrian heartland two and a half centuries after the movement was founded. If the manuscript's

decoration incorporates the latest trends in classicizing Renaissance ornament, it also displays a profound understanding of Franciscan visual traditions reaching back into the Middle Ages.

The Mass Books of the Friars

Missals were the most common category of liturgical book used by Franciscan communities. Large convents might possess a set of graduals and lectionaries for the choral celebration of Mass by the whole community, but missals formed the backbone of the Franciscan stock of liturgical manuscripts. Convents accumulated multiple examples to facilitate the celebration of Mass at the many side altars proliferating in Franciscan churches from the late thirteenth century onward. Usually these books—or the money to acquire them— came from lay donations. The Montone notarial archives record a typical example from 1361, when one Santuccio di Giovagnoli Dati requested burial in San Francesco and bequeathed 15 florins to the friars for a chalice and 30 for a missal.[10] Missals and chalices were the two most common categories of object specified in testamentary bequests and were often donated together.

Sacristy inventories survive for only a handful of Franciscan houses in central Italy and, unfortunately, we have no inventories at all for San Francesco, Montone. Anecdotal evidence from the lists we have suggests that following the rapid growth of the order in the century or so after Francis's death, the number of missals in Franciscan convents remained relatively stable during the late fourteenth century and the fifteenth century. In 1338 the Basilica of San Francesco at Assisi possessed nineteen missals.[11] In 1473 the basilica's sacristan again recorded nineteen missals, although presumably some books would have worn out and been replaced during the intervening century and a half.[12] The richest evidence for Franciscan holdings of liturgical manuscripts in central Italy relates to the convent of San Francesco in Pisa, where ten sacristy inventories cover the period 1368 to 1484.[13] The first inventory recorded sixteen missals; in 1402 there were eighteen, but by the time the inventories of 1420 and 1423 were compiled, the number had slipped back to thirteen.[14] Whatever the precise ebb and flow of manuscripts, the large numbers of missals and chalices in Franciscan houses contrasted starkly with the modest resources of parish churches, which often possessed only a single missal.[15] Indeed, poorer parishes in the countryside often lacked all but the most basic essentials for celebrating Mass.[16]

Many of the missals acquired by Franciscan convents were intended for use at particular side altars or to honor specific bequests for votive masses. Often these books bore the coats of arms of their lay sponsors.[17] However, contemporary documents distinguish between the majority of missals connected with side altars or private bequests and a minority of more expensive examples reserved for conventual use on the high altar. At

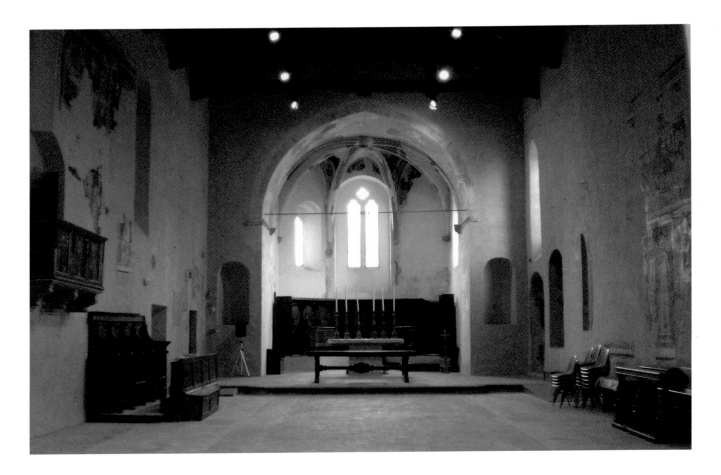

FIGURE 1 High altar chapel of San Francesco, Montone, with late fifteenth-century carved walnut and intarsia choir stalls. Photograph: Michael J. Tevesz.

Assisi the 1338 inventory singled out one missal as "sollempne et pulcrum et bene illuminatum, pro altari superiori," presumably the high altar of the Upper Church.[18] This may well be the same book that was praised in 1473 as "pulcrum et bene illuminatum, pro ecclesia superiori."[19] In Pisa the 1423 inventory recorded a "missale magnum solemne pro altari conventus cum armis comitum de Gherardeschis."[20] Given that the Gherardeschi had patronized the Pisan church in the first half of the Trecento, this may be the missal associated with the high altar in the 1368 inventory.[21] Closer to Montone, a 1421 testament from Sansepolcro cited the "calicis et missalis convenctus" as benchmarks for the liturgical equipment to be commissioned for a private chapel in the local church of San Francesco.[22]

We do not know how many liturgical books the Montone convent possessed, although it is unlikely to have been as generously stocked as the order's mother church at Assisi or a large urban convent like Pisa. If Santuccio's 1361 testament was eventually honored, his 30 florins could have purchased an impressive missal for the Montone Franciscans, and we can assume that the convent accumulated other pious bequests of this kind.[23] But Father Stefano's missal undoubtedly falls into the more select category of conventual missals, its level of decoration commensurate with the celebration of Mass at the high altar. The Montone convent was relatively small, its Renaissance choir seating only thirteen brothers (fig. 1).[24] Given their modest numbers, we can assume that the Montone Franciscans never commissioned an expensive set of choir books to match those of larger convents. Father Stefano's missal would therefore have played a central role in the performance of the conventual liturgy at the high altar. The missal's excellent state of preservation

suggests that its use was reserved for the most important points of the liturgical year.[25] Its iconographic program placed the book firmly within established traditions of Franciscan conventual imagery. Indeed, notwithstanding Bartolomeo and Giapeco Caporali's up-to-date Renaissance style, the manuscript's illumination may be said to be consciously conservative in its iconographic choices.

The Ordo Missalis: *Saint Francis as an* Alter Christus

Folio 9, the opening page of the ordinary of the Mass, makes a clear statement of Franciscan corporate identity. Saint Francis is prominently depicted within a roundel supported by winged putti and centrally placed in the broad lower border.[26] Moreover, the saint is shown in a frontal pose with arms raised and palms facing outward to display the wounds of the stigmata. This gesture was associated specifically with Saint Francis and was especially widespread in Tuscany and Umbria. It is frequently said to show Francis as an *alter Christus*—i.e., as another Christ—although we should remember that this is a modern iconographic term coined in the 1970s; we do not know how contemporary Franciscans referred to images of this kind.[27] The iconography was certainly intended to emphasize the Christ-like wounds of Francis's stigmata, miraculously imprinted on the saint's body during a vision on Mount La Verna in 1224. As we shall see, alter Christus images seem to have been associated particularly with the spaces and objects used by communities of Franciscan friars. The iconography appears a second time in the Montone missal on folio 318v in the illuminated initial accompanying the texts for the Feast of Saint Francis (October 4).

This mode of representing Saint Francis probably originated at Assisi in the early fourteenth century, and by the fifteenth century—if not earlier—it figured on the seal of the Sacro Convento, the Franciscan convent attached to the basilica there (fig. 2).[28] It also appeared on liturgical objects commissioned for Franciscan communities. One fine if rather restored example is an altar cross preserved in the Victoria and Albert Museum, probably made shortly after the Montone missal in the 1480s for a convent in central Italy.[29] The front of the V&A cross, which originally bore the crucifix corpus (now lost), is embellished with a set of translucent enamels on the termini with the conventional mourning figures of the Virgin and Saint John to the left and right, Mary Magdalene at the foot of the cross, and God the Father above; at the crux is an image of the lamb. The program on the back, however,

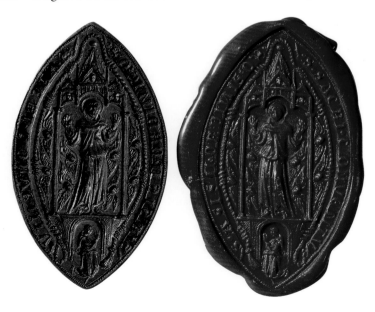

FIGURE 2 Engraved bronze matrix and wax impression of the seal of the Sacro Convento, Assisi, early fifteenth century. Treasury of the Basilica of San Francesco, Assisi.

FIGURE 3 *Processional Cross,*
c. 1480–90. Antonio di Salvi? (Italian,
1450–1527). Silver and translucent
enamel. Victoria and Albert Museum,
London, Salting Bequest, M.580-1910.
Photograph: Courtesy the Board of
Trustees of the V&A.

FIGURE 4 Detail of Saint Francis
alter Christus, from *Processional
Cross.*

is completely given over to saints of the Franciscan order: Anthony of Padua, Clare of Assisi, Bernardino of Siena, Louis of Toulouse, and the newly canonized Bonaventure (fig. 3). Francis is placed at the crux, back-to-back with the corpus and the lamb. The Francis enamel is one of the most damaged on the object, perhaps the result of ritual kissing over the centuries, but the raised hands of the alter Christus gesture are clearly visible (fig. 4). The size of the V&A cross and the corporate program of saints on the back make it all but certain that the object was the principal ritual cross of a Franciscan community, carried in processions and displayed on the high altar.[30]

A similar image that both Father Stefano and the Caporali brothers would certainly have known was the radiant standing figure of Saint Francis atop the monastic vices that dominated the back of Taddeo di Bartolo's great polyptych in San Francesco al Prato in Perugia, painted for the high altar of that church in 1403 (fig. 5).[31] The dynamic sway of Taddeo's Francis echoes the truncated figure in the *bas-de-page* of the *ordo missalis,* and the Perugia altarpiece may have been the artists' immediate source. But there would have been several other opportunities to see this iconography: besides the many painted images that are lost to us, the seal matrix of the Sacro Convento would have disseminated the alter Christus on wax impressions throughout Umbria (fig. 2).

Within the order's Umbrian province, the Montone convent lay in the same administrative district (or custody) as Sansepolcro, and Father Stefano must have been familiar with the great double-sided altarpiece by Sassetta that had graced the high altar of San

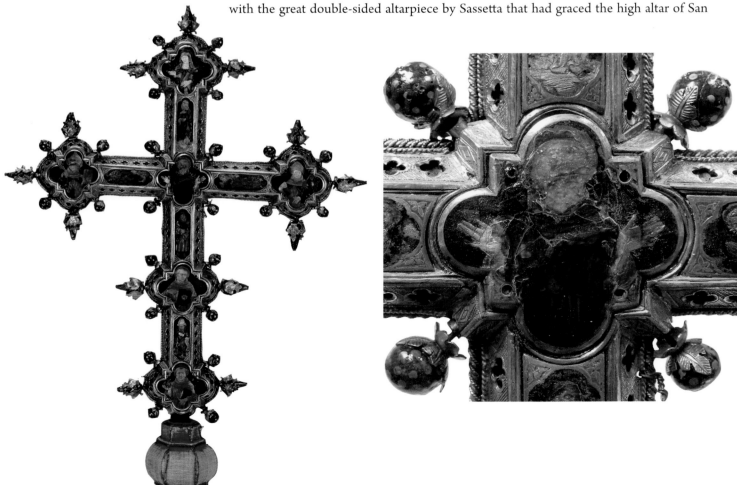

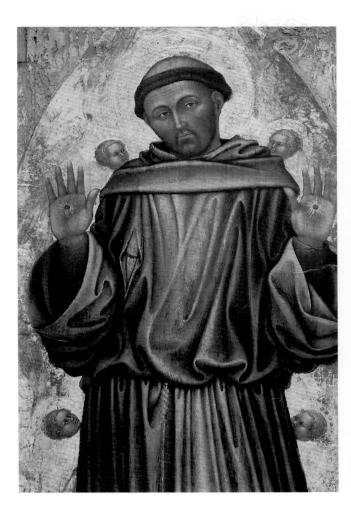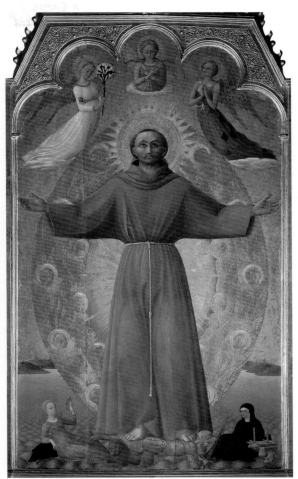

Francesco in Sansepolcro since 1444.[32] Sassetta's polyptych, the most expensive documented altarpiece commission of the whole fifteenth century, would still have been one of the most impressive artworks in the Upper Tiber Valley when Father Stefano was commissioning his missal. As with Taddeo's polyptych at Perugia, the figure of Saint Francis as an alter Christus formed the central focus of the back of Sassetta's altarpiece and faced the friars' choir stalls in the apse of the Sansepolcro church (fig. 6). Furthermore, we know from the notarial documents associated with the construction of the choir at Sansepolcro that the precinct's central stall was larger than the others.[33] This preeminent chair must have been reserved for the guardian of the convent, and it would have directly faced the central image of Saint Francis on Sassetta's altarpiece. The resulting alignment bestowed the authority of the order's founder upon the leader of the local Franciscan community. By analogy we may deduce that Father Stefano, as guardian, would have similarly occupied the central seat in the arc of thirteen stalls that forms the conventual choir in the main apse of the Montone church, having the optimum view of the high altar (fig. 1).

It is highly likely that Father Stefano would have known another impressive image of Saint Francis as an alter Christus in the church of San Francesco in Città di Castello, even closer to Montone than Sansepolcro or Perugia. In 1439 Sassetta had been asked to model his figure of Saint Francis with the virtues and vices on an existing image of "San Francescho in uno trono" in Città di Castello.[34] The precise meaning of the term *enthroned* in the 1439 document has been much debated by art historians, but the most

FIGURE 5 *Saint Francis Trampling the Monastic Vices*, 1403, from San Francesco al Prato polyptych. Taddeo di Bartolo (Italian, c. 1362–c. 1422). Tempera and gold on panel. Galleria Nazionale dell'Umbria, Perugia.

FIGURE 6 *Saint Francis with the Monastic Virtues and Vices*, 1439–44, from Sansepolcro polyptych. Sassetta (Italian, c. 1400–1450). Tempera and gold on panel. Villa I Tatti, Settignano. Photograph: Harvard University Center for Italian Renaissance Studies.

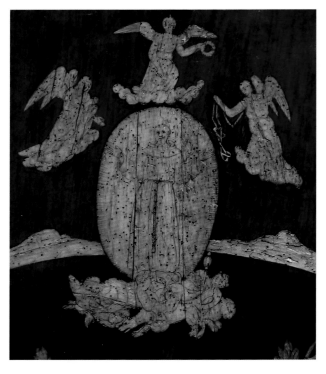

FIGURE 7 *Saint Francis with the Monastic Virtues and Vices*, c. 1560. Anonymous Umbrian woodworker. Intarsia panel. Vitelli Chapel, San Francesco, Città di Castello. Photo: Donal Cooper.

plausible explanation is that it referred to an image of Saint Francis within a mandorla, similar to both Taddeo's image in Perugia and the iconography that Sassetta did in fact eventually use at Sansepolcro.[35] There are good reasons to think that the image Sassetta was instructed to copy formed the centerpiece of a third double-sided altarpiece painted for the high altar of the Franciscan church in Città di Castello by Spinello Aretino in the years around 1400. One fragment of this altarpiece has been securely identified: the panel depicting the approval of the Franciscan Rule now in the Art Institute of Chicago (cat. 14). The alter Christus image itself did not survive, but its iconography was preserved in a sixteenth-century intarsia panel now in the Vitelli Chapel in the Città di Castello church (fig. 7).[36] If the intarsia copy can be trusted, the pose of the Francis alter Christus figure on the Città di Castello altarpiece may also have been similar to the illuminations in the Montone missal. Unfortunately, it is unclear if the Montone church possessed a high altarpiece before Berto di Giovanni was commissioned to paint his *Virgin and Child Enthroned with Saints* in 1506.[37]

Elsewhere in Umbria, mural schemes juxtaposed images of Saint Francis as an alter Christus with high altars and choir enclosures in Franciscan churches. The frescoes in the high altar chapel of San Francesco in Montefalco completed by the Florentine painter Benozzo Gozzoli in 1452 incorporated an image of Saint Francis alter Christus in a roundel at the apex of the entrance arch directly above the high altar (fig. 8). Its orientation

FIGURE 8 *Saint Francis Alter Christus*, 1452. Benozzo Gozzoli (Italian, c. 1421–1497). Fresco. High altar chapel, San Francesco, Montefalco.

FIGURE 9 Detail of Saint Francis *alter Christus*, c. 1477, from predella, *Adoration of the Shepherds*, Santa Maria di Monteluce. Bartolomeo Caporali (Italian, c. 1420–c. 1505). Tempera and gold on panel. Galleria Nazionale dell'Umbria, Perugia.

was reversed so as to face the friars gathered in the apsidal choir, reinforcing the sense that this was an image with powerful corporate connotations for Franciscan communities, especially in Umbria.[38] Several decades earlier, probably around 1422–24, the apse of San Francesco, Montone had been frescoed by the Ferrarese artist Antonio Alberti. As at Montefalco, the Montone mural program included a cycle of Franciscan scenes on the side walls of the polygonal apse.[39] Only fragments of these frescoes survive, and it is impossible to tell whether the scheme incorporated alter Christus images of Saint Francis. But these narratives would have provided the backdrop to the liturgy of the choir and high altar and would have resonated with the Franciscan iconography of Father Stefano's missal.

Bartolomeo Caporali's own familiarity with the alter Christus iconography is confirmed by his altarpiece depicting the Adoration of the Shepherds, painted around 1477 for the choir of Santa Maria di Monteluce, the principal house of Franciscan Clarissan nuns in Perugia.[40] The altarpiece's predella contains roundels with predominantly Franciscan saints, and Saint Francis himself is set at the center (fig. 9), directly below the Christ Child in the main panel above. Here, Caporali offers a more developed form of the alter Christus iconography that is closer to Taddeo's, with gold rays bursting behind the saint and emanating from the stigmata.

The Te Igitur *Opening: Saint Francis Embracing the Cross*

If the inclusion of Saint Francis as an alter Christus alluded to the established iconography of the Umbrian province, the other major illumination in the Montone missal—the Crucifixion scene on the *Te igitur* opening—harked back to even older Franciscan models.[41] It was probably around the middle of the thirteenth century that Umbrian artists first portrayed Saint Francis kneeling at the foot of the cross.[42] By the early fourteenth century, the iconography was common in mural painting, on small-scale devotional panels, and especially on monumental painted crucifixes. The attitude of these supplicant figures

varied: sometimes Francis kneeled in veneration (fig. 10); in other examples he embraced the cross or kissed the feet of Christ or even the nail that affixed them to the cross (fig. 11).

Sassetta realized a typically refined version for the Sansepolcro polyptych, with Francis placing his right hand on the wood of the cross, the bleeding wound of the stigmata on his palm touching the blood flowing down from the wounds on Christ's feet (cat. 15).[43] This formed the central pinnacle on the front of the Sansepolcro polyptych and was originally flanked by standing figures of the Virgin and Saint John. In addition to the image on Sassetta's altarpiece, Father Stefano would have seen many others in local Franciscan churches. We know, for example, that a similar Crucifixion in fresco was envisaged in 1395 for the chapter house of the Franciscan convent in nearby Città di Castello.[44]

Other religious orders and institutions portrayed their founders and patrons in similar fashion on crucifixes and in Crucifixion scenes, but the only other supplicant figure who approached Francis's popularity was Mary Magdalene.[45] Caporali's appreciation of these iconographic traditions is demonstrated by his large panel crucifix for the church of San Michele on Isola Maggiore in the middle of Lake Trasimeno (cat. 7).[46] The San Michele cross, probably painted in the decade before the Montone missal, is an archaic work. By the mid-fifteenth century,

FIGURE 10 Detail of Saint Francis at the feet of Christ, from *Crucifix*, 1272, from San Francesco al Prato, Perugia. Maestro di San Francesco. Tempera and gold on panel. Galleria Nazionale dell'Umbria, Perugia.

FIGURE 11 Detail of Saint Francis kissing the feet of Christ, from *Crucifix*, early fourteenth century. Maestro Espressionista di Santa Chiara (Italian, c. 1290–c. 1330). Tempera and gold on panel. San Francesco, Montefalco.

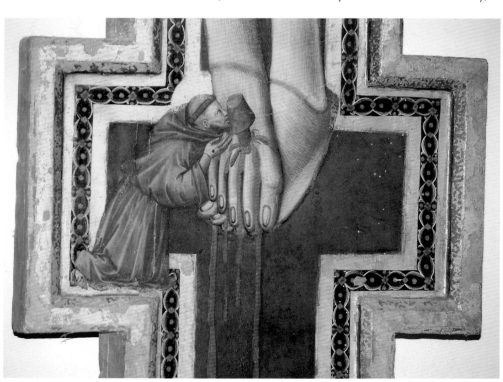

large-scale panel crosses of the so-called cut-out type had fallen out of fashion. Drawing on thirteenth-century models, Caporali included the traditional mourning figures of the Virgin and Saint John the Evangelist to the left and right, and the skull of Adam at the foot of the cross. To the right Mary Magdalene embraces the cross while to the left Saint Francis kneels with his hands clasped in prayer.

It was common to illuminate the beginning of the canon of the Mass with a Crucifixion scene, and the initial *T* of the opening words *Te igitur* often gave form to the cross.[47] One very early example from a Franciscan context is the cutting attributed to the anonymous Maestro di San Francesco that appeared on the art market in the 1990s (fig. 12).[48] The cutting was almost certainly from a missal produced in Umbria, probably at Assisi, in the 1260s or 1270s. Although it predates the Montone missal by two centuries, the Maestro di San Francesco cutting provides a meaningful precedent in two respects. First, it was painted by an artist who, like Caporali,

FIGURE 12 *Te igitur Illumination,* c. 1270. Maestro di San Francesco. Cutting from a missal; 17.5 × 14 cm. Private collection.

worked in different media and on different scales: in 1272 the Maestro di San Francesco also painted for the Franciscans in Perugia a monumental panel crucifix with a supplicant Saint Francis (fig. 10).[49] Second, the thirteenth-century artist similarly inserted Francis into his Te igitur Crucifixion miniature, standing behind Saint John the Evangelist to the right.[50]

Father Stefano: Guardian and Patron

The inclusion of Father Stefano's donor figure and monogram below the Crucifixion is a notable feature of the Montone missal.[51] The early Franciscans demonstrated some reticence when it came to inserting donor images. For example, the mural decoration of the basilica at Assisi is almost devoid of readily identifiable Franciscan patrons.[52] By the fifteenth century, this reserve had abated and senior friars were often commemorated in the art commissioned for their convents.

Even so, the duration of Father Stefano's patronage at Montone is remarkable.[53] The 1469 missal represents his earliest known commission; the so-called Banco dei Magistrati

(Bench of the Magistrates) in 1505 and Berto di Giovanni's high altarpiece in 1506, his last. Such longevity reflects another trend in Franciscan patronage: the emergence of prominent local friars who would remain connected with their native convents over many decades. These friars would repeatedly hold the senior offices in their communities, serving multiple terms as guardian or deputy guardian (vicar). Even when they did not occupy official positions of authority, these figures could exercise considerable influence by virtue of their seniority and local connections.

A good parallel for Father Stefano's sustained patronage at Montone is provided by Father Giacomo Mattioli at Montefalco. Father Giacomo was lector of the Montefalco convent in 1431, attended the provincial chapter in Perugia that year, and went on to serve as lector at the Sacro Convento in Assisi by 1437.[54] Evidently a theologian of some distinction, Giacomo was sent to teach at the University of Bologna in 1441, but he did not forget his home convent at Montefalco. In 1452 he commissioned Benozzo Gozzoli to fresco the life of Saint Francis in the apse and choir chapel of the local church of San Francesco.[55] Gozzoli's cycle included the unique scene of Francis blessing Montefalco, which presented an opportunity to include donor figures of Father Giacomo and a number of other local notables. Around the same time, Gozzoli also painted a small panel for Father Giacomo, probably for the friar's private devotions (fig. 13).[56] The picture, now in Vienna, shows the Montefalco friar kneeling in prayer and being presented by Saint Francis to the Virgin and Child, with Saint Bernardino balancing the composition to the right. The brocade draped over the Virgin's throne is woven with a repeat pattern bearing the two cyphers FG and OM, generally read as "F[ra] G[iacobus/iacomo] O[rdinis] M[inorum]."[57] Monograms or cyphers seem to have emerged as a fashionable way to signal the patronage of individual friars in the fifteenth century: a Franciscan with the cypher MF appears on the front of the V&A cross discussed above (fig. 14).[58]

An earlier parallel for Father Stefano would be Father Daniele di Stefano at Sansepolcro, who played a significant role in the early stages of the commission for his church's new high altarpiece in the 1420s. Daniele was a prominent member of the Sansepolcro community: he came from a wealthy local family and resided in the town's convent for over three decades, serving as guardian several times.[59] In 1408, as vicar of the Sansepolcro house, Daniele had attended the provincial chapter in Perugia, where he would have seen Taddeo's newly painted polyptych over the high altar of the Franciscan church there.[60] The first document relating to the high altarpiece commission at Sansepolcro— the contract with the carpenter Bartolomeo di Giovannino d'Angelo in August 1426 for the wooden support—grants a pivotal role to Father Daniele. Bartolomeo was to follow Daniele's instructions when designing and decorating both the front and back of the panel.[61] When the local artist Antonio d'Anghiari was contracted to paint the altarpiece in 1430, Father Daniele was one of the two friars present besides the guardian.[62] Daniele probably died shortly afterward and disappears from the historical record. When Sassetta

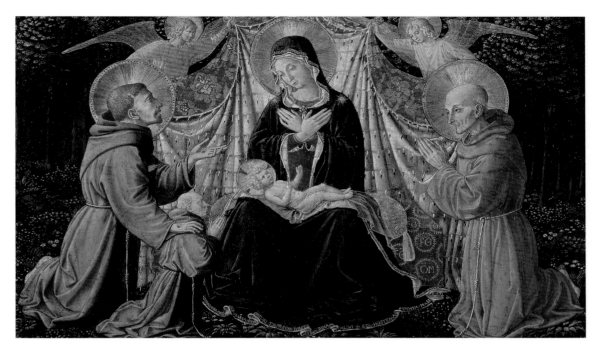

finally completed the commission in 1444, the two lay *operaii* charged with maintaining the Sansepolcro church had their names inscribed on the great high altarpiece below the alter Christus image of Saint Francis. But the 1426 contract for the carpentry of the high altarpiece was not the only occasion when Father Daniele was called upon for artistic guidance. When the Sansepolcro friars commissioned a chalice in 1427 from Giovanni di Giorgio, a goldsmith in neighboring Città di Castello, they instructed the craftsman to follow Father Daniele's instructions when devising the cup's enamel decoration.[63] Daniele seems to have been regarded by his peers as an expert on artistic matters and must have had a substantial impact on a series of commissions for the church at Sansepolcro.

Like Father Jacopo at Montefalco and Father Daniele at Sansepolcro, Father Stefano maintained a lifelong association with his home convent at Montone, serving multiple terms as guardian. The pinnacle of his administrative career seems to have been his

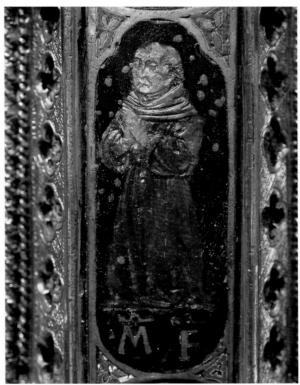

appointment at the close of the fifteenth century as custodian of the Città di Castello Custody, the administrative district that encompassed the convents in Montone, Città di Castello, and Sansepolcro.[64] He probably spent almost all his life in the Upper Tiber Valley.

However, as guardian of Montone or custodian of Città di Castello, Father Stefano was required to attend the Franciscan provincial chapter that was held each year in a different convent of the Umbrian province. He would have stayed in Franciscan houses throughout the region and must have visited the province's principal convents in Perugia and Assisi on a frequent basis. The order's bureaucratic structure meant that senior friars like Father

FIGURE 13 *Madonna of Humility with Saints Francis and Bernardino and Fra Jacopo Mattioli,* c. 1452. Benozzo Gozzoli (Italian, c. 1421–1497). Tempera and gold on panel. Kunsthistorisches Museum, Vienna.

FIGURE 14 Detail of "MF" Franciscan donor, from *Processional Cross.*

Stefano would have been familiar with an extensive corpus of Franciscan art, from hallowed thirteenth-century images to the latest commissions. It also bred competition, for Stefano would have had a very clear sense of how his convent at Montone compared with other Franciscan houses across Umbria.

Father Stefano's local and regional horizons help to explain the distinctive mixture of old and new in the Caporali Missal. The book is an exceptional example of Renaissance illumination, its lavish decoration clearly designed to impress. But its iconography is also steeped in Franciscan history and has a specifically Umbrian flavor. For the friars at Montone, the book's principal miniatures would have recalled similar images in other media in other Franciscan churches.[65] The Montone community would have connected the depictions of Saint Francis as an alter Christus with a series of Franciscan high altarpieces in Perugia, Sansepolcro, and probably Città di Castello too, and perhaps with Gozzoli's high altar chapel frescoes at Montefalco as well. Saint Francis embracing the cross had been a staple of Franciscan art in the region for over two hundred years.

It is tempting today to regard the Caporali Missal, with its burnished gold and elaborate ornament, as far removed from the memory of Saint Francis. This reading would have made little sense to Father Stefano and his Franciscan peers in the fifteenth century. Their missal connected them with the order's past, its imagery asserting their identity as sons of Saint Francis and members of a broader Franciscan family that reached out across Umbria, Italy, and beyond.

NOTES

I am grateful to Stephen Fliegel, Maria Rita Silvestrelli, Silvia Braconi, Alberto Maria Sartore, James Banker, Andrea De Marchi, and Linda Pisani for invaluable assistance and advice. My research in Tuscany and Umbria has been generously supported by the Leverhulme Trust through a Philip Leverhulme Prize and by a fellowship at the Harvard University Center for Italian Renaissance Studies, Villa I Tatti.

Regis J. Armstrong, J. A. Wayne Hellmann, and William J. Short, eds., *Francis of Assisi: Early Documents* (New York: New City Press, 1999), 1: p. 99.
Ibid., p. 56.
Ibid., p. 119.

1 For a recent treatment of the centrality of the Mass to Saint Francis and his early followers, see Edward Foley, "Franciscan Liturgical Prayer," in *Franciscans at Prayer,* ed. Timothy J. Johnson (Leiden: Brill, 2007), pp. 385–412. The quote is taken from Francis's Testament of 1226, see Armstrong, Hellmann, and Short, *Francis of Assisi,* 1: p. 125.

2 From the saint's Testament, see ibid.; Foley, "Franciscan Liturgical Prayer," in Johnson, *Franciscans at Prayer,* pp. 390–91.

3 "Mass continuously from dawn until the hour of Terce. Except for one, which they say solemnly together, they join together several Masses in a short space of time by reading them, and because modern men rejoice in this brevity, people prefer to go to these Masses, thus neglecting the monastic and parish churches." For Bishop Bruno of Olomouc's report on the church in Germany, see "Relationes Episcopi Olomucensis Pontifici Porrectae," *Monumenta Germaniae Historica,* Legum, sec. 4, bk. 3 (1904–6): p. 591. Alongside the Franciscans, Bruno also accused their chief rivals, the Dominicans.

4 The classic account of the Franciscan adaptation of the *ordo* of the papal curia—which, in the process, laid the foundations for the liturgy of the Friars Minor and, in time, the whole Roman Catholic Church—remains S. J. P. van Dijk and Joan Hazelden Walker, *The Origins of the Modern Roman Liturgy* (London: Darton, Longman & Todd, 1960).

5 Josef Andreas Jungmann, *The Mass of the Roman Rite: Its Origins and Development,* trans. Francis A. Brunner (New York: Benziger Brothers, 1951), 1: pp. 104–7.

6 For the importance of the private mass and for Haymo of Faversham's ordinal *Indutus planeta* of 1243 for the celebration of the private mass,

see Van Dijk and Hazelden Walker, *The Origins,* pp. 45–66, 292–301.

7 The statutes approved at the general chapter at Assisi in 1354—the so-called Statuta Farineriana—remained in force throughout the fifteenth century, and the proper handling of books is addressed repeatedly in the rubrics on the correct observation of poverty. See Michael Bihl, "Statuta Generalia Ordinis edita in Capitulo Generali an. 1354 Assisii celebrato communiter Farineriana appellata," *Archivum Franciscanum Historicum* 35 (1942): pp. 90–97. The statutes grant considerable discretion to ministers and guardians.

8 See appendix B, p. 125.

9 For the rise of the Observant movement in Umbria, see Mario Sensi, *Dal movimento eremitica alla regolare osservanza francescana: l'opera di fra Paoluccio Trinci* (Assisi: Porziuncola, 1992).

10 Montone, Archivio Comunale, Archivio Notarile 1, Ser Matteo di Fuccio, fol. 127v (May 7, 1361): Santuccio bequeathed the friars of San Francesco "de bonis suis pro anima sua quindecim florenos auri convertendos in uno callice pro celebrando corpus Christi . . . triginta florenos auri convertendos in quodam mesale pro missis dicendis" (from his goods 15 gold florins for his soul to be spent on a chalice for celebrating the body of Christ . . . and 30 gold florins to be spent on a missal for saying Masses). We do not know, however, if this bequest was honored; Santuccio was in good health and about to set out on a pilgrimage to Monte Sant'Angelo in Puglia.

11 Beda Kleinschmidt, *Die Basilika San Francesco in Assisi* (Berlin: Verlag für Kunstwissenschaft, 1928), 3: p. 36

12 Ibid., p. 43.

13 Chiara Balbarini, "Gli arredi liturgici della chiesa di San Francesco a Pisa: il complesso dei corali miniati (sec. XIV) ricostruito," *Bollettino Storico Pisano* 70 (2001): pp. 253–63.

14 Pisa, Archivio di Stato, Commune D, Opera di San Francesco, 1386, *Inventari, ricordi, et altro attenenti al convento di S. Francesco dell'anno 1344,* fols. 28 (1368), 36v (1402), 61 (1420), 70v (1423).

15 To take one example from the Upper Tiber Valley, in 1374 and again in 1409 the Pieve of Santa Maria in Sansepolcro, an important urban parish church with six altars, possessed only "unum bonum missale" (a good missal). See Città di Castello, Archivio Storico Comunale, Archivio Notarile, Ser Marco Vanni, vol. 11, fols. 48–48v; Florence, Archivio di Stato, Notarile Antecosimiano 7131, fol. 5321v.

16 For the paucity of chalices and liturgical books in the rural parishes around Cortona, see Daniel

Bornstein, "Spiritual Culture, Material Culture: Church Inventories in Fifteenth-Century Cortona," *Medievalia et Humanistica* 28 (2002): pp. 101–15.

17 The Pisan inventories describe missals bearing the coats of arms of prominent Pisan families: Pisa, Archivio di Stato, Commune D, Opera di San Francesco, 1386, fol. 70v (1423): "Item aliud missale novum cum armis de Mazzolis . . . Item aliud missale cum armis et signo de Guicciardis" (Item another missal, new with the arms of the Mazzoli . . . Item another missal with the arms and insignia of the Guicciardi). Both the Mazzoli and Guicciardi patronized altars in the church of San Francesco.

18 "solemn, beautiful and finely illuminated, for the upper altar." Kleinschmidt, *Die Basilika,* 3: p. 36.

19 "beautiful and finely illuminated, for the Upper Church." Ibid., p. 43.

20 "large and solemn missal for the high altar with the arms of the Count of Gherardeschi." Pisa, Archivio di Stato, Commune D, Opera di San Francesco, 1386, fol. 70v (1423).

21 Ibid., fol. 28 (1368): "Missale pro altari conventus magnum in tribus voluminibus" (A large missal for the conventual altar in three volumes).

22 On July 10, 1421, Uguccio di Bartolo left money for a chalice and missal for his chapel "ad similitudinem valorem et pretium calicis et missalis convenctus dicti loci de Burgo" (of similar value and price to the chalice and missal of the convent [of San Francesco] of Borgo [Sansepolcro]); cited by Donal Cooper and James R. Banker, "The Church of San Francesco in Borgo San Sepolcro in the Late Middle Ages and Renaissance," in *Sassetta: The Borgo San Sepolcro Altarpiece,* ed. Machtelt Israëls (Florence: Villa I Tatti, the Harvard University Center for Italian Renaissance Studies; Leiden: Primavera Press, 2009), 1: p. 104.

23 This seems to have been a relatively generous sum to spend on a missal; later bequests to the Franciscans in Città di Castello and Perugia left only 25 and 20 florins, respectively. See Città di Castello, Archivio Storico Comunale, Archivio Notarile, Ser Piero di Lapo di Piero, vol. 2, fol. 142v (joint testament of the sisters Mayutia and Laurenza di Francesco Vanni, November 20, 1424); Perugia, Archivio di Stato, Corporazioni relgiose soppresse, San Francesco al Prato, pergamene (testament of Vanna di Tengharini Tinghi, August 5, 1418).

24 For the Montone choir stalls, generally dated to the end of the fifteenth century, see Carla Mancini's catalogue entry in *Museo Comunale di San Francesco a Montone,* ed. Giovanna Sapori (Milan: Electa, 1997), p. 137.

25 See "The Caporali Missal: A Masterpiece of Renaissance Illumination," pp. 13–33.

26 See figure 5 in "The Caporali Missal: A Masterpiece of Renaissance Illumination," p. 22.

27 Francis was described as an *alter Christus* in medieval texts, but its iconographic application depends on Henk Van Os, "St. Francis of Assisi as a Second Christ in Early Italian Painting," *Simiolus* 7 (1974): pp. 115–32.

28 For the engraved bronze seal matrix of the Sacro Convento, probably dating from the early fifteenth century, see Umberto Utro's catalogue entry in *The Treasury of Saint Francis of Assisi*, eds. Giovanni Morello and Laurence B. Kanter (Milan: Electa, 1999), p. 195.

29 V&A M.580-1910, most recently attributed to the Florentine goldsmith Antonio di Salvi. See Alison Wright, *The Pollaiuolo Brothers: The Art of Florence and Rome* (New Haven, CT: Yale University Press, 2005), p. 534. The appearance of Saint Bonaventure among the Franciscan saints on the back of the V&A cross suggests a date after his canonization in 1482. See also the online catalogue record at http://collections.vam.ac.uk/item/O40148/altar-cross/.

30 The V&A cross is 49 centimeters high, not including its base.

31 For the iconographic program of Taddeo's Perugia polyptych, see Gail E. Solberg, "A Reconstruction of Taddeo di Bartolo's Altar-Piece for S. Francesco a Prato, Perugia," *Burlington Magazine* 134 (1992): pp. 646–56. Van Os, who regarded Taddeo's 1403 image as the first true representation of Francis as an alter Christus, stressed the distinctive pose of the saint, "something between an orant and a man crucified" ("St. Francis of Assisi as a Second Christ," p. 120).

32 For a comprehensive study of the Sansepolcro polytych, see Machtelt Israëls, ed., *Sassetta: The Borgo San Sepolcro Altarpiece*. 2 vols. (Florence: Villa I Tatti, the Harvard University Center for Italian Renaissance Studies; Leiden: Primavera Press, 2009).

33 For the Sansepolcro choir, first commissioned in 1378 and again in 1392, see Cooper and Banker, "The Church of San Francesco," in Israëls, *Sassetta*, 1: pp. 69–76, and for the relevant documents, see Israëls, *Sassetta*, 2: pp. 586–88: "la sedia grande nel mezzo del decto cuoro" (the large stall in the middle of the said choir).

34 James R. Banker, "Appendix of Documents Relating to the High Altarpiece, the High Altar, and the Tomb of the Blessed Ranieri in the Church of San Francesco in Borgo San Sepolcro," in ibid., 2: pp. 571–72: "In mezzo San Francescho in uno trono como quello di Castello con quelle vertù da capo et i vitii da piey" (In the middle Saint Francis in a throne like the one in [Città di] Castello with those virtues at the top and the vices at his feet).

35 Donal Cooper, "Le tombe del Beato Ranieri a Sansepolcro e del Beato Giacomo a Città di Castello: Arte e santità francescana nella terra altotiberina prima di Sassetta," in *Il beato Ranieri nella storia del francescanesimo e della terra altotiberina*, ed. Franco Polcri (Sansepolcro: Comitato per le celebrazioni del VII centenario della morte del beato Ranieri dal Borgo, 2005), pp. 103–33. I will return to the reconstruction of Spinello's altarpiece in a future publication.

36 For this intarsia panel, probably dating to around 1560, see ibid., pp. 123–30.

37 We do not have evidence of a high altarpiece in San Francesco, Montone before Berto di Giovanni's *Virgin and Child Enthroned with Saints*, commissioned by Father Stefano in 1506 and completed in 1507 (and now in the Royal Collection at Windsor Castle). See Tom Henry, "Berto di Giovanni at Montone," *Burlington Magazine* 138 (1996), pp. 325–28, and here, "San Francesco, Montone," pp. 69–83.

38 Although the present stalls at Montefalco date from the eighteenth century, it seems safe to assume that the conventual choir was already located in the apse in the fifteenth century. Gozzoli's frescoes appear to have been designed with the stalls below in mind. In particular, his frieze of eminent Franciscans would have formed an additional tier of friars above the physical stalls of the choir. Documents record the construction of new stalls in the years following the completion of Gozzoli's cycle. See Silvestro Nessi, ed., *La Chiesa e il Convento di S. Francesco a Montefalco: Cronologia documentaria* (Padua: Centro Studi Antoniani, 2002), pp. 26–27 (for the years 1455 and 1457).

39 For the apsidal frescoes and their attribution, see Francesco Santi, "Gli affreschi dell'abside del S. Francesco a Montone," *Bollettino d'Arte*, 5th ser., 52 (1967): pp. 97–99; Giovanna Sapori, ed., *Museo Comunale di San Francesco a Montone* (Milan: Electa, 1997), pp. 67–81. In terms of the Franciscan cycle, fragments of *Saint Francis before the Crucifix in San Damiano, Saint Francis Renounces His Father*, and the *Stigmatization* are still visible.

40 For the Monteluce *Adoration of the Shephards*, see Pietro Scarpellini's entry in *Dipinti, sculture e ceramiche della Galleria Nazionale dell'Umbria: Studi e restauri*, eds. Caterina Bon Valsassina and Vittoria Garibaldi (Florence: Arnaud, 1994), pp. 235–39.

41 See catalogue 1.

42 The first example of this iconography is often identified as the so-called Abbess Benedetta cross in Santa Chiara, Assisi, usually dated to around 1260. See William R. Cook, *Images of St. Francis of Assisi in Painting, Stone, and Glass from the Earliest Images to ca. 1320 in Italy: A Catalogue* (Florence: L. S. Olschki; Perth: Department of Italian of the University of W. Australia, 1999), pp. 63–64. However, Andrea De Marchi has recently suggested a later dating in the mid-1270s for the Santa Chiara crucifix. See "'Cum dictum opus sit magnum': il documento pistoiese del 1274 e l'allestimento trionfale dei tramezzi in Umbria e Toscana fra Due e Trecento," in *Medioevo: immagine e memoria*, ed. Arturo Carlo Quintavalle (Milan: Electa, 2009), p. 610.

43 For the Cleveland panel, see the entry by Christa Gardner von Teuffel and Machtelt Israëls in Israëls, *Sassetta*, 2: pp. 534–37, and here, catalogue 15.

44 Città di Castello, Archivio Storico Comunale, Archivio Notarile, Ser Nicolao di Ser Dato Vanni, vol. 13, fol. 99v (testament of Ludovico di Ser Francesco Neri, June 22, 1395): Ludovico's executors are held to spend what is necessary "in pingendo et pingi faciendo in dicto loco capituli figuram domini nostri Yhesu Christi crucifixum, figuram beate Marie virginis, et figuras Sancti Iohannis et Sancti Francisci iuxtam dictum crucifissum" (for the painting and having the painting made of the figure of Our Lord Jesus Christ crucified, the figure of the Blessed Virgin Mary, and the figures of Saint John and Saint Francis beside the said crucifix in the said place of the chapter house).

45 Ketti Neil, "St. Francis of Assisi, the Penitent Magdalene and the Patron at the Foot of the Cross," *Rutgers Art Review* 9-10 (1988-89): pp. 83–110; Bridget Heal, "Paradigm of Penance: The presence of Mary Magdalen at the foot of the Cross in thirteenth- and fourteenth-century Crucifixion imagery from Tuscany and Umbria" (master's thesis, Courtauld Institute of Art, University of London, 1996).

46 Mirko Santanicchia, "Pittura nell'area del lago Trasimeno tra medioevo e Rinascimento," in *Storie di pittori tra Perugia e il suo lago*, eds. Francesco Piagnani and Mirko Santanicchia (Morbio Inferiore: Selective Art, 2008), pp. 65–67; the presence of Saint Michael in the upper terminal suggests that the crucifix was painted for the parish church of San Michele, but the presence of Saint Francis at the foot of the cross may also suggest a connection with the nearby Franciscan convent on the island.

47 See "The Caporali Missal: A Masterpiece of Renaissance Illumination," pp. 24–26. A number of late thirteenth-century Franciscan missals from Umbria already contain impressive full-page *Te igitur* Crucifixion miniatures, notably the missal from San Francesco, Deruta (now in the local Pinacoteca Comunale) and the example now in the State Library of Victoria, Australia. See Enrica Neri Lusanna, "Il miniatore del Messale di Deruta e i

corali del San Pietro a Gubbio," in *Francesco d'Assisi: Documenti e Archivi; Codici e Biblioteche; Miniature*, ed. Comitato regionale umbro per le celebrazioni dell'VIII centenario della nascita di San Francesco d'Assisi (Milan: Electa, 1982), pp. 178–88; Margaret M. Manion, "The Codex Sancti Paschalis," *La Trobe Library Journal* 13 (1993): pp. 11–23.

48 The cutting, measuring 17.5 by 14 centimeters and now in the T. Robert and Katherine States Burke collection, was published with a date before 1272 in Morello and Kanter, *The Treasury of Saint Francis*, pp. 140–41.

49 For the Maestro di San Francesco's cross for San Francesco al Prato, Perugia, see Serena Romano's entry in Bon Valsassina and Garibaldi, *Dipinti, sculture e ceramiche*, pp. 63–65. The cross measures 489 by 352 centimeters.

50 Iconographically, an even closer antecedent for Caporali's composition is provided by the Franciscan missal now in Atri but probably produced in Assisi in the final years of the thirteenth century. There, Saint Francis kneels at the foot of the cross alongside a bishop donor. See Maria Luigia Fobelli, "Circolazione artistica nel 'golfo di Venezia': la croce in cristallo di rocca del Museo Capitolare di Atri," in *L'Abruzzo in età angioina: arte di frontiera tra Medioevo e Rinascimento*, eds. Daniele Benati and Alessandro Tomei (Milan: Silvana, 2005), pp. 167–79, esp. pp. 177–79.

51 See figure 6 in "The Caporali Missal: A Masterpiece of Renaissance Illumination," p. 23. For the interpretation of Father's Stefano's FC / ST monogram, see ibid., p. 21.

52 While cardinals and ecclesiastics feature prominently in the basilica's private chapels, Franciscan donors are notably absent from the main spaces of both the Upper and Lower Churches. It is possible that the friars kneeling between Saints Francis and Anthony in Giotto's *Crucifixion* in the north transept of the Lower Church recorded provincial ministers. See Donal Cooper and Janet Robson, "'A great sumptuousness of paintings': frescos and Franciscan poverty at Assisi in 1288 and 1312," *Burlington Magazine* 151 (2009): p. 661.

53 See "San Francesco, Montone," pp. 74–75.

54 For "frater Iacobus [de Montefalcone]" as lector of the Montefalco convent in 1431, see Ugolino Nicolini, "Le tavole dei capitoli provinciali dell'Umbria del 1408 e del 1431," *Archivum Franciscanum Historicum* 59 (1966): p. 314. For Giacomo's teaching career, see Nessi, *La Chiesa*, p. 24.

55 Giacomo's personal patronage is emphasized in the accompanying inscription: "HOC OPUS FECIT FIERI FRATER IACOBUS DE MONTEFALCONE ORDINIS MINORU[M]." Elvio Lunghi, *Benozzo Gozzoli a Montefalco* (Assisi: Minerva, 1997), pp. 32–34,

notes that it was relatively unusual for a Franciscan community to maintain patronage rights over their high altar chapel rather than conceding them to lay donors.

56 For the Vienna panel, which measures only 34.3 by 54.7 centimeters, see most recently Silvestro Nessi's catalogue entry in *Benozzo Gozzoli: allievo a Roma, maestro in Umbria*, eds. Bruno Toscano and Giovanna Capitelli (Milan: Silvana, 2002), pp. 208–10.

57 "Friar Giacomo of the Order of Minors"—i.e., the Franciscans. Father Giacomo's four letter cypher represents the closest comparison to Father Stefano's monogram in the Montone missal, although Nessi observes that one might have expected *J*—for the Latin "Jacopus"—to feature in the cypher rather than *G*—for the Italian "Giacomo" (ibid., p. 210).

58 It is likely that the *M* here stands for "Magister," which would identify the friar as a university-trained master of theology; the alternative reading, "m[e] f[ecit]" (made me), seems much less likely.

59 Daniele is recorded as guardian in 1395 and 1401. See Florence, Archivio di Stato, Notarile Antecosimiano 7117, fol. 3413 (February 2, 1395); ibid., Notarile Antecosimiano 6875 (September 1, 1401, at date). In 1410 Daniele also acted on behalf of the Franciscan community, "nomine guardiani et fratrum conventualium" (in the name of the guardian and the convent's friars), agreeing to the consecration of several altars with the local abbot: ibid., Notarile Antecosimiano 7133, fol. 5427v (February 16, 1410). His family owned a good deal of property in the area; on his father's death in 1402, the friar oversaw the sale of farmland from his estate. See ibid., Notarile Antecosimiano 7123, fols. 4286v–4287v.

60 Ugolino Nicolini, "Le tavole dei capitoli provinciali dell'Umbria del 1408 e del 1431," *Archivum Franciscanum Historicum* 59 (1966): p. 307: "vicarius ibidem [conventus Burgi], frater Daniel de Burgo" (the vicar [of the Sansepolcro convent], brother Daniel of Borgo).

61 Banker, "Appendix of Documents," in Israëls, *Sassetta*, 2: p. 568: "Et super ornamentis fiendis ad dictam tabulam stare debeat dictus Bartholomeus ad declarationem fratris Danielis Stefani de dicto ordine et conventu, et prout dictus frater Daniel declaraverit, teneatur et debeat dictus Bartholomeus dictam tabulam a qualibet parte ornare et aptare" (And as regards the decorative elements to be made for the said panel, the said Bartolomeo should follow the explanation of brother Daniele di Stefano of the said order and convent, and as the said brother Daniele will declare, the said

Bartolomeo is held and should decorate and prepare the said panel on each side). Father Daniele's role in the early stages of the high altarpiece commission has been noted by James R. Banker, *The Culture of San Sepolcro during the Youth of Piero della Francesca* (Ann Arbor, MI: University of Michigan Press, 2003), p. 175; Roberto Cobianchi, "Franciscan Legislation, Patronage Practice, and New Iconography in Sassetta's Commission at Borgo San Sepolcro," in Israëls, *Sassetta*, 1: p. 110.

62 Banker, "Appendix of Documents," in Israëls, *Sassetta*, 2: p. 568.

63 Gaetano Milanesi, "Documenti inediti dell'arte Toscana dal XII al XVI secolo," *Il Buonarroti*, 3rd ser., 2 (1885): pp. 82–83: "facere unum calicem de argento deaurato ornatum, smaltatum et figuratum, videlicet cum quinque smaltis in patena dicti calicis et cum aliis smaltis supra dicto calice et cum armis de Gratianis, et prout et sicut declarabitur per fratrum Danielem Stefani de dicto Burgo, fratrem dicti ordinis Sancti Francisci" (to make a silver gilt chalice, decorated, enamelled and figured, that is with five enamels on the patena of the said chalice and with other enamels on the said chalice and with the arms of the Graziani, according to and as will be specified by brother Daniele di Stefano of the said Borgo [Sansepolcro], brother of the said order of Saint Francis).

64 See "San Francesco, Montone," p. 74.

65 An analogy may be drawn here with Staale Sinding-Larsen's characterization of a manuscript illumination of Christ in Glory in a missal as an "architectural image . . . belonging to the same functional system as a similar image on the triumphal arch or in the apse": *Iconography and Ritual: A study of analytical perspectives* (Oslo: Universitetsforlaget, 1984), p. 94.

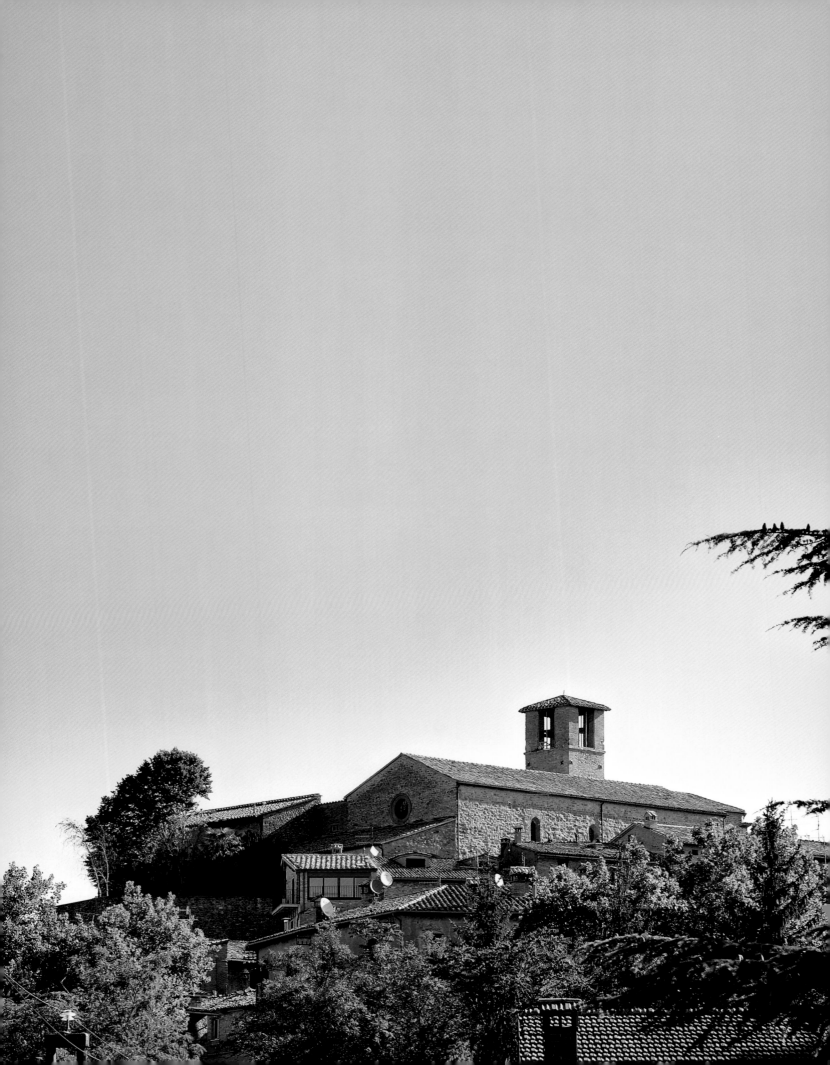

San Francesco, Montone

MOST LIKELY at the beginning of the fourteenth century, the Franciscans erected the church and convent of San Francesco, Montone, located on the northern hill of the medieval village within the district of Borgo Vecchio.[1] It has not been possible to establish a precise date for the religious complex given the dearth of original sources after the loss of the convent's records, dispersed during the French occupation.[2] Indeed, only seven of the convent's documents from the nineteenth century remain, preserved in the historical archives of Montone. The lack of primary sources thus makes it difficult to reconstruct the history of the Franciscan settlement and to clarify the various phases of its architectural and artistic development. The only information related to the Minorite complex has been discovered amid archives of legal documents and in the registers of the Consigli e Riformanze of the municipal historical archives. These provide the most important facts pertaining to the second half of the fifteenth century, the chronological period on which this essay focuses. The results should be added to those already published by Maria Rita Silvestrelli in 1997.[3]

We do not know in what year the Franciscans arrived in Montone. The first general indication of a Franciscan settlement dates to the second half of the thirteenth century. On February 6, 1268, a certain Friar Andrea, "guardiano loci fratrum Minorum de Montone," was one of the witnesses to a notarial deed,[4] and in 1284 the convent of Montone is mentioned as one of the beneficiaries in the will of Giacomo Coppoli from Perugia.[5] Early in the following century, on January 31, 1307, witnesses to a document again included a guardian father, "fratre Mattheo de Castello guardiano loci fratrum minorum de Montone."[6] On April 29 of the following year, Pope Clement v granted an indulgence to the church of San Francesco.[7] However, documents from the fourteenth century still yield little information. Indeed, it is not until 1348 that the Franciscans, at this point fully integrated into local, social, and civic dynamics, are mentioned in the statutes of Montone, in which one may note an offering of wax and alms "et pro reparatione dicti loci decem libras denariorum, aliquo non obstante et teneatur ipsum locum et fratres in ipso habitantes defendere et mantenere, conservare et aumentare."[8] In 1357 the municipality of Montone once again dispensed a sum of 40 lire for alms intended for the monks.[9] Another mention of the Franciscan settlement is also found in certain wills drawn up between 1359 and 1361, specifying that burial places be established "apud locum fratrum minorum Sancti Francisci de Montone."[10] A testament drawn up in 1361 for Santuccio di Giovagnolo Dati specifies that he leaves "quindecim florenos auri convertendos in uno callice pro celebrando corpus Christi . . . triginta florenos auri convertendos in quodam mesale pro missis dicendis."[11]

San Francesco, Montone.
Photograph: Silvia Braconi.

These fragments of information, in fact, tell us little. To attempt a historical reconstruction, we need to turn to local tradition passed down over time. In the nineteenth century, Monsignor Muzi recounted how the first Franciscan settlement was on the site where there now exists an oratory dedicated to Saint Ubaldo, land that until the eighteenth century belonged to the Giugi family from Montone.[12] Newly discovered archives allow us to understand traditional lore and to partially reconstruct the history of that first Franciscan site that, once abandoned by the Minorite friars, took the name of Loco Vecchio, or "the old place." In this regard a document from 1482 states that "Lucas olim Ser Mactei Pontelli de Montone"[13] came into possession of a property in the "comitato" (county) of Montone in the locality known as "el Luocho Vecchio," which included a "casalenum sive sassorum congeries ubi dicitur iam antiquitus fuisse ecclesia Sancti Francisci antequam supradicti conventus et ecclesia in dicto castro construeretur et edificaretur."[14] This gentleman decided to return the ancient little church—now reduced to ruins—to the friars through a donation to the guardian father at that time, "frater Stefanus Marci Cambii," whom we shall discuss later.[15] There was one condition, however: the property could not be sold or transferred and, instead, a church or chapel had to be built there.[16] We do not know when the little church was rebuilt, but it is certain that in 1622 the "Luocho Vecchio" was once again separated from the property of the convent of San Francesco and sold to Cristoforo Giugi.[17] From then on the property remained private, and in at least 1767, the little church was dedicated to Saint Ubaldo.[18]

Thus, it is possible to hypothesize that what happened in Montone was something that occurred in other, better documented contexts, following a common model whereby an initial settlement in the countryside close to an urban center subsequently moved within the walls of the town, in this case presumably at the beginning of the fourteenth century. Therefore, the present-day church of San Francesco represents the second settlement of Franciscans in Montone. According to a recent theory, the new church and convent were most likely built on the ruins of the ancient Castel Vecchio (or Capanneto), a fortification from the early Middle Ages around which the medieval town developed over the subsequent centuries.[19] However, it is still not possible to establish if, at the time the new religious complex was built, the ancient castle was already in ruins or if it was demolished specifically to make room for the new San Francesco. Moreover, we do not know the reasons behind the choice of that site, nor is it possible to reconstruct the stages involved in the building of the church, given the paucity of primary sources.

Some useful information for dating, however, can be gleaned from a stylistic analysis of the monument, the typology of which is typical of the architecture of the mendicant orders and relates to Franciscan models widespread in Umbria during the same period. Simple and linear in appearance, the church had a single nave with a trussed ceiling and a polygonal apse resting on partially preserved corbels, one of which is stylistically similar to those executed in the oldest part of the Palazzo dei Consoli in Gubbio, which dates

FIGURE 1 Interior of the church of San Francesco, Montone. Photograph: Silvia Braconi.

to approximately 1322.[20] On the left side of the church is the convent as well as a cloister that was later expanded, presumably in the sixteenth century. Later, perhaps between the seventeenth and eighteenth centuries, a portico was added in front of the facade; it was oriented canonically toward the west and equipped with a rose window without decoration. Prior to 1446, along the right side, next to the chapel of Giobbe Fortebracci, there was also a second entrance, still visible from the exterior today.

The current appearance of the interior of the church is very different from how it looked originally (fig. 1). Destruction wrought by Napoleonic troops in the late eighteenth century; the state takeover of properties following the unification of Italy in 1866; the renovations that began in the mid-nineteenth century and continued into the early twentieth century; as well as the property's later abandonment have resulted in much damage and devastation. For example, only fragments remain of the frescoes that, at the height of the fifteenth century, must have covered the entire wall surface, and the sculptural program is now only partially preserved. The recovery and restoration of the religious complex—begun to accommodate the establishment of the municipal museum, located there since 1995—has allowed for a limited reconstitution of the church's original layout.

The surviving fragments of the oldest frescoes, executed by unknown masters from the Perugia-Assisi region, date back to the first half of the fourteenth century and are useful in the dating of the church, the architectural structure of which was obviously already built at the time the paintings were created. A second extensive decorative project took place during the second half of the century, after the church had already been repaired, as the 1348 statute suggests. Moreover in the fourteenth century, there already existed an altar dedicated to the Virgin that was then transformed in the following century to accommodate Bartolomeo Caporali's *Madonna of Mercy,* as is evidenced by the presence of a

FIGURE 2 Fragment of *Virgin and Child with Saints Anthony Abbot, Leonard, and Francis,* fourteenth century, from altar dedicated to the Virgin. Fresco. San Francesco, Montone. Photograph: Silvia Braconi.

fourteenth-century fresco depicting the Virgin and Child with Saints Anthony Abbot, Leonard, and Francis (fig. 2). This piece was discovered in 1984 underneath the plaster that covered the wall occupied by the gonfalon.[21]

However, it was during the following century that the most significant artistic contributions were made to the church's interior. The fifteenth century proved to be the period of greatest political and cultural significance for the entire town. After the first decade of the century, when Montone was still under the administration of Perugia, the town was part of the domain of the Fortebracci family. They played a guiding role in local politics and in the promotion of the arts as a result of their close relationships with noble families throughout the variegated chessboard that was central Italy, namely, the Este family of Ferrara, the Malatesta family of Rimini, the Da Varano family of Camerino, the Trinci family of Foligno, and the Baglioni family of Perugia. At the beginning of the century, Braccio Fortebracci, a renowned soldier of fortune and a protagonist in the historical events of his time, distinguished himself through his patronage, commissioning paintings, architecture, and engineering projects for Montone, Perugia, and the other cities he conquered. These works included the expansion of the fortress of Montone by Bolognese architect Fioravante Fioravanti, who also designed the loggia in Perugia that linked the Fortebracci palace to the cathedral.[22] Pope Martin V subsequently granted authority over the domain to Carlo, Braccio's son, enabling him to follow in his father's footsteps and promote public building projects in Montone, such as the reinforcement of the village walls; this was carried out by a master mason, Giovanni di Domenico da Lucarno Lombardo.[23] Beginning in 1477 the town continued to develop while Montone was ruled directly by the church under the papacy of Sixtus IV, who brought an end to Fortebracci rule and subjected the family to *damnatio memoriae,* literally "condemnation of memory," ordering their fortress destroyed in 1478. In the sixteenth century, the church and convent of Santa Caterina were built upon the ruins.

During the second half of the fifteenth century, following the brilliant period of Braccio's reign, the arts burgeoned in Montone. Evidence of this can be seen in the fervor with which embellishments were made to the church of San Francesco, the focal point of the city's artistic ambitions. The art for which the Franciscans served as patrons overlapped with the civic role the church played, as demonstrated throughout much of the century by the Fortebracci, who chose it as their family chapel. Indeed, it was Braccio who commissioned the fresco cycle in the apse. Executed in 1423–24 by Antonio Alberti, a painter

from Ferrara, it depicted episodes from the life of Saint Francis and the Last Judgment. The painter is also credited with a contemporaneous large fresco portraying Franciscan subject matter—also commissioned by Braccio and now reduced to fragments—on the right wall of the church.[24] Baldassarre Mattioli, a painter from Perugia, probably also worked in San Francesco; he, his compatriot Pietro della Catrina, and Alberti are mentioned in records pertaining to the decoration of the Fortebracci residences, and *Madonna Enthroned with Walking Christ Child,* a fresco on the right wall of the church, is also attributed to him.[25] These paintings represent the only figurative equivalent to the courtly culture surrounding Braccio since the decorations of his fortress residence in Montone were demolished by Sixtus IV and his home in Perugia was destroyed in the sixteenth century. Other family members and descendants were inspired by his refined taste and continued to embellish the church of San Francesco, Montone with chapels, sculptures, and paintings. Braccio's near contemporary Giobbe di Bencivenne Fortebracci, who chose to be buried in San Francesco, commissioned a chapel there in 1446; it was frescoed with the images of Saints Anthony of Padua and Bernardino, as well as his own likeness as patron of the chapel. They were executed by an unknown painter from the circle of Benedetto Bonfigli of Perugia.[26] Likewise, in 1473 Carlo donated to the church of San Francesco a relic of the Santa Spina, now preserved in the collegiate church and still venerated in Montone.[27] In 1476 he and his wife, Margherita Malatesta, commissioned the *Altar of Saint Anthony,* or the *Fortebracci Altar,* located in the middle of the north wall of the church, as an ex voto for the birth of a male heir. In fact, the sculpted altar, which bears the date and the family coat of arms, was completed in 1491 under the patronage of Carlo's son, Bernardino, who commissioned Caporali to execute the fresco *Saint Anthony of Padua between Four Angels, Saint John the Baptist, Archangel Raphael, and Tobias,* as an inscription on the painting reads.[28]

The *Fortebracci Altar* represented the Fortebracci family's contribution to a new movement to embellish the church of San Francesco beginning in the 1460s. After Braccio's campaign early in the century, the first works to modernize the church initially found support from local institutions. Indeed, on September 14, 1464, the city council, in the name of the entire community, ordered the construction of a chapel in honor of Saint Sebastian, Martyr in the church of San Francesco as an ex voto to ward off the plague that had struck the upper Tiber region.[29] In October of the following year, "Li Magnifici Signori Sei . . . dietero affare la capella de Sancto Sebastiano a mastro Giannio."[30] The commission called for a payment of 6½ florins on the condition that the chapel "stia beniximo"[31] and that the space between one column and another be 8 feet in front and 5 feet on the side.[32] No trace remains of the chapel's architectural structure, but it must have been similar to an aedicule. In 1514, next to the chapel of Saint Sebastian, to the right of the entrance, the municipality decided to fresco images of the city's four patron saints, Saints John the Baptist,

Sebastian, Gregory, and Biagio. Berto di Giovanni, a painter from Perugia, received the commission to create the paintings, of which there remain only fragments of Saints John the Baptist and Gregory.[33]

During this same period, another chapel was also created. Dedicated to Saint Bernardino and also executed by "mastro Giannio,"[34] this chapel may be the same one mentioned in a document dated June 30, 1466, which specifies that "magister Angelutius è Tutii"[35] leave 202 florins to the church of San Francesco and that his heir see to the creation of "figuram et imaginem Sancti Bernardini in dicta capella [Sancti bernardini] scultam et arlevatam."[36] Even if it is not easy to establish the location of this latter chapel, it is interesting to note how, already at this date, work to embellish the interior of the church was being financed by private sources through donations or bequests—a practice that would become frequent in subsequent decades of the fifteenth century when increasing numbers of people would elect to be buried in San Francesco rather than in other churches in Montone. It is undeniable that starting in at least 1464, the friar Stefano di Cambio, the guardian father, played a significant role in this phenomenon. He was also important in the context of art patronage at San Francesco and probably promoted the campaign to modernize the church during the second half of the fifteenth century, as is attested to by the numerous works to which his name is connected. Indeed, many commissions—not only from the Franciscans and local institutions but also from private citizens—date to the years of his fruitful activity, resulting in the creation of new votive chapels, sculptures, and paintings.

Father Stefano held the post of guardian father at the convent of San Francesco, Montone for an unusually long period of time. The first document in which he is mentioned as "guardianus dicti loci conventus et capitoli"[37] is a receipt dated April 2, 1464, issued by the friars of Montone to "Meo Dominici de Montone" for a sum of 16 florins to be spent "amor dei pro utilitate dicte ecclesie videlicet pro uno paramento altaris et pro una planeta."[38] The last known record is dated March 14, 1507, and is related to the payment made to Berto di Giovanni for the commission of an altarpiece depicting the Virgin and Child and Saints Gregory, John the Baptist, John the Evangelist, and Francis, now in Buckingham Palace in London.[39] Father Stefano came from one of the city's wealthiest families, as is verified by land registry documents of the Cambii family, who had possessed numerous properties since the fourteenth century.[40] Where the monk served his novitiate is unknown, but we do know that in the final phase of his career, he was also in charge of the safekeeping of Città di Castello, as is noted in two documents dated 1497 in which he is mentioned as "custos custodie Civitatis Castellis."[41]

The first significant work to which his name is linked is the illuminated missal attributed to Bartolomeo and Giapeco Caporali, as the liturgical book's colophon, dated October 4, 1469, specifies. A Crucifixion scene in the book even features a portrait of the friar in prayer.[42] Unfortunately, archival research has not yet yielded results that might clarify

the circumstances surrounding the commission of this work, which, nonetheless, marks the beginning of his enduring relationship with Bartolomeo.

Thirteen years after creating the illuminations for the missal, Bartolomeo Caporali would be asked by Father Stefano to complete his most important commission: the renovation of the fourteenth-century altar dedicated to the Virgin. Located halfway down the right wall of the church, it would include the Perugian painter's gonfalon on silk, the *Madonna of Mercy* (cat. 6).[43] In a resolution dated April 23, 1471, this undertaking was initially ordered by the Consiglio dei Sei, which established a payment of 4 florins and the resumption of work at the "capella Sancte Marie noviter incipiata in Sancto Francischo."[44] However, we can hypothesize that Father Stefano encouraged the decision; not only were the funds dispensed directly to the guardian father, but he also had a close relationship with one of the civic priors who ruled in his favor. "Marcus Cepechi Cambii,"[45] one of the Domini Sex[46] of that period, was in fact the friar's father and the person who, in his will, would make arrangements for his burial in the Franciscan church, donating some of his assets to the convent.[47] The 1471 resolution should also be seen in relation to an earlier, intermediary intervention that called for the preexisting altar table to be dismantled and moved against the wall, where traces of it still remain, and for a new altar table to be created bearing the inscription "1474 IHS MARIA," which still exists today.[48] The realization of a sculpted altar display, dated 1480, and the gonfalon by Caporali, dated 1482, completed the renovation of this altar dedicated to the Virgin Mary.[49] Judging from the presence of his portrait in both works, Father Stefano once again was involved with these undertakings. In a compartment of the right pier of the altar display, the image of a friar with the key to the convent hanging from his Franciscan cord can be identified as a portrait of the guardian father (fig. 3). Two years later he would be portrayed once again, this time represented beside Saint Sebastian in the gonfalon by Caporali (fig. 4).

The altar dedicated to the Virgin, however, was created at the height of Pope Sixtus IV's restoration projects, as can be seen in the inscription carved along the beam of the sculpted altar display: "UBER[RI]MO CELATUM OPUS ANNIS SUB GLANDE

FIGURE 3 Image of Father Stefano di Cambi in compartment of right pier of altar dedicated to the Virgin, 1480. San Francesco, Montone. Photograph: Silvia Braconi.

FIGURE 4 Detail of Father
Stefano di Cambi, from *Gonfalon
with the Madonna of Mercy and
Saints*, 1482. Bartolomeo Caporali
(Italian, c. 1420–c. 1505). Tempera
and gold on canvas; 236 × 164 cm.
Museo di San Francesco, Montone.
Photograph: Silvia Braconi.

LABENTIBUS MILLENIS QUATRINGENTESIMO OTUAGENI,"[50] recalling the execution
of the work under the papacy of Sixtus IV della Rovere ("UBER[RI]MO . . . GLANDE")[51]
after the year 1480. This undertaking seems to have been part of a series of works encour-
aged by Sixtus IV, who, significantly, was already the head of the Franciscan order. In a
brief dated December 21, 1473, the pope addressed all provincial ministers, establishing
that "pro urgenti necessitate aut aliqua evidenti utilitate bona inmobilia conventum loco-
rum ac monasterioum provintie . . . vendere alienare ac permutare."[52] The provisions in
the brief apparently enabled Father Stefano to obtain huge sums of money through the
sale of houses and lands belonging to the Franciscans in Montone, assets often inherited
from bequests; these sums were used not only "pro utilitate et comoditate dicti loci et
ecclesie" but also for the creation of works for the decoration and embellishment of the
church's interior.[53] We can presume that such works included the completion of the altar
dedicated to the Virgin and, it now seems certain, the creation of another chapel dedi-
cated to her as well, which can be identified as the one in the aedicule, dated 1481, and now

located at the end of the left nave in the parish church of San Gregorio. However, in my opinion, the chapel once stood inside the church of San Francesco near the niche at the end of the right wall that features a fresco depicting the Virgin and Child with Saints John the Baptist and Francis. The presence of the Della Rovere coat of arms makes it possible to date the painting to between 1477 and 1484, and for this reason it should also be considered an homage to Pope Sixtus IV.[54] Some documents of particular interest confirm that the chapel originated in the Franciscan church. In one, dated February 28, 1485, and drawn up in the sacristy of the church of San Francesco in Perugia, the provincial head of the Minorite order, "Bartolomeus Tome Blaxioli"[55] of Perugia, in a brief issued by Sixtus IV, orders the procurators and the guardian father of San Francesco, Montone to sell a house, setting aside the proceeds "pro emendo rem stabilem pro maiori utilitate dicti loci Sancti Francisci de Montone."[56] A later document, dated April 26, 1485, drawn up in the refectory of the church of San Francesco, Montone in the presence of Father Stefano and the procurators of the convent, refers to the previous document and establishes, "pro capillam Virginis Marie site et fabricate in dicto loco et ecclesia,"[57] the sale of the house of "domina Magia filia olim Guidi Iohannis Iacobi uxor Iuliani Iohannis de Montone,"[58] who can be recognized as the "MAGIA FILIA GUIDONIS" recorded in an inscription on the aedicule in question.[59] The same document then leaves a bequest of 25 florins to the chapel of the Virgin Mary to be spent on a chalice and a chasuble.[60]

Having verified the existence of two contemporaneous chapels dedicated to the Virgin in the church of San Francesco, it is still difficult to determine which of these is connected to the numerous bequests "pro fabriche aconcimine et ornamentum capelle Gloriose Virginis Marie site et fabricate in dicta ecclesie," drawn up in the presence of Father Stefano, who probably directed private donations to both projects.[61] These bequests included one from his own father, Marco di Cambio, who left to the "capelle Gloriose Virginis Marie in Sancto Francesco de Montone fabricata florenos quinque pro uno calice."[62] For the same reason, it is still not possible to establish which of the projects was overseen by "magister Iacobus Antonii scarpellino de Septignano distripto Florentie,"[63] who on May 24, 1482, received from the monks in Montone, under the leadership of Father Stefano, a payment of 4 florins "pro fabrica et hornamentis et aconcimine capelle beate Virginis Marie in dicte ecclesie Sancti Francisci."[64]

During this same period, specifically on July 2, 1481, the monks, once again under the leadership of Father Stefano, entrusted "Luca Iohannis de Montone"[65] with the building to the left of the church entrance "unam capellam ad honorem omnipoentis Dei et reverentiam Beati Bernardini."[66] Unfortunately, no trace remains of this chapel, which must have been located in a position symmetrical to and opposite the Saint Sebastian chapel that the municipality had erected. In that area there remains only a fragment of a Saint Sebastian attributed to Caporali bearing the inscription "A.D. [MCCCC] LXXXX [. . .]

IDEM LUCAS [. . .] OMNIA POSUIT"—the same Luca noted in the aforementioned document.[67]

Contributions from private citizens, as in the above instance, also proved to be decisive in the years that followed, not only for creating works of decoration and embellishment but also for the renovation and maintenance of the convent. These included the repair of the underground pipe for the cistern leading to the garden and the organization of dormitory rooms, resulting from donations given to the monks in the mid-1480s.[68] Other documents, however, suggest how the expansion of the cloister most likely began at the end of the century and was completed during the following century. In 1489 Guardian Father Stefano, in fact, received 5 pounds from the bequest of "Rainaldus Paoli de Agello,"[69] who set aside funds for "aconcimine dicti loci videlicet in claustrum dicti loci."[70] Similarly, the following year, the monks of Montone received from "Baldassarre Angeli Magistri Pace de castro Fracte Filiorum Uberti"[71] a sum of 49 florins designated "in usum et utilitatem dicti conventum videlicet in fabrica et aconcimine trasandarum claustri dicti conventus."[72] During the same period, the church sacristy was also renovated, and the resulting beautiful cornices, sculpted in pietra serena sandstone, can be attributed to the craftsmen who also worked on the altars and chapels in the church, as certain bequests suggest. Indeed, in 1494 a "Domina Magia" who had previously financed the chapel dedicated to the Virgin Mary left the Franciscans in Montone half of 25 florins for "embellishments to the sacristy."[73] Likewise, a document from 1497 refers to a "Domina Apolonia filia olim Laurenti,"[74] whose bequest states that she be buried in San Francesco and that a sum of 50 florins be set aside "pro ornamento sacrestie."[75] And then in 1500, the will of "Laurentius olim Silvestri Rentii,"[76] drawn up in the church of San Francesco in the presence of witnesses who included Father Stefano, specifies burial in the Franciscan church and the sum of 10 florins be left "pro ornamentis sacrestie."[77]

The tireless prior's promotion of the arts would continue into the following century. Indeed, the sixteenth century began with the creation of another work clearly desired by Father Stefano, namely, the Banco dei Magistrati (Bench of the Magistrates), inscribed on its side in his memory: "FRATER STEPHANUS CAMBIUS LOCI INSTAURATOR CONVENTUS ERE SEDILIA FIERI CURAVIT MCCCCCV" (fig. 5).[78] It was probably the work of the same master carver who created the contemporaneous choir stalls.[79]

But the now elderly guardian father's last undertaking was the commissioning of Berto di Giovanni to create the aforementioned altarpiece depicting the Virgin and Child and Saints Gregory, John the Baptist, John the Evangelist, and Francis, completed in 1507 according to pertinent documents. This crowning achievement of Father Stefano's activity—begun almost forty years before when he commissioned the missal for the altar—thus symbolically closed the circle of his involvement with the convent. In subsequent years other important works would be executed, completing the renovation he had so ardently desired: the construction of the chapel of Saint Christine, intended to

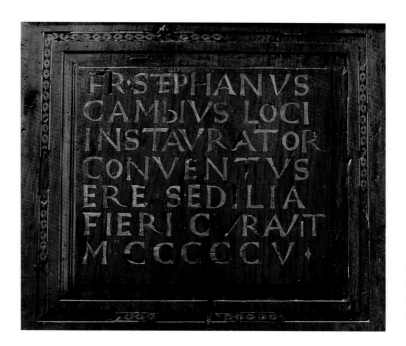

FIGURE 5 Inscription mentioning Father Stefano di Cambi on the Banco dei Magistrati (Bench of the Magistrates), 1505. San Francesco, Montone. Photograph: Silvia Braconi.

accommodate the 1515 altarpiece by Luca Signorelli that depicts the Virgin and Child with Saints Sebastian, Christine, Jerome, and Nicholas, commissioned by the same patrons of the chapel and now in the National Gallery in London;[80] the painting in 1514 of frescoes by Berto di Giovanni for the chapel of Saint Sebastian; and the creation of the beautiful carved and inlaid portal, executed in 1519 by Master Antonio di Bencivenne from Mercatello di Massa.[81] In the early sixteenth century, the church thus must have been richly ornamented with sculpted and painted chapels, the appearance of which was maintained at least until the period of the French occupation. Father Stefano's legacy was undoubtedly important, especially if one considers that after the renovation he promoted, no significant work was done on the church's interior in subsequent centuries.

The patronage for most of the works produced during this period thus should be sought within the Franciscan orbit, where one can look for channels through which most of the artists working at San Francesco arrived in Montone. At least in the case of Caporali, who worked in the Franciscan church at different times, it seems credible to propose this relationship. His first contact with San Francesco must have occurred in 1469, when the illuminated missal was commissioned. In the early 1480s the painter was again called upon by the guardian father, this time to create the gonfalon featuring the Madonna of Mercy, completing the altar dedicated to the Virgin Mary. The latter was an undertaking that must have had a certain resonance in the small community of Montone, considering that civic and religious institutions and private citizens all participated in various ways in its creation, attesting to a convergence of the ecclesiastical-religious and civic-political realms, typical of society at that time. Perhaps the project inspired the private patrons who, ten years later, once again brought Caporali to Montone to decorate their chapels.

They probably included Luca di Giovanni, who in 1490 had the image of Saint Sebastian created, a work that may once have been located in the lost chapel of Saint Bernardino. One of the private patrons was certainly Bernardino Fortebracci, who in 1491 wanted to complete the altar his father had hoped to have built, commissioning a painting of Saint Anthony and thus continuing the Fortebracci family tradition of financing works in the Franciscan church. Although the splendors of the countship had by then come to an end, traditional devotions linked to the Franciscan order may have played a role in the commission of this work, the only one signed and dated by Caporali—hence, a significant point of reference in a reconstruction of the artist's final phase of activity. Indeed, he was well received in Montone thanks to the nature of his painting. During his late phase as well, Caporali, who had modeled himself on Bonfigli, Fra Angelico, and Benozzo Gozzoli, demonstrated a change in his style after becoming familiar, through Perugino, with the new Florentine tendencies. Yet, he maintained the gracious, popular manner that obviously found favor with a provincial clientele. However, only supporting documentary evidence, as in the case of Berto di Giovanni, will be able to clarify and define the reasons for his repeated presence in Montone. Archival research has thus far failed to uncover new information.

NOTES

1 Since medieval times Montone has been divided into three districts: Borgo Vecchio, Monte, and Verziere. For the history of Montone, see Angelo Ascani, *Montone, la patria di Braccio Fortebracci* (Città di Castello: Gesp, 1965; anastatic repr., 1992). An important contribution in terms of the general historical picture is also provided by Maria Vittoria Baruti Ceccopieri, "Braccio da Montone. Le compagnie di ventura nell'Italia del XV secolo," in *Braccio da Montone e i Fortebracci: atti del convegno internazionale di studi, Montone, 23–25 marzo 1990* (Narni, Italy: Centro Studi Storici, 1993).

2 On May 6, 1798, the Napoleonic troops "misero a sacco tutto il convento, chiesa, Granaro, Cantina, e Dispensa; bruciarono tutta la libraria unitamente a tutti gli altri libri continenti gli interessi del convento . . . unitamente ai patrioti finirono di sciupare tutto quel poco che era rimasto doppo il saccheggio bruciando tutta la mobilia del convento e chiesa, essendo riuscito ai poveri religiosi di salvare poco, o nulla di robbe, e nel ritorno che fecero in convento vi trovarono le sole muraglie, con solo qualche finestra e porta" (sacked the entire convent, church, granary, cellar and dispensary; they burned the entire library, along with all other books containing things of interest to the convent . . . along with the patriots they ended up ruining the little that remained after the pillaging, burning all the furniture in the convent and church, leaving little or nothing for the poor churchmen to salvage, and upon returning to the convent they found there only the walls, with some windows and doors). Thus reads the account of the guardian father of the time, which appears at the beginning of the book on the events of 1798. Archivio storico del comune di Montone (hereafter referred to as ASCM), Convent of San Francesco di Montone, "Libro dell'esito del 1798," 1798–1823, v.s. F, fol. 1. See Maria Rita Silvestrelli, "Appunti sulla storia e l'architettura della chiesa di San Francesco," in *Museo Comunale di San Francesco a Montone*, ed. Giovanna Sapori (Perugia: Electa, Editori Umbri Associati, 1997), p. 24.

3 Ibid., pp. 23–29.

4 "guardian of the place of the Friars Minor of Montone"; ibid., p. 23. See Giovanna Casagrande, ed., *Chiese e conventi degli ordini mendicanti in Umbria nei secoli XIII e XIV. Gli archivi ecclesiastici di Città di Castello* (Perugia: Regione dell'Umbria, 1989), p. 16.

5 Silvestrelli, "Appunti sulla storia e l'architettura," in Sapori, *Museo Comunale*, p. 23. See Felice Ciatti, *Secondo paradosso historico nel quale si dà giudizio e parere sopra la bella e antichissima statua di bronzo già nel distretto di Perugia ritrovata* (Perugia, 1631), p. 2.

6 "Brother Matteo da Città di Castello, guardian of the place of the Friars Minor of Montone"; Ascani, *Montone*, p. 250.

7 Ridolfi da Tossignano, *Historia seraphica religionis*, vol. 1 (Venice, 1586), fol. 109; Luke Wadding, *Annales minorum, in quibus res omnes trium Ordinum a S. Francisco institutorum ex fide ponderosius asseruntur, calumniae refelluntur, praeclara quaeque monumenta ab obliuione vendicantur* (Lugduni: C. Landry, 1625–54), 5: p. 306; Ascani, *Montone*, pp. 249, 257; Silvestrelli, "Appunti sulla storia e l'architettura," in Sapori, *Museo Comunale*, p. 28.

8 "and for the repair of the said place 10 lire, anything notwithstanding, and that he shall be obliged to defend and maintain, preserve and increase the said place and the brethren dwelling in it"; ASCM, Statuti, vol. 1, chaps. 34–35; cf. Silvestrelli, "Appunti sulla storia e l'architettura," in Sapori, *Museo Comunale*, p. 23; Adriano Bei, "Il processo penale a Montone alla metà del XIV secolo negli Statuti del Comune e nei registri giudiziari" (PhD diss., Università degli studi di Perugia, 1990–91), pp. 153–54.

9 ASCM, Consigli e Riformanze, 1362–71, v.s. 444 F VI, fol. 133, November 1, 1457; Silvestrelli, "Appunti sulla storia e l'architettura," in Sapori, *Museo Comunale*, pp. 23, 29.

10 "at the place of the Friars Minor of San Francesco di Montone"; ASCM, Notarile, Matteo di Fuccio di Bruno, reg. no. 1, fols. 20–21v (Luca di Guido, April 23, 1359); ibid., fols. 53v–56v (Giunta di Benvenuto di Ugolo, December 6, 1359); ibid., fols. 95–97v (Donna Maria di Muzio, April 29, 1360); ibid., fols. 109v–110v (Massolo di Manciolo, December 10, 1360); ibid., fols. 114–115v (Vanni di Domenico di Staccione, January 31, 1361); ibid., fols. 127v–128 (Santuccio di Giovagnolo, May 7, 1361); ibid., fols. 133–134 (Checco de Agurello, July 22, 1361).

11 "fifteen gold florins to be converted into a chalice to celebrate the body of Christ . . . 30 gold florins to be converted into a missal for saying Mass." See "The Franciscan Context," pp. 51–67.

12 Episcopal archive of Città di Castello, Visita Muzi, fol. 48; Silvestrelli, "Appunti sulla storia e l'architettura," in Sapori, *Museo Comunale*, p. 23; Ascani, *Montone*, p. 258.

13 "Luca, son of the late Matteo di Pontello of Montone."

14 "hovel or heap of stones where there is said to have been in former times a church of Saint Francis before the aforesaid convent and church were put up and built in the said castle."

15 "Brother Stefano di Marco di Cambio."

16 ASCM, Notarile, Andrea di Giuliano "de Angiis" di Gubbio, reg. no. 14.3, fols. 25v–26v, January 2, 1482.

17 ASCM, Catasto (recorded without old press marks and modern numbering), 1604, fol. 158v.

18 ASCM, Catasto dei beni laicali della terra e territorio di Montone, 1762.

19 See ITGC "Ippolito Salviani," *La pieve antica di San Gregorio e le origini di Montone*, vol. 9, *Architettura e territorio* (Città di Castello: Petruzzi, 2010), p. 42.

20 Silvestrelli, "Appunti sulla storia e l'architettura," in Sapori, *Museo Comunale*, p. 23.

21 For more on existing fourteenth-century paintings at San Francesco, refer to the entries written by Paola Mercurelli Salari in Sapori, *Museo Comunale*.

22 Regarding Braccio's patronage, see Cristina Galassi, "Vita artistica al tempo di Braccio da Montone e dei Trinci di Foligno," in *Braccio da Montone e i Fortebracci*, pp. 61–71.

23 ASCM, Consigli e Riformanze, reg. v.s. 448 63 (1461–74), fol. 92, October 1, 1472. Between 1472 and 1475 the latter also received payment for the construction of a turret above the gateway to the town (ibid., fol. 98, October 31, 1473); for work carried out on the Chapel of the Guard (ibid., fol. 101, March 14, 1474); for the fortress bridge (ibid., fol. 107v, October 22, 1474); for a well near the fortress (ibid., fol. 114v, June 2, 1475). See Silvia Braconi, "La scultura lapidea a Montone nel Quattrocento" (PhD diss., Università degli Studi di Perugia, 2003–4), pp. 51–52.

24 For Alberti's frescoes, see entries written by Silvestrelli in Sapori, *Museo Comunale*, pp. 68–81, 97.

25 See entry written by Mercurelli Salari in Sapori, *Museo Comunale*, p. 60.

26 See entry written by Silvestrelli in Sapori, *Museo Comunale*, pp. 64–65.

27 Regarding the Santa Spina in Montone, see Ascani, *Montone*, pp. 261–65.

28 "CARROLUS BRACCIO GENITUS OB NATUM SIBI FILIUM EX VOTO DIVO ANTO ARAM ET SACELLUM ERIGI INSTITUIT. QUO EXSTINTO BERNARDINUS FILIUS OPUS COMPLERI MANDAVIT. 1491 BARTOLOMEUS CAPORALIS PINX (IT)" (Carlo di Braccio, for the son born to him, in consequence of a vow, began the erection of an altar and chapel to Saint Anto[ny]; after his death, his son Bernardino ordered the work to be completed. 1491. Bartolomeo Caporali painted it). Regarding the painting, see entry written by Silvestrelli in Sapori, *Museo Comunale*, pp. 94–96, and here, figure 12 in "The Caporali Missal: A Masterpiece of Renaissance Illumination," p. 28.

29 Ascani, *Montone*, p. 119.

30 "The Magnificent Six Lords . . . gave Mastro Giannio [the task of] making the chapel of Saint Sebastian."

31 "be very fine"

32 ASCM, Consigli e Riformanze, reg. v.s. 448 63, 1461–74, fol. 38, October [. . .], 1465.

33 ASCM, Notarile, Guido di Giovanni di Renzo, reg. no. 29, fol. 2, July 31, 1514, published by Tom Henry, "Berto di Giovanni at Montone," *Burlington Magazine* 138 (1995): pp. 325–28. Also see the entry written by Mercurelli Salari in Sapori, *Museo Comunale*, pp. 39–44, which suggests that the chapel of Saint Sebastian may correspond to one of the aedicules now in the parish church of San Gregory; according to local tradition, it may have come from San Francesco.

34 ASCM, Consigli e Riformanze, reg. v.s. 448 63, 1461–74, fol. 38, April 6, 1467. Regarding works in the chapels of Saint Sebastian and Saint Bernardino, also see ibid., fol. 37v, October 15, 1465 (payment to Francesco di Ser Giovanni for goblets provided for the chapel of Saint Bernardino); ibid., fol. 39v, April 24, 1466 (payment to Tommaso di Cristiano for bricks, sand, and slaked lime to be used for the chapel of Saint Sebastian); and ibid., fol. 43, April 24, 1466 (order for payment for slaked lime to be used for both). See Braconi, "La scultura lapidea," pp. 142–44.

35 "Master Angeluccio di Tuccio"

36 "a figure and image of San Bernardino in the said chapter [of San Bernardino] sculpted and in relief"; ASCM, Notarile, Pietro d'Angelo di Montone, reg. no. 4.1, fols. 29–30, June 30, 1486. See Silvestrelli, "Appunti sulla storia e l'architettura," in Sapori, *Museo Comunale*, p. 24.

37 "guardian of the said place, convent, and chapter"

38 "the love of God for the benefit of the said church, namely for an altar-cloth and a chasuble"; ASCM, Notarile, Cristoforo di Gregorio di Montone, reg. no. 8.3, fol. 53, April 2, 1464.

39 ASCM, Notarile, Guido di Giovanni di Renzo, reg. no. 26, fols. 101v–102. The documents relating to the altarpiece by Berto di Giovanni are published by Henry, "Berto di Giovanni," pp. 327–28.

40 ASCM, Catasto (recorded without old press marks and modern numbering), 1331, fol. 7v.

41 "the warden of the wardship of Città di Castello"; ASCM, Notarile, Cristoforo di Giovanni di Dontuccio di Perugia, reg. no. 22.1, fols. 151v–153, 155–155v.

42 See figure 6 in "The Caporali Missal: A Masterpiece of Renaissance Illumination," p. 23. For more on Bartolomeo and Giapeco Caporali, see "Bartolomeo and Giapeco Caporali," pp. 35–49.

43 Regarding the painting, see the entry written by Silvestrelli, "Appunti sulla storia e l'architettura," in Sapori, *Museo Comunale*, pp. 109–11.

44 "chapel of Saint Mary newly begun in San Francesco"; ASCM, Riformanze, reg. v.s. 448 63, 1461–74, fol. 72, April 23, 1471. See Braconi, "La scultura lapidea," pp. 46, 144–45.

45 "Marco di Cepeco di Cambio"

46 "Six Lords"

47 ASCM, Notarile, Cristoforo di Gregorio, reg. no. 6.5, fols. 11v–14v, March 27, 1483. See Silvestrelli, "Appunti sulla storia e l'architettura," in Sapori, *Museo Comunale*, p. 29.

48 "1474 Jesus Mary"

49 See catalogue 6.

50 "Work carved under the most flourishing oak as 1480 years slipped by"

51 "UBER[RI]MO GLANDE" is translated literally as "most fecund acorn," and thus should be considered an allusion to Pope Sixtus IV della Rovere, whose family's coat of arms is the fruit-bearing branch of the oak.

52 "for an urgent necessity or some manifest good benefit to sell, alienate, and exchange the immoveable property of the convents, places, and monasteries of the province . . . property might be sold or transferred." The entire text of the brief is known to us from a subsequent document drawn up in the refectory of the convent of San Francesco, Montone on June 3, 1488, which calls for the regional minister of the order, Bartolomeo di Tommaso, from Perugia, to act "plena auctoritate et licentia per quodam breve apostolicum" (with full authority and license by a papal brief); ASCM, Notarile, Andrea di Giuliano "de Angiis," reg. no. 13.5, fols. 21–22v, June 3, 1488.

53 "for the benefit and advantage of the said place and church"; ASCM, Notarile, Pietro d'Angelo, reg. no. 4.7, fols. 17–18, April 5, 1484. Thus in a contract for sale, Guardian Father Stefano di Cambio and the procurators of the convent sell to Giuliano di Giovanni of Montone a house inherited from the deceased Giovanni di Paolo di Fabro. In the years following the brief of Sixtus IV, we find various contracts of sale for lands inherited as bequests: ibid., Andrea di Giuliano "de Angiis," reg. no. 14.1, fols. 5v–6v, March 2, 1480; ibid., Cristoforo di Gregorio, reg. no. 9, fols. 289v–291, August 2, 1488; ibid., Cristoforo di Giovanni di Donatuccio, reg. no. 22.1, fol. 32, April 8, 1497; ibid., fols. 117–120, September 4, 1497; ibid., 238v–244v, December 14, 1497.

54 See Braconi, "La scultura lapidea," pp. 129–34.

55 "Bartolommeo di Tommaso di Biagiolo"

56 "for buying permanent property for the greater benefit of the said place of San Francesco, Montone"; Archivio di Stato, Perugia, Notarile, Tancio di Nicola di Tancio, reg. no. 276, fol. 13v, February 28, 1485.

57 "for the chapel of the Virgin Mary situated and built in the said place and church"

58 "Donna Magia, daughter of the late Guido di Giovanni di Giacomo, wife of Giuliano di Giovanni of Montone"; ASCM, Notarile, Cristoforo di Giovanni di Donatuccio, reg. no. 19.4, fols. 45v–48v, April 26, 1485.

59 The aedicule bears two inscriptions in Latin characters, one with a dedication to the Virgin—"DIVE MARIE VIRGINI DEDICATUM" (Dedicated to Mary the Virgin)—and the other with the names of possible patrons and the date—"[. . .] HS MAGIA FILIA GUIDONI[S] ET MARGARITE PARENTIBUS DEFUNCTIS SIBIQUE AC POSTERIS SUIS POSUIT ANNO DOMINI MCCCCLXXXI" (Magia daughter of Guido and Margherita set up [this tomb] for her deceased parents, herself, and her descendants in the year of Our Lord 1481).

60 ASCM, Notarile, Guido di Giovanni di Renzo, reg. no. 28, fols. 66–67, December 30, 1510. See Valentina Ricci Vitiani, "La committenza di Luca Signorelli in Umbria; nuove indagini e ricerche" (PhD diss., Università degli studi di Perugia, 2001–2), p. 239.

61 "for the building, upkeep, and adornment of the chapel of the Glorious Virgin Mary situated and built in the said church"; ASCM, Notarile, Pietro d'Angelo, reg. no. 4.5, fols. 46v–47v, November 30, 1476. See Silvestrelli, "Appunti sulla storia e l'architettura," in Sapori, *Museo Comunale*, p. 25. In subsequent years we find other wills with bequests in favor of the "capella Gloriose Virginis Marie in ecclesia Sancti Francisci": ASCM, Notarile, Cristoforo di Gregorio, reg. no. 6.5, fols. 34–34v, June 26, 1483 (Donna Caterina di Cepecho di Antonio); ibid., Cristoforo di Giovani di Donatuccio, reg. no. 19.4, fol. 83v, December 22, 1485 (Donna Costanza di Florido di Cepecho "Barbalglie"); ibid., Cristoforo di Gregorio, reg. no. 9, fols. 91–91v, May 24, 1485 (Giovanni di Giovanni di Matteo de Provenza); ibid., Pietro d'Angelo, reg. no. 4.8, fols. 21–23v, August 2, 1486 (Ser Alovisio di Meo di Giuduccio); ibid., Andrea di Giuliano "de Angiis," reg. no. 13.7, fols. 1–2, July 2, 1489 (Donna Giovanna di Paternostro); ibid., Cristoforo di Gregorio, reg. no. 8.12, fols. 30v–36v, September 10, 1491 (Antonio de Simone); ibid., Guido di Giovanni, reg. no. 25, fols. 125–127v, July 13, 1503 (Lazzaro di Antonio de Cardaneto).

62 "chapel of the Glorious Virgin Mary built in San Francesco 5 florins for a chalice"; ASCM, Riformanze, reg. v.s. 448 63, 1461–74, fol. 72, April 23, 1471.

63 "Master Giacomo di Antonio Scarpellino of Settignano, a district of Florence"

64 "for the building and ornaments and embellishment of the chapel of the Blessed Virgin Mary in the said church of San Francesco"; ASCM, Notarile, Pietro d'Angelo, reg. no. 4.6, fols. 44v–45, July 2, 1481. Regarding sculptors working in Montone during that period, see Braconi, "La scultura lapidea," where Prof. Giancarlo Gentilini suggests that the altar display containing Caporali's gonfalon can be ascribed to a sculptor from Urbino/Perugia, hypothesizing that this could be the Perugian Ludovico d'Antonibo, who had already done the sculptures that crown the portal of the Collegio del Cambio in Perugia. However, the aedicule of San Gregorio, at the same location as a chapel dedicated to the Virgin Mary that came from San Francesco, Montone, is ascribed to a sculptor from the second half of the fifteenth century. This sculptor is culturally similar to the artists active in San Francesco between 1476 and 1480. His pieces are generally related to the Florentine sculptor Agostino di Ducco, who worked for some time in nearby Perugia, where he contributed to the Renaissance renewal of the local artistic culture. The recent discovery of this document, dated 1482 and unknown to me prior to this project, opens up new lines of research that merit further in-depth study.

65 "Luca di Giovanni of Montone"

66 "a chapel in honor of Almighty God and veneration of Blessed Bernardino"; ASCM, Notarile, Cristoforo di Giovanni di Donatuccio, reg. no. 19.12, fols. 126–127v, July 2, 1481. See Silvestrelli, "Appunti sulla storia e l'architettura," in Sapori, *Museo Comunale*, p. 25.

67 "in AD 1490 the same Luca . . . set up everything"; ASCM, Notarile, Cristoforo di Giovanni di Donatuccio, reg. no. 19.12, fols. 126–127v, July 2, 1481.

68 ASCM, Notarile, Cristoforo di Gregorio, reg. no. 9, fols. 273–274v, May 16, 1484: offering of Morello di Piero di Bozzo "pro certis necessitatibus dicti conventus et maxime pro reparatione conductus cisterne posite versus ortum" (for certain necessities of the said convent and especially for the repair of the cistern to the east). Ibid., Andrea di Giuliano, reg. no. 14.8, fols. 13v–14, December 20, 1485; the monks of Montone received a sum designated in the will of Meo di Bene, known as "il Mareschalco," from Montone, who decided to specify "in utilitate et evidens aconcimine dicte ecclesie videlicet in actatione et aconcimine cuiusdam camere dormitore dicte ecclesie" (on the benefit and manifest embellishment of the said church, namely on the adaptation and embellishment of a dormitory chamber of the said church).

69 "Rainaldo di Paolo of Agello"

70 "in embellishment of the said place, namely for the cloister of the said place"; ASCM, Notarile, Baldo di Mazzancollo, reg. no. 11, fol. 65, March 27, 1489.

71 "Baldassare di Angelo di maestro Pace of the castle of Fratta de' figli d'Uberto." Present-day Umbertide.

72 "for the use and benefit of the said convent, namely on the building and embellishment of the passageways of the cloister of the said convent"; ASCM, Notarile, Cristoforo di Gregorio, reg. no. 9, fols. 378v–379v, June 23, 1490.

73 Ibid., Baldo di Mazzancollo, reg. no. 11, fol. 214v, February 26, 1494.

74 "Donna Apollonia of the late Lorenzo"

75 "for the adornment of the sacristy"; ibid., Cristoforo di Gregorio, reg. no. 8.9, fols. 11–13v, July 30, 1487. See Silvestrelli, "Appunti sulla storia e l'architettura," in Sapori, *Museo Comunale*, p. 25.

76 "Lorenzo di fu Silvestro di Renzio"

77 Ibid., Cristoforo di Giovanni di Donatuccio, reg. no. 23.8, fols. 59v–60, October 8, 1500.

78 "Brother Stefano di Cambio, restorer of the place, caused the seats to be made at the convent's expense 1505."

79 See the entries written by Carla Mancini in Sapori, *Museo Comunale*, pp. 137, 139.

80 In January 1510 the monks of Montone granted to Luigi de Rutanis, a French doctor living in Montone, and to his wife, Tomassina, a space between the chapels of Saint Bernardino and Saint Anthony so that they might build a chapel dedicated to Saint Christine: ASCM, Notarile, Guido di Giovanni di Renzo, reg. n. 28, fols. 11–12v, January 18, 1510; the document is cited by Ricci Vitiani, "La committenza di Luca Signorelli," pp. 235–36.

81 The inscription carved into the center of the portal reads: "ANTONIUS BENCIVENNIS DE MER/ CATELLO MASSAE / H[O]C OPUS FECIT MDXVIII" (Antonio Bencivenni of Mercatello di Massa made this work in 1518). Regarding the work in question, see Mancini in Sapori, *Museo Comunale*, pp. 138–39.

ste sunt: qr verba que
dedisti michi dedi eis. Et
ipi acceperunt: et cog-
noverunt vere quia
a tu me misisti. Ego
pro eis rogo. Non p-
mundo rogo: sz p hijs
quos dedisti michi:
qr tui sunt et mea oi-
a tua sunt. 7 tua mea
sunt. et clarificatus
sum in eis. Et iam no
sum in mundo; et hij in
mundo sunt: et ego ad
te venio. Si vero i
dicta vigilia fuerit ali-
quod festum simplex
fit de ipo comemoratio
in missa. Nd si fuerit
festum sollempne mi-
sa dr de festo cum co-
memoratione vigilie
Si aut fuerit festuz
duplex de eadem fit
missa. Et nulla fit c-
memoratio de vigilia.

In die ascensiois sto
do scm petrum. Inteu
Viri galilei quid a-
miramini aspicientes
in celum alla. que ammo-
dum vidistis eum ascen-
dentem in celum. ita veniet
alla alla alla. V. Cumq;
intuerentur celum euntem
illum. ecce duo viri astite-
runt iuxta illos in vestibus
albis qui 7 dixerunt. V. Vlla

Oracio.
Oms omps
deus; ut
qui hodie
dia die u-
nigenitum tuum rede-
ptorem nrm ad celos a-
scendisse credimus.
ipi quoq; nrie i celes-
tibus habitemus. Per
eundem. Lc. actuum
Primum quidem
sermonem feci te
omnibus o theophyle q-

Catalogue

EIOITVROLEMENTISSIMEPHER
DERVHOSVOXPMRILIVOTVV

Missal, from the convent of San Francesco, Montone, near Perugia

1469
Illuminations by Bartolomeo Caporali
Italian, Perugia, c. 1420–c. 1505
and Giapeco Caporali
Italian, Perugia, died 1476
Bound manuscript (complete), 400 folios,
2 columns, 26 lines, written in gothic
textualis; capitals touched in red with
filigree penwork extending into margins
COLLATION: regular quires of 10 leaves with
the exception of I(2), II(6), XIX(12), XX(10 + 1),
XXI(12), XXVI(8), XXVII(8 + 1), XXXIV(8), XXXXI(14)
with catchwords. JUSTIFICATION OF
TEXT: 20.8 × 15.5 cm. BINDING: nineteenth-
century black morocco, gilt edging; front
cover includes arms and motto "carpe diem"
(presumed to be that of John Webster,
London). FOLIO: Ink, tempera, silver and
burnished gold on vellum
35 × 25 cm
The Cleveland Museum of Art, John L.
Severance Fund, 2006.154

PROVENANCE
Convent church of San Francesco, Montone;
John Webster (d. 1826), Upper Mall, Hammer-
smith, and Queen Street, Cheapside, London
(probable owner of armorial stamp on
binding); Thomas Edwards (1762–1834),
Halifax, West Yorkshire; collection of Philip
Augustus Hanrott (1776–1856); sale, Quaritch,
London, December 1893, lot 95, cat. 138;
collection of Leo S. Olschki, Florence;
collection of Conte Paolo Gerli di Villagaeta,
Milan (see ex libris); private collection,
Switzerland; Jörn Günther, Hamburg.

REFERENCES
Fliegel 2007a, cat. 106, pp. 278–79.
Fliegel 2007b, pp. 5–7.
Caleca 1969.
Salmi 1957, pp. 56–57.
Muzzioli 1954, p. 421.
Aeschlimann 1940, pl. xxii, p. 37.
Perrott 1934, pp. 173–84.
Salmi 1933, pp. 253–72.

ACCORDING TO the colophon on folio 400, this illuminated missal was pro-
duced for the Franciscan convent of San Francesco, Montone, near Perugia in
Italy's Umbria region. The buildings of this male convent are still extant, and the
present volume, a liturgical service book for the Mass, very likely was intended
for use on the church's high altar. The colophon provides the name of the Ger-
man scribe, Henricus Haring (Heinrich Haring), and the precise date of comple-
tion, October 4, 1469. It also identifies the convent's guardian as Presbiter Frater
Stephanus Cambi (Stefano di Cambio) and its two procurators as Franciscus Ser
Johannis de Ciurellis (Francesco di Ser Giovanni de'Cirelli) and Petrus Paulus de
Miraculis (Pierpaolo de'Miraculi); the role of the procurators in the commission
of the missal is uncertain. The individuals represented within the upper borders of
the canon illustration on folio 185v are those of a male and female, probably Carlo
Fortebracci, Count of Montone, and his wife, Margherita Malatesta, who commis-
sioned an altarpiece in the same church. Such internal evidence referencing the
date, place, commission, and scribe of a manuscript is exceptionally rare.

Of principal interest are the illuminations, extensive for a manuscript mis-
sal. They include a luxuriously decorated opening page *(ordo missalis)* on folio 9
that features elaborate borders with naturalistically rendered animals, putti, and
roundels showing Saint Francis displaying his stigmata and King David in prayer.
Folios 185v and 186 reveal the volume's masterpiece: a two-page deluxe opening
to the canon of the Mass with a Calvary scene (verso) and an elaborate *Te igi-
tur* (recto). The latter comprises a large decorated initial *T* with highly involved
foliate decoration and putti and birds. The former is a magnificent rendering of a
traditional Calvary scene with a crucified Christ flanked by the Virgin and Saint
John with two angels. Saint Francis kneels at the foot of the cross, attesting to the
missal's Franciscan use and affiliation. Elaborate use of burnished gold appears
throughout. The volume also presents thirty-one small historiated initials with
various scenes, among them a Nativity, Pentecost, and Saints Peter and Paul. Each
of the small initials is further embellished with marginal floral extensions and fili-
gree fillings within some letters.

The most excellent aspects of the illumination clearly fall to Bartolomeo Capo-
rali, an important documented panel and fresco painter and miniaturist who pro-
duced other works for the convent. His hand may be perceived first and foremost
in the monumental full-page miniature of the Crucifixion. The central element of
the crucified Christ with Saint Francis kneeling at the foot of the cross is a master-
piece of rare quality. The corpus and its imposing musculature are carefully mod-
eled in subtle shades of ochre, yellow, and brown, indicating intensive anatomical
study and a highly developed sense of naturalism on the part of the artist. Christ's
head, turned to the right, rests upon his chest, capturing the moment of death
(Christo morto), and his face evinces exhaustion. He wears an almost translucent
loincloth (perizonium) beautifully draped in fine folds that appear soft and tactile.
Bartolomeo was likely assisted by his brother, Giapeco, a Perugian miniaturist,
who completed the remaining illuminations. SNF

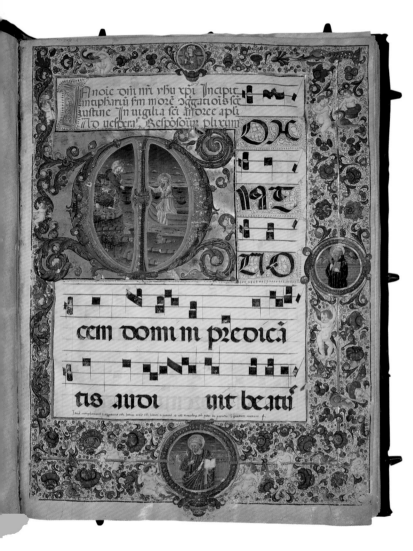

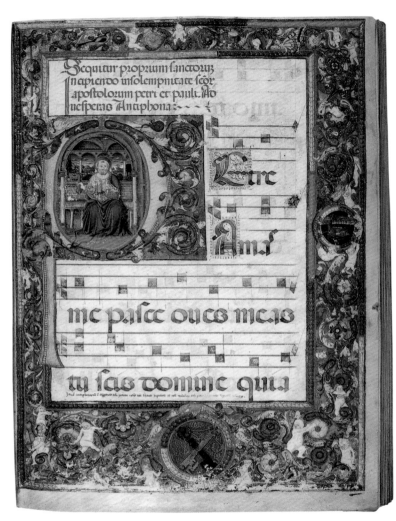

CAT. 2, VOLUME K

CAT. 3, VOLUME M

Two Volumes from the Antiphonary of the Abbey of San Pietro, Perugia

1472–76
Written in Perugia, Italy, by Don Alvige
Illuminations by Giapeco Caporali
Italian, Perugia, died 1476
and others
Ink, tempera and gold on parchment
Vol. K: 56 × 40 cm; Columbia University
Library, Rare Book and Manuscript Library,
Plimpton MS 041. Vol. M: 57 × 41 cm;
Abbazia di San Pietro, Perugia, cod. 161

PROVENANCE
Vols. K & M: Abbazia di San Pietro, Perugia;
vol. K: removed from San Pietro by Dr. Oddi,
physician to the prior, 1906; sale, Anderson
and Co., New York, March 7, 1911, lot 593;
acquired by George A. Plimpton and
bequeathed to Columbia University, 1936.

REFERENCES
Garibaldi and Mancini 2008, cat. 6, pp. 178–79.
Alexander 1994, cat. 124, pp. 232–33.

1 See figures 14 and 15 in "The Caporali Missal:
A Masterpiece of Renaissance Illumination,"
pp. 30–31.

THESE TWO VOLUMES derive from a multivolume set of antiphonaries produced for the Benedictine monastery of San Pietro in Perugia. The production of such large sets of choir books was frequently assigned to a team of scribes and illuminators for the sake of expediency, as seems to be the case here. Surviving records in the San Pietro archives record the scribe as Don Alvige, about whom nothing is known. The documents also mention Giapeco Caporali among the team of illuminators, noting payments to him in 1472, 1473, and 1476. Other illuminators listed include Pierantonio di Nicolò del Pocciolo, Ercolano di Pietro da Mugnano, and Tommaso di Mascio, who may have been responsible for the fine filigree penwork initials. Today, four volumes from the original set are still preserved in Perugia, their bindings marked prominently with the letters *I, J, L,* and *M* to indicate their location within the abbey library or sacristy. A fifth volume marked *K* is today housed in the Columbia University Library in New York, having been removed from San Pietro in 1906. It was eventually obtained on the art market by George A. Plimpton, who bequeathed it to the university in 1936.

The two volumes included here both feature illuminated pages by Caporali. He is responsible for folio 1 in volume K, which contains the antiphons for the Sanctorale from the vigil of Saint Andrew (November 29) to Saints John and Paul (June 26). The spectacular initial *M* illustrates Christ calling to Andrew, who stands in the boat. It introduces the chant responsory "Mox ut vocem Domini" for the Feast of Saint Andrew. Roundels in the borders include Saint Giustina (top), Saint Benedict (right), and Saint Paul (bottom). The rubric on folio 1 indicates that the text is written according to the use of Santa Giustina, a reform movement that originated in Padua in the monastery dedicated to that saint.

Volume M has twelve folios that can be attributed to Caporali's hand. The volume covers the Sanctorale from the Feast of Saints Peter and Paul (June 29) to the first Sunday in Advent. The frontispiece to this volume features a large initial *P* with Saint Peter seated "in cathedra." He holds a key in his right hand and a book in the left. A portico and an arcade appear behind the saint, and a landscape recedes into the background. A roundel in the center of the *bas-de-page* includes Peter's crossed keys.

Both of these volumes exemplify the painterly style of Caporali, who was at this time treasurer of the miniaturists' guild in Perugia and a prominent illuminator in that city. His style, as has been observed by Alexander, reveals a competent and experienced hand but a somewhat old-fashioned decorative vocabulary. Both volumes feature Caporali's love of borders infused with foliage, especially acanthus, flowers, and occasional birds. Within these lush borders are highly animated putti who climb, posture, and occasionally interact with each other. Multicolored laurel garlands encircle these roundels in the borders. His palette includes deep cobalt blues, acid greens, yellows, reds, and pinks as well as the rich use of burnished gold. These same characteristics are found in the missal from the convent of San Francesco, Montone (cat. 1), another manuscript missal in the Morgan Library & Museum, and a bifolium from a choir psalter now in the Worcester Art Museum.[1]

SNF

Civic Document / Land Register for the Entry BARTOLOMEUS SIGNOLE DICTO CAPORALE ET JACOBUS EIUS FRATER CARNALIS

1454
Illuminations by Giapeco Caporali
Italian, Perugia, died 1476
Register, 668 folios
Tempera on parchment
34 × 54 cm
Perugia, Archivio di Stato, ASCPg, Registry of Deeds I, 33, fol. 60

REFERENCES
Scarpellini and Mancini 1987, pp. 3–8, esp. p. 4.
Lunghi 1984, pp. 149–97, esp. pp. 163–64.
Grohmann 1981, p. 472.

Not in exhibition

ACCORDING TO this civil document, on February 14, 1454, Bartolomeo Caporali and his brother, Giapeco, declined the inheritance from their father, Segnolo di Giovanni (known as Caporale), from Massa Lombarda and formerly registered in Porta Sole and the parish of Santa Maria Nuova. The brothers instead requested registration in Porta Eburnea, in the parish of Santa Maria della Valle, to establish residency there. Here, Bartolomeo states that he possesses one-third of a plot of land left to him by Tomassino di Paolo Vannoli—later transferred in 1462 due to the flooding of the Tiber River.

The register entry for Bartolomeo and Giapeco begins at 36 lire and 15 soldi, rises to 56 lire, and then goes back down to 12 before rising again and ending at 82 lire, 2 soldi, and 6 denari. Subsequent documents show numerous increases in property value with purchases of land in Fratticciola (present-day Fratticiola Selvatica), Sant'Angelo di Celle, and Deruta, all of which are located in the region of Perugia. The document provides valuable information regarding the family and economic status of the two brothers and also offers clues for reconstructing their artistic personalities. Indeed, we see that the name *Bartolomeo* precedes that of his brother, proving that he is the elder of the two, contrary to past claims. This page, though previously mentioned by scholars, has never been reproduced or taken into consideration to reconstruct the biography of the two artists.[1]

The entry features two Gothic letters shaded in alternating red and purple. The illuminated initial *I*, colored in purple, is decorated with acanthus leaf motifs terminating with a partial figure of a winged putto whose face is framed by blond hair. The illuminated initial *B*, larger in size and having plant and acanthus leaf elements, is shaded in purple and yellow. The two letters resemble the initial *I* illuminated in bright colors in the edict of 1474 signed by Giapeco at the time of his priorate.[2] There are also strong similarities with the illuminated *I* in volume K from the antiphonary of the abbey of San Pietro and attributed to Giapeco, to whom payments are recorded in 1472.[3] The simplicity of the decoration, without the usual chromatic exuberance, can be seen as appropriate to a young artist who, in this case, is trying out new ideas.

It is possible to track the estate of Bartolomeo and his descendants further in another land register entry associated solely with Bartolomeo and already noted.[4] Here, around the years 1489/97, a greatly expanded estate is registered, initially amounting to 467 lire (fig. 1). As of this date Bartolomeo was living in Porta Eburnea in the parish of San Savino in a house purchased in 1473. The register then records continuous additions and deletions to assets by the painter's sons and heirs, making this an important document in terms of information about the artist's descendants. MRS

1 Lunghi 1984, pp. 163–64; Scarpellini and Mancini 1987, p. 4.
2 Archivio di Stato, Perugia, ASCPg, Consigli e Riformanze, 110, fol. 58.
3 Columbia University, Rare Book and Manuscript Library, Plimpton MS 041, fol. 45; see also catalogue 2, 3.
4 Archivio di Stato, Perugia, ASCPg, Catasti 2, 21, fols. 72–77v; Grohmann 1981, p. 472.

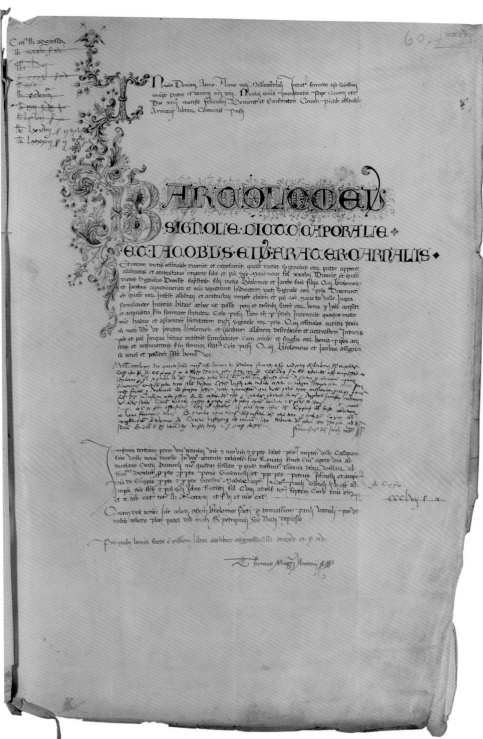

FIGURE 1 Register for land owned by
Bartolomeo Caporali, c. 1489. Archivio di Stato,
Perugia, ASCPg, Catasti 2, 21, fol. 72.

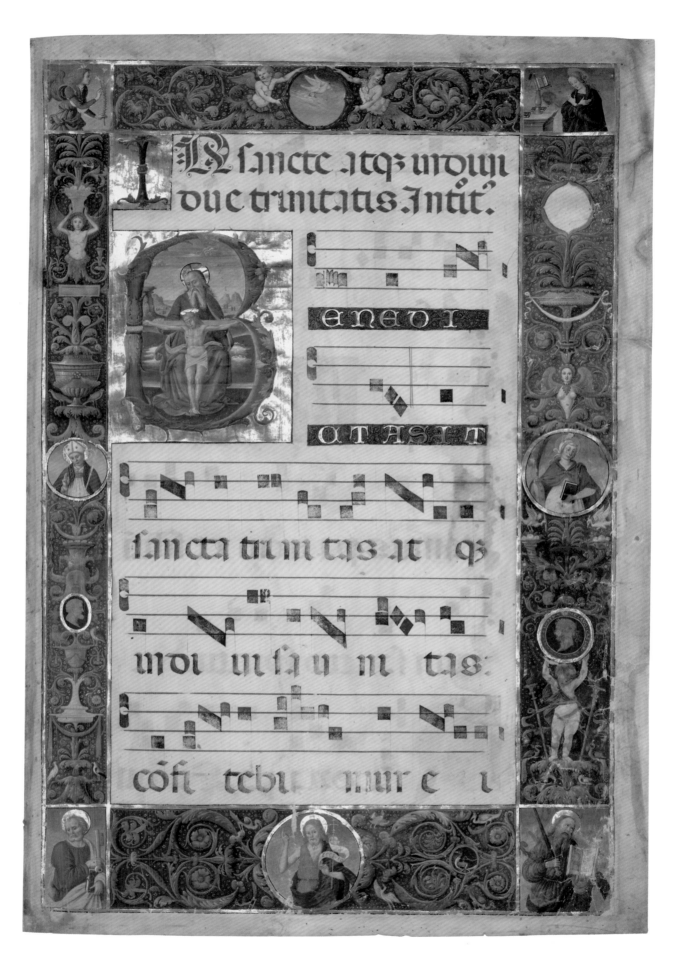

Excised Single Leaf from a Gradual: Initial B[enedicta sit sancta Trinitas] with the Trinity

c. 1490–1500

Circle of Perugino [Pietro di Cristoforo di Vannucci]

Italian, Perugia, c. 1446/50–1523

Tempera, ink and gold on vellum

78.7 × 53 cm

The Cleveland Museum of Art, Purchase from the J. H. Wade Fund, 1952.461

PROVENANCE

Unknown before 1952; Vladimir G. Simkhovitch, New York.

REFERENCES

Alexander 2010, p. 114.

THE FOCUS OF this lavishly decorated page is the large initial *B* containing a representation of the Holy Trinity. The letter incorporates the seated God the Father, who supports the horizontal crossbeam of the cross upon which his son is crucified. Above, in a roundel at the center of the upper margin, is the ethereal dove of the Holy Spirit. The design features a receding verdant landscape with mountains and blue skies, and the entire composition creates the illusion of viewing the scene through the frame of an open window. This highly elaborate decorated letter—itself formed by two contorting dragon heads and acanthus foliage—introduces the text for the opening of the introit of the Mass for Trinity Sunday, celebrated one week after Pentecost.

The decoration of the leaf extends to all four margins that are enlivened with small roundels depicting saints and cameos, one of which in the upper right was left blank by the artist. The page provides a masterful example of the style of manuscript illumination fashionable in Italy at the close of the fifteenth century. Here, the artist employed classicizing leaf scrolls, masks, urns, putti, mermaids, and a sphinx. The upper corners feature miniatures of the archangel Gabriel and the Annunciate Virgin while Saints Peter and Paul appear below. The verso consists of text, musical staves, and two small initials.

Little is known about the leaf's original provenance. It was clearly excised from a set of important choir books that, on the basis of the elaborate decoration of this leaf, must have been a major commission for a wealthy client. The leaf has been in the Cleveland collection since 1952, and tradition states that it once belonged to the cathedral of Perugia. Museum documents cannot substantiate the source of this conjecture, nor has the alleged association with the cathedral been verified independently. One theory advanced was that the leaf derives from an unfinished volume, given the presence of the blank roundel in the upper right margin. However, this seems to be little more than speculation, and other means can be used to account for the blank.

The highly accomplished style of the painting seems to suggest that it belongs to an artist in the circle of Perugino, who was a younger contemporary of Bartolomeo Caporali in Perugia. Caporali, who was likely still alive when this leaf was painted, seems to have been progressively influenced by the style of both Pintoricchio and Perugino. This little-known leaf illustrates the vibrancy of Perugian illumination at the century's close. SNF

Gonfalon with the Madonna of Mercy and Saints

1482

Bartolomeo Caporali
Italian, Perugia, c. 1420–c. 1505
Tempera and gold on canvas
236 × 164 cm
Museo di San Francesco, Montone

INSCRIPTIONS
SANCTUS GREGORIUS (on the book of Saint
Gregory); SANCTUS FRANCISCUS, SANCTUS
SEBASTIANUS (on the halos of Saints Francis
and Sebastian); ANNO DOMINI MCCCCLXXXII
OP[US] H[UIUS] CONVENTUS [In the year of
Our Lord 1482 made by the Convent] (on the
scroll below the Madonna).

PROVENANCE
Convent church of San Francesco, Montone.

REFERENCES
Garibaldi and Mancini 2008, cat. 4, pp. 174–75.
Silvestrelli 1997, pp. 109–11.
Weber 1904, pp. 119–20.
Berenson 1897, pp. 141–42.
Guardabassi 1872, p. 130.

Not in exhibition

DRESSED IN A boldly patterned pink and gold brocade gown, the Madonna of Mercy (Madonna della Misericordia in Italian) spreads her deep blue mantle over the people of the Umbrian town of Montone. Above, the judging Christ, flanked by two angels, holds three arrows symbolizing war, plague, and famine. Broken arrows litter the shoulders of the Madonna's cloak, suggesting that she protects Montone and its population from these blights. Saints important to Montone and to the Franciscan order appear on either side of her. At the left are John the Baptist, an age-old protector of the town; an unidentified bishop-saint holding what appears to be a tau cross; Francis of Assisi, gold lines emanating from his stigmata; and Sebastian, struck through with arrows. At the right are Gregory the Great, Montone's patron saint, identified by his papal tiara and the inscription on his book; Nicholas, who holds his standard attribute, three golden balls; the Franciscan Anthony of Padua, offering up a heart to the Virgin; and the Franciscan Bernardino of Siena. Montone's faithful populous kneels in prayer beneath the Madonna's skirts; the men and boys appear at the left, the women and girls at the right.

A view of the cityscape of Montone, set upon its hilltop, is below. The right features the now-destroyed imposing castellated structure built by Braccio Fortebracci, the *condottiero* whose family ruled Montone in the fifteenth and sixteenth centuries, while the left offers a depiction of the Franciscan convent of San Francesco. The walls of the city bear marks of the damage caused by Pope Sixtus IV's army in its assault on Carlo Fortebracci between 1477 and 1478. Half-length figures of the Madonna and Saint Francis enclosed in tondi flank the town. Both raise their hands in gestures of blessing, and Francis holds a scroll, the inscription on which is now illegible. Death holding a scythe advances into the picture from the lower right corner. Although the Madonna and the saints do their best to protect Montone and its inhabitants, death, judgment, and hardship are nonetheless inevitable and ever-present; thus, piety is the only recourse.

This extraordinary painting is a gonfalon, a sort of banner displayed aloft on a pole during civic and religious ceremonies and processions. The Madonna of Mercy appeared often on gonfalons, which were usually commissioned by confraternities and lay religious groups who gathered together for devotional purposes such as the singing of hymns, the performance of charitable works, or flagellation. However, it is more likely that the present gonfalon was commissioned by Stefano di Cambio, the guardian father of the convent of San Francesco, for the convent's use. Father Stefano was responsible for major renovations to and the commissioning of furnishings and decorations for the convent, most notably the church's so-called Banco dei Magistrati (Bench of the Magistrates), which was inscribed with his name, and the missal bearing his name and portrait that was ostensibly used on the high altar (cat. 1). The gonfalon was at one point incorporated into a marble altarpiece on a side wall of the church, though it may have been removed from that place from time to time for use in processions.

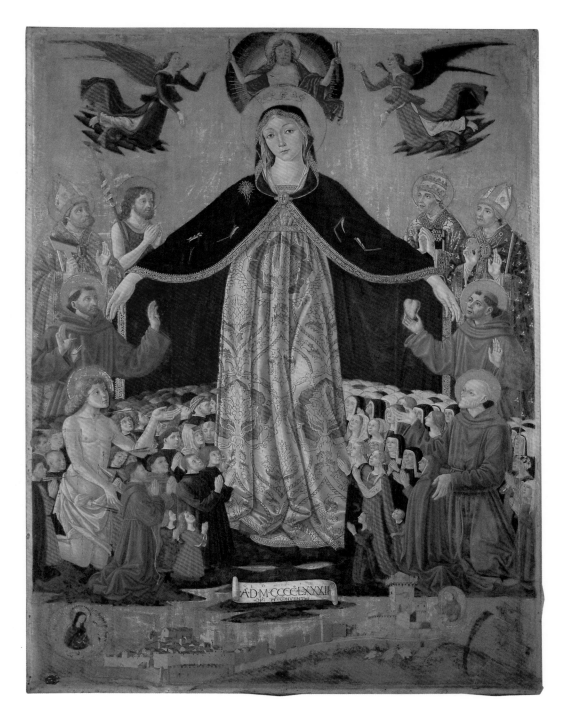

Although many of the diminutive figures beneath the Madonna's skirts are simply types or refer to a particular group in the town—such as the nuns on the right who must have belonged to the local convent of Santa Caterina—others appear to be portraits. Male and female members of the Fortebracci family, both adults and children, are present in the foreground, and Saint Sebastian recommends to the Madonna a kneeling Franciscan friar with strikingly specific facial features. This figure may represent Father Stefano, and it does not seem unreasonable to identify the commission with his ongoing program of improvements to the convent, in which Bartolomeo Caporali appears to have participated more than once. VB

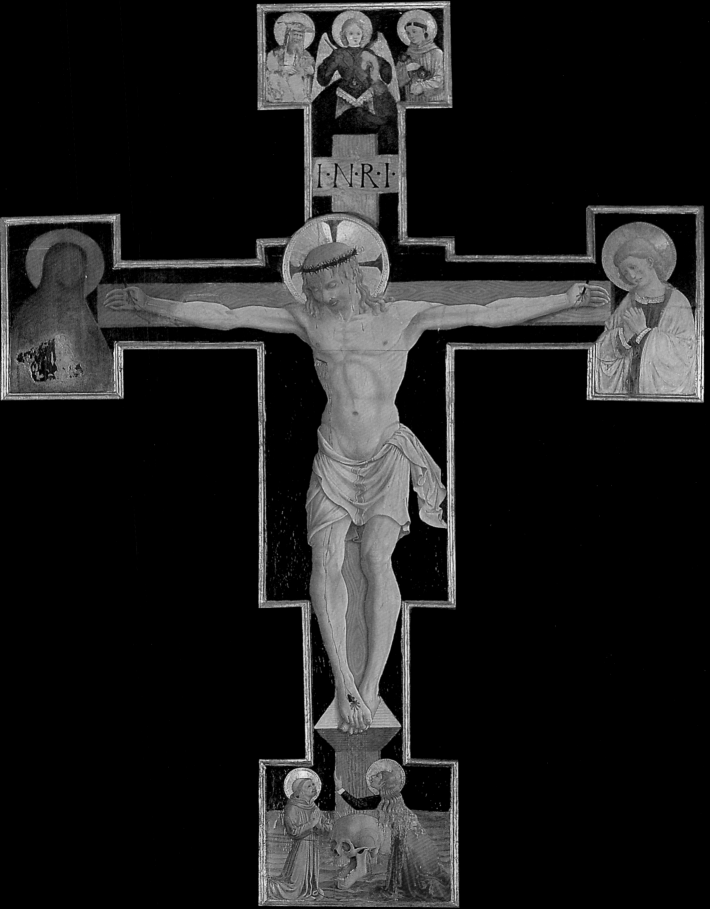

Crucifix

c. 1460–70
Bartolomeo Caporali
Italian, Perugia, c. 1420–c. 1505
Tempera and gold on wood
242.5 × 169 cm
San Michele Arcangelo, Isola Maggiore del
Trasimeno

INSCRIPTION
I.N.R.I. [abbreviation of *Iesus Nazarenus,
Rex Iudaeorum,* "Jesus of Nazareth, King of
the Jews" (John 29:19)] (on the tablet of
the cross).

PROVENANCE
Church of San Michele Arcangelo,
Isola Maggiore del Trasimeno.

REFERENCES
Todini 1989, p. 50.

Photograph: Stefano Medici

MONUMENTAL CRUCIFIXES dating from the twelfth and thirteenth centuries are among the earliest surviving Italian panel paintings. By the time the present crucifix was created, this type of object was well on its way out of fashion. Yet the church of San Michele Arcangelo, set high atop a hill on the Isola Maggiore in the middle of Lake Trasimeno in Umbria, is not merely provincial but unusually isolated. Despite radical developments in the visual arts in Italy's urban centers throughout the fifteenth century, provincial patrons with traditional, less au courant tastes and expectations may have preferred a *retardataire* type of object; such a crucifix would also have been an eminently suitable furnishing for the simple, rustic church constructed in the thirteenth century, the heyday of such works. Typically suspended in a church's main apse, attached to a rood screen, or placed above altars in side chapels, monumental crucifixes were important focal points of devotion in late medieval Italian churches, affording the faithful the opportunity to contemplate Christ's Passion. This one is displayed at present over the main altar of the church of San Michele, where it may have been suspended since the fifteenth century.

Christ hangs on the cross, set upon the barren hill of Golgotha. His head slumps forward, and nails pierce each of his hands and both of his feet. Blood flows in linear rivulets from these wounds and the one in his side. He is mourned in the left and right terminals by the (severely abraded) Virgin and the youthful John the Evangelist, respectively, and in the upper terminal by Saints Jerome, Michael the Archangel (the church's titular saint), and Leonard. In the lower terminal, Mary Magdalene embraces the base of the cross while Saint Francis of Assisi joins his hands in prayer.[1] Both kneel, flanking a large skull, its mouth menacingly ajar. John 19:17 refers to Golgotha, the site of the Crucifixion, as "that place which is called Calvary," but in Hebrew *Golgotha* means "place of heads and skulls"; thus, the skull at the foot of the cross is meant to be that of Adam, whose fall and its repercussions on mankind are redeemed through Christ's sacrifice.

This little-known crucifix may be attributed to Bartolomeo Caporali and dated to about 1460–70 when compared with the full-page miniature of the Crucifixion on folio 185v of the Cleveland missal (cat. 1). The corpuses are virtually identical. Christ's body is poised on the cross in precisely the same manner in the manuscript and the panel painting; even the nails enter his hands and feet at the same angle and have similar diamond-shaped heads while the blood gushes from his wounds in nearly identical patterns. The surprisingly naturalistic musculature—which seems to owe something to recent developments in painting, particularly the work of Perugino—is carefully modeled in a restricted palette of pale yellows, browns, whites, and creams in both works. However, in the miniature Christ wears a filmy, transparent loincloth and is shown triumphantly alive, meeting the gaze of Francis, who embraces the cross. Together, the works demonstrate not only Caporali's ability to paint effectively on both monumental and miniature scales but also his skill in reusing figures when they proved successful, though it is unclear which of these works was made first. Moreover, even when dealing with an older type of object, Caporali worked in a resolutely forward-looking style. VB

1 See catalogue 15 for more on Francis at the foot
 of the cross.

The Angel of the Annunciation and The Virgin Annunciate

c. 1460–1500

Bartolomeo Caporali
Italian, Perugia, c. 1420–c. 1505
Tempera and gold on wood
49.5 × 47.5 cm and 49 × 47.5 cm
Galleria Nazionale dell'Umbria, Perugia

INSCRIPTION
ECCE.ANCIL[L]ADOMI[NI] [Behold the
handmaid of the Lord (Luke 1:38)]
(on the Virgin's halo).

PROVENANCE
Church of San Domenico, Perugia.

REFERENCES
Bury 1990, pp. 469–75.
Todini 1989, 1: p. 51.
Santi 1985, pp. 51–52 (with complete bibliographic
listing).

IN THIS PAINTING the archangel Gabriel announces to Mary that she will bear the son of God. At this moment God's plan for salvation is set in motion; through Christ's human incarnation, the old era of the law is transformed into a new era of grace. Bartolomeo Caporali imagined the event as taking place in a loosely domestic interior set upon a golden ground and over which further golden embellishments protrude. Diverted from her devotional reading, Mary modestly draws back and responds, as is inscribed on her halo, "Behold the handmaid of the Lord."

Events in this drama took place in sequence: Mary was first startled at the angel's sudden appearance; she then reflected on his message and queried Gabriel about her fitness; finally, she submitted to God's will. Here, her downcast eyes, hand resting tentatively on her breast, and kneeling posture, together with the inscription on her halo, suggest her submission to divine will and to the dove of the Holy Spirit descending toward her with rays of light emanating from its beak. Mary's purity is represented by the lilies Gabriel holds while her chastity is symbolized by the enclosed garden seen through the opening in the colorful marble structure; the setting incorporates a bench and a wall running the length of the panels' backgrounds, creating continuity between their picture fields. Mary was often called the *hortus conclusus* (enclosed garden) and the *porta clausa* (closed door), and many Annunciation scenes represent these references to her virginity with images of walled gardens and locked doors. Here, an open door leads into the heavenly garden of paradise, underscoring the promise of salvation brought about by the Incarnation. Curious are the cat and dog antagonizing one another beside Gabriel; perhaps the faithful dog fighting the wicked cat refers to Christ's triumph over the devil.

This pair of panels, together with several others also in the Galleria Nazionale dell'Umbria in Perugia, is traditionally thought to have been part of Caporali's first surviving documented work: an altarpiece for the chapel of San Vincenzo in the church of San Domenico in Perugia on which Caporali collaborated with Benedetto Bonfigli. There are records of the receipt of two payments made to the painters in 1467 and 1468 in which Caporali's name is placed second, suggesting that he was the junior partner in the undertaking. The altarpiece was apparently dismantled in the eighteenth century, and by the nineteenth century, the pieces were scattered about the church of San Domenico. Indeed, by the nineteenth century, the two present panels, which would have been pinnacles of the altarpiece, were installed on either side of the sacristy doors. However, the absence of Saints Vincent and Francis among the surviving fragments—the altarpiece was made in fulfillment of the testamentary deposition of a man called Francesco di Maestro Pietro—renders the hypothesis somewhat problematic. Bonfigli is also documented as making another altarpiece for San Domenico in 1494 that remained incomplete, though this information does not correlate any better with the fragments. Whatever the case, the panels have been consistently and repeatedly attributed to Caporali.

VB

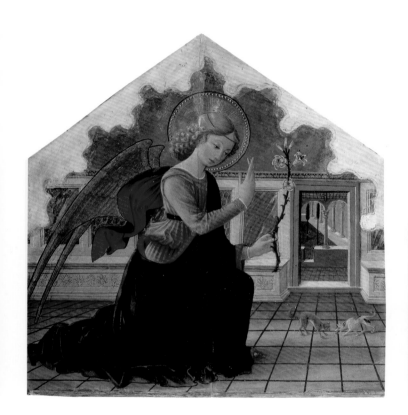

Virgin and Child with Angels

c. 1460
Benozzo Gozzoli
Italian, Florentine, c. 1421–1497
Tempera and gold on wood
104.1 × 81.9 cm (framed)
Detroit Institute of Arts, Bequest of Eleanor
Clay Ford, 77.2

INSCRIPTIONS
AVE MARIA GRATIA PLENA [Hail Mary Full of
Grace] (in Latin on the Virgin's halo); YHS XPS
[Jesus Christ] (in Latinized Greek on the
Christ Child's halo).

PROVENANCE
Baron von Tucher, Vienna, by 1908 and until
1930; Duveen Brothers, New York, by 1932;
sold to Mr. and Mrs. Edsel Ford, Detroit, 1932.

REFERENCES
Kanter and Palladino 2005, cat. 60, pp. 304, 306–9.
Toscano and Capitelli 2002, p. 253.
Garibaldi 1998, p. 78.
Ahl 1996, cat. 11, pl. 276, pp. 210, 214–15
(dates painting to c. 1452–56).
Acidini Luchinat 1994, p. 41 (dates painting to
c. 1460).
Padoa Rizzo 1992, p. 71 (dates painting to c. 1456–61).
Berenson 1909, p. 116.
Wickhoff 1908, pp. 21–30 (dates painting to late
1480s).

BENOZZO DI LESE, whose family came from Sant'Ilario a Colombaia, a village on the outskirts of Florence, was probably born in 1421. He collaborated between 1445 and 1448 with Lorenzo and Vittorio Ghiberti on the Doors of Paradise of the baptistery in Florence, and while he may have worked early on with Fra Angelico on the frescoes in the convent of San Marco (1438–43), he is securely documented in Rome in 1447 assisting Fra Angelico with the frescoes he created for the papal court. Between 1452 and 1456, Gozzoli was active in Umbria, where he influenced local artists like Bartolomeo Caporali, whose life span mirrors that of the better known Florentine master. Gozzoli was in Florence again between 1459 and 1464 and in 1459 was awarded the prestigious commission to paint in the chapel of the Palazzo Medici in Via Larga a fresco cycle representing the procession of the Magi, considered his great masterpiece.

In this beautifully preserved panel, forceful, sculptural modeling of figures is combined with a painstaking attention to the rendering of sumptuous details. A monumental Virgin cradles a pensive Christ Child against a background of red seraphim alternating with blue cherubim, their hair and faces highlighted with gold to match the gold stippling on their wings. The Virgin wears a heavily embroidered golden gown emblazoned at the collar and cuffs with pearls and precious or semiprecious stones, over which is draped an ermine-lined blue cloak. Wearing a yellow tunic with blue highlights and a red cloak edged in gold trim, Christ is poised upon his mother's arm in a seated position. He raises his right hand in a gesture of blessing and holds a goldfinch, a symbol of the Passion, in his left.

While Ahl dates the work to Gozzoli's Umbrian period, most scholars have placed it nearer to the Magi fresco cycle in the chapel of the Palazzo Medici in Florence, executed around 1459–61. Acidini Luchinat suggests that it may have been a presentation piece made for Cosimo de' Medici in hopes of securing the commission for the chapel. She further argues that Gozzoli's placement of the Virgin on a ground of seraphim and cherubim was inspired by Donatello's work in the Old Sacristy of San Lorenzo and the Coronation of the Madonna window in the Duomo, and that such conscious citations and reworkings of prestigious and groundbreaking Florentine monuments would have appealed to the aging Cosimo's civic pride. Intriguing though such suggestions are, stylistic evidence has led more recent scholarship to date the panel after Gozzoli's work in the chapel; Toscano and Capitelli as well as Garibaldi argue that the bright palette, robust figures, relief-like monumentality, and carefully described decorative details more directly anticipate Gozzoli's frescoes in Sant'Agostino in San Gimignano, which were executed around 1464–65.

A much damaged version of the present panel is in the collection of the Fogg Art Museum. The Fogg panel conforms in iconography and format to standard images of the Virgin and Child made for use in private devotional practices, suggesting that the Detroit work was also used in this way. Yet the angels' cropped wings and halos suggest that the Detroit panel was originally larger—substantially so, according to Acidini Lucinat who argues that the Virgin may have once been enclosed in a mandorla following a few rather rare examples in Florence of the

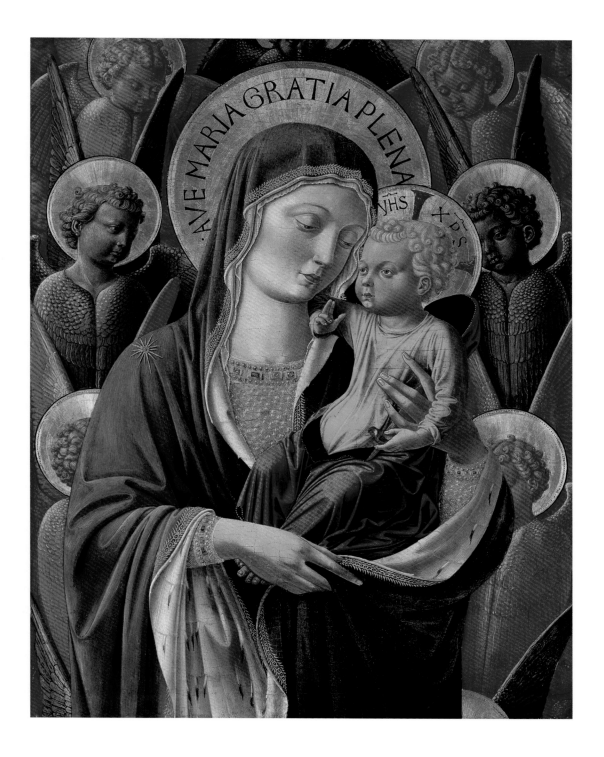

Madonna in Glory. Surrounded by angels and enclosed in a mandorla, the Detroit Madonna may have figured in the central panel of an altarpiece. But perhaps more important are a substantial group of works by Umbrian followers of Pintoric-chio and Perugino in which standing, three-quarter-length Virgins holding the Christ Child are shown surrounded by mandorlas composed of cherubim heads. It remains unclear, however, if these Umbrian works were originally part of larger constructions or made for use in private devotions. Perhaps, though, it may be broadly suggested that the Detroit panel be seen as having an Umbrian prototype that Gozzoli reinterpreted in the light of important Florentine examples. VB

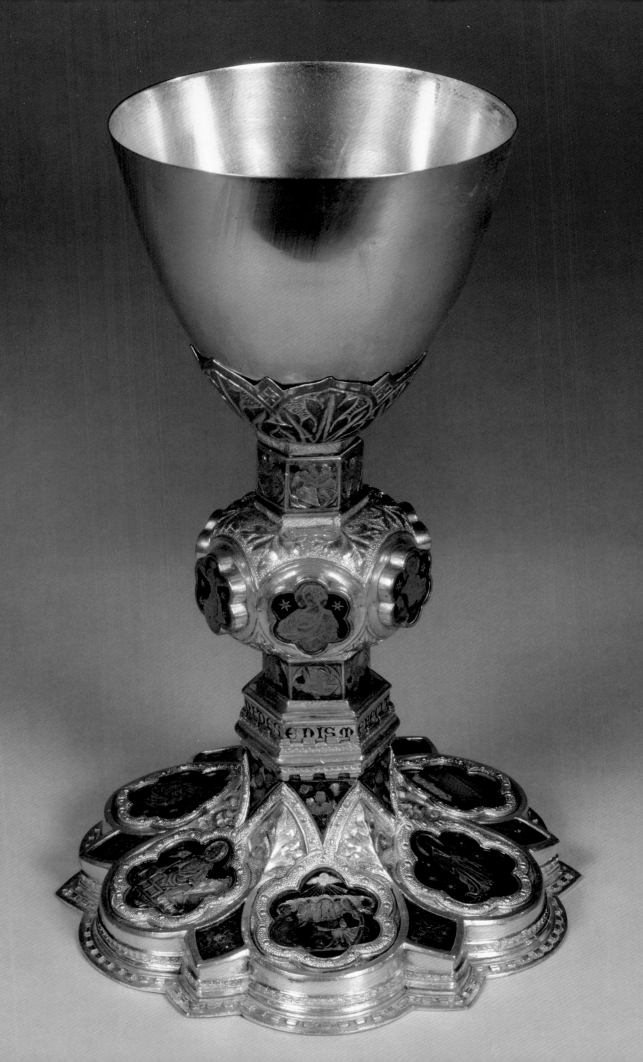

Chalice

c. 1375
Giacomo Guerrino
Italian, Siena
Copper and gilt base and silver cup with
basse-taille enamels
24.4 × 15.6 cm
Loyola University Museum of Art, Martin
D'Arcy, SJ Collection, Gift of Mr. and
Mrs. Donald F. Rowe Sr., 1969-18

INSCRIPTIONS

Medieval: JACHOBUS GUERRINI DE SENIS ME
FECIT [Giacomo Guerrino of Siena made me]
(around the stem). Modern: IN MEMORY OF
EDWARD J. GARVIN (on the base).

PROVENANCE

Unknown until mid-twentieth century;
Bellarmine College, Plattsburg, New York.

REFERENCES

Wixom 1999, pp. 145–46.
Cioni 1998, pp. 625–48.
Rowe 1979, cat. 31.

Photograph: Michael Tropea

DURING HIS SHORT PAPACY (1288–1292), the Franciscan Nicholas IV commissioned a new chalice for the Basilica of San Francesco at Assisi. Still in the church's treasury, this chalice set the standard for the Gothic chalice. Wrought of silver, gilt, and translucent enamels by the Sienese goldsmith Guccio di Mannaia, the creation masterfully fuses form and function. Indeed, it so succinctly embodies the theology and liturgical practices of the medieval Mass that its form was imitated by goldsmiths across Latin Christendom, not least by Guccio's confreres in Siena who for over a century dominated the Italian market in liturgical metalwork.

A Latin inscription around the stem ascribes authorship of the chalice here to Giacomo Guerrino of Siena. Surviving records reveal that he was a member of a multigenerational family of goldsmiths and sometime dean of his professional guild. He is known to have married his wife, Bartolommea, in 1349, and to have died around 1375, the year in which his widow received the final payment for a chalice for the city's cathedral. Giacomo's older brother Tondino was one of the preeminent goldsmiths of his generation, and two of his chalices survive in museum collections: one at the British Museum that is signed; the other attributed to him on stylistic grounds at the Metropolitan Museum of Art.

Like Guccio's archetype, Giacomo's chalice was shaped by the Church's Doctrine of the Real Presence—the belief that, at the moment of consecration during the Mass, the wine transubstantiates into the sacrificial blood of Christ. The constituent elements within the chalice's distinctive form were highly practical, devised to keep safe its divine content. The broad polylobe base ensured stability and, should it be accidentally knocked over, prevented it from rolling while the deep cup and smooth rim reduced the dangers of spillage and drips. The bulbous knop at mid-stem provided the priest with a secure grip as he raised the chalice above his head to signify to the attentive congregants the wine's transubstantiation.

For the medieval laity who would never have drunk from this chalice, its striking silhouette, use of precious materials, gilding, and jewel-like enamels gave physical manifestation to the mystery of the divine presence in the Mass. The theological argument expressed in its decorative program of enamels was intended for the officiating priests. Its theme was Christ's redemptive sacrifice, articulated on the base by the rather unusual image of a sacrificial lamb upon an altar. The presence of a halo and dots of red enamel on the animal's feet identify it as Christ, whom Saint John the Baptist—depicted wading the river Jordan in a flanking panel— called the Lamb of God *(Agnus Dei)*. The lamb's bleeding wounds correspond to those suffered by Christ and triumphantly displayed by him in the image of the Resurrection, set between representations of the Ascension and Pentecost on the other side of the base. On the knop, five busts flank an image of the crucified Christ: the Virgin Mary, Saints John, Peter, and Paul, and a mitred bishop wearing a leather belt who is identifiable as Saint Augustine. The latter's portrayal seemingly indicates that this chalice was originally commissioned for a foundation of Augustinian friars. JC

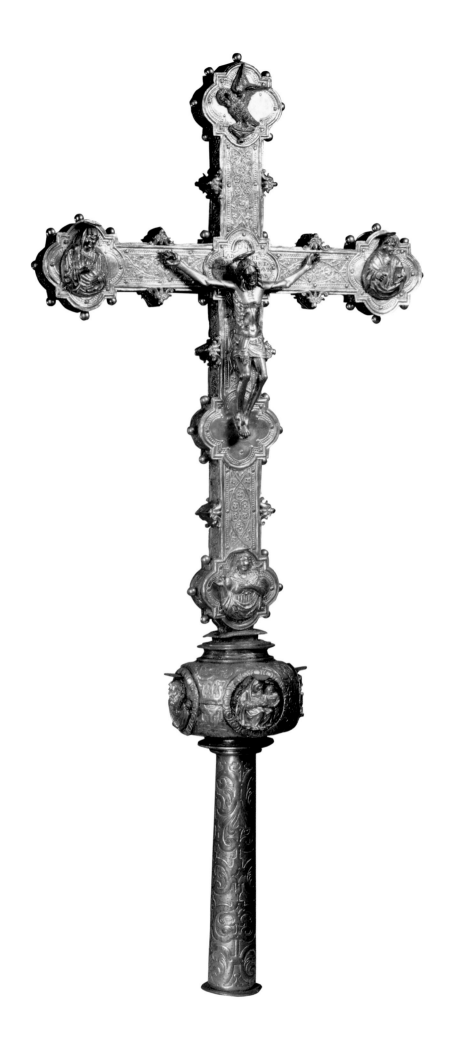

Processional Cross

Fifteenth and sixteenth centuries

Italian

Cross: copper gilt and beaten silver

Corpus: bronze, gilded and cast silver

76.2 × 33.7 cm

Loyola University Museum of Art, Martin
D'Arcy, SJ Collection, Gift of Fr. Martin D'Arcy,
SJ, 1970-05

INSCRIPTION

AD HONORE DEI TEMPORE GENTELESCHE
SAVANI V[I]LLA LONGNE ABATISA M[ONA]ST.
S. M[A]RIE MATALENE ANNO DOMINI 1551
[To the honor of God in the time of
Gentelescha Savani from Villa Longne, abbess
of the monastery of Saint Mary Magdalene
in the year of Our Lord 1551].

PROVENANCE

The monastery of Saint Mary Magdalene,
Italy, by 1551; Fr. Martin C. D'Arcy, SJ.

REFERENCES

Seidel 2000, p. 10.

Rowe 1979, cat. 40.

LITURGICAL PROCESSIONS were a component of several of the masses included in the illuminated missal of the Franciscan friars of San Francesco, Montone (cat. 1). At the commencement of the Palm Sunday Mass (fol. 116v), for example, the friars would have reenacted Christ's entry into Jerusalem with a procession into their church. Then, at the height of summer, they would have participated in the festive pageantry of Montone's celebration of the Feast of Corpus Christi. Clergy, members of religious guilds, and prominent citizens would have processed through the streets accompanied by crosses, religious banners, prized relics, and a consecrated Host borne under a canopy of cloth of gold. It is possible that the friars of San Francesco walked behind a processional cross much like this one, which is typical of the crosses made in northern Italy in the fifteenth century.

The Crucifixion is portrayed on the cross's principal face. Christ's body, cast separately in silver and suspended from oversized nails, hangs at its center. Busts in high relief of the Virgin, Saint John, and Mary Magdalene fill the quatrefoil panels at the terminus of three of the cross's arms. The fourth is adorned with the image of a pelican plucking at its breast. According to medieval bestiaries, the pelican fed its offspring with its own blood; thus, the bird is emblematic of Christ's sacrifice. The terminal figures on the back of the cross portray the four Evangelists, each of whom holds a copy of his Gospel.

Whether in the gloom of a church or in bright summer sunlight, this cross catches the light, its elements designed to play off one another. The studded quatrefoil terminals embellish the simple silhouette of a Latin cross. Its flanks are encased in silvered metal, in contrast to the shimmering gilt copper panels beaten with a low-relief tendril pattern that adorn the principal faces. The smooth reflective fields at the center of the quatrefoils set off the high sculptural relief of the terminal figures attached to them. Christ's fully three-dimensional body, cast in silver, is the cross's most prominent feature. The sharp angles of Christ's outstretched arms and their strained musculature, as well as his prominent rib cage, convey the gruesomeness of his mortal demise while the variety of rich materials expresses his death's triumphant significance to Christians.

An engraved silver plaque set into the quatrefoil behind the silver corpus records that approximately a century after its creation in 1551, the cross was presented to the abbess Gentelescha Savino of a convent dedicated to Saint Mary Magdalene. A mid-sixteenth-century date stylistically would suit the strapwork decoration hammered into the orb at the base of the cross. Four additional saints' busts are included there: Saints Peter and Paul, an unidentified male saint, and a tender image of Saint Anne teaching the Virgin to read. The cross's renovation and subsequent survival is testament to the continuing appeal of liturgical objects from fifteenth-century Italy. JC

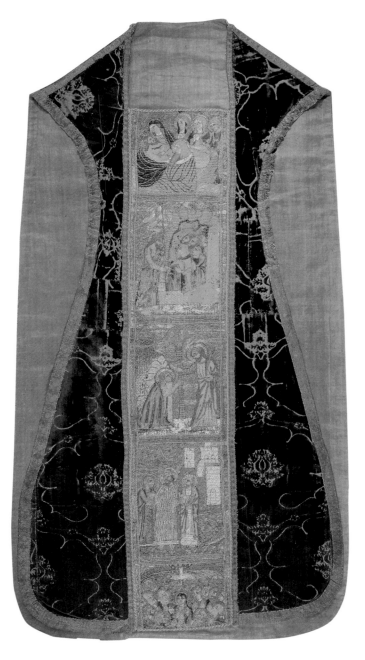

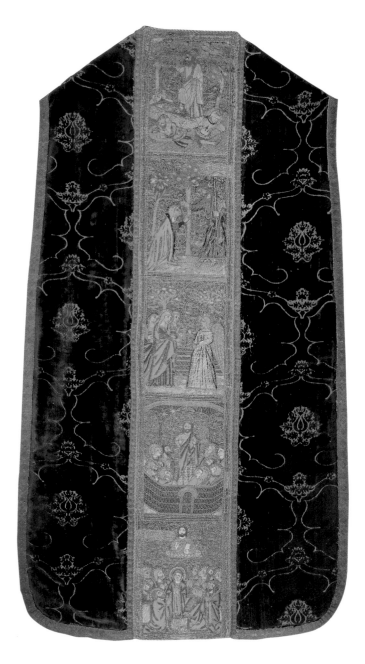

FRONT

BACK

Chasuble

Orphrey bands: early to mid-fourteenth
century; velvet: mid-fifteenth century
Italy, Florence
Silk cut and voided velvet weave with linen
orphreys embroidered with silk, silver, and
gilt thread
L. 130.8 cm
Philadelphia Museum of Art, Gift of
Mrs. Donald Vaughn Lowe, 1972

PROVENANCE
Mrs. Donald Vaughn Lowe, before 1972.

REFERENCES
Thurman and Batty 2003, pp. 20–21, 94.
Gronwaldt 1989, pp. 245–47.
Wardwell 1982, pp. 141–53.
Wardwell 1979, pp. 322–33.
Van Fossen 1968, pp. 141–52.
Cavallo 1960, pp. 505–12, 515.
Hague 1933, pp. 38–49.
Kurth 1931, pp. 455–62.
Salmi 1930–31, pp. 385–406.

1 If they had been designed to decorate the two
straight edges of a cope, the scenes would be
out of sequence because the bands would have
been read from top to bottom and from left to
right.

THIS CHASUBLE features embroidered pillar orphrey bands dating from the early to mid-fourteenth century and a cut and voided velvet woven with a pomegranate motif from the mid-fifteenth century. One band decorates the front of the chasuble and another the back. Each is embroidered with five scenes from the life of Christ presented in chronological order. On the front, starting from the top, the scenes depict the Lamentation of Christ; Christ's Descent into Hell; *Noli me tangere*; Christ on the Road to Emmaus; and Pentecost. The band on the back recounts the Resurrection; *Noli me tangere*; the Three Marys and the Angel at the Tomb; Christ Teaching the Apostles; and the Ascension with Mary and the Apostles.

It is rare to find vestments that have not been repaired or remodeled over their lifetime. This chasuble had been recut into its present shape by the sixteenth century. The orphrey bands were originally both wider and longer; the top and bottom scenes on the front band were also trimmed to accommodate a lower neckline. The bands reveal no horizontal cuts or seams to indicate that the scenes have been rearranged, and it is likely that the bands were originally made for a chasuble.[1] The embroidery is worked through two pieces of plain weave linen—the top layer a finer weave than the bottom layer. Originally, the figures were outlined in stem stitch and filled in using tiny split stitches. However, the bands have been re-embroidered many times: the original untwisted floss silk and metal thread needlework sustained substantial wear during the chasuble's use, and the variety of silk and metal threads (silver, silver gilt, and gold in a range of forms including flat fillet, crimped fillet, and gold and silver fillet plied with silk) and types of stitches (split, stem, laid and couched, satin, and running) attest to the many repairs over the vestment's lifetime. The figures are simplified architectural settings against a background of scrolling vines in relief that were executed in metal threads laid and couched over cotton cord emulating the raised gesso and gold leaf surface of Florentine paintings from this period.

The embroidery seen on this chasuble is considerably less sophisticated in design and execution than that on the only two fourteenth-century Florentine embroideries ascribed to known embroiderers: an elaborate altar frontal in the collection of the Museo degli Argenti, Florence, signed by Jacopo Campi and dated 1336, and a second altar frontal donated to the Collegiate Church of Manresa, Spain, signed by Geri Lapi and dated to around 1346–48. Instead, the embroidery on this chasuble represents the type of work produced in smaller convent workrooms, in which cartoons were used and reused to produce multiple versions of embroideries to satisfy the needs of an expanding church. This practice accounts for the similarities in the drawing and composition of a number of early- to mid-fourteenth-century examples now in museum collections in this country and in Europe.

DB

Saint Francis before the Pope (Confirmation of the Franciscan Rule by Pope Honorius III)

1390–1400
Spinello Aretino
Italian, active Arezzo, 1346–1410
Tempera on wood
88.7 × 62.9 cm
The Art Institute of Chicago, Mr. and
Mrs. Martin A. Ryerson Collection,
1933.1031

PROVENANCE
Private collection, possibly Conte Donino
Pierleoni, Città di Castello, Umbria; sold by a
dealer in Città di Castello to Horace Morison,
Boston, by 1915; sold by Morison to Martin A.
Ryerson (d. 1932), Chicago, 1916; intermit-
tently on loan to the Art Institute of Chicago
from 1916.

REFERENCES
Israëls 2009, 1: pp. 231–41.
Cooper 2005, pp. 118–20.
Weppelmann 2003, pp. 75, 168–72.
Cooper 2001a, pp. 21, 25.
Cooper 2001b, pp. 23–24, 27–29.
Lloyd 1993, pp. 222–25.
Boskovits 1975, pp. 146–47, 249, nos. 244, 434.
Van Os 1974, pp. 125, 127.
Perkins 1918, pp. 5–6.

SAINT FRANCIS, accompanied by eleven friars in imitation of Christ and his apostles, kneels before and presents a document to the pope, who raises his hand in blessing. Three cardinals sit beside the pope, the arm of whose chair is deco-rated with the head of a lion while the leg terminates in a clawed foot, a reference to the Throne of Solomon, or the Throne of Wisdom, which implies the origin of papal authority (1 Kings 10:18–20).

Francis had audiences with two different popes concerning the confirmation of two separate versions of his Rule, the body of regulations governing the Fran-ciscan order. In 1209 Pope Innocent III approved the first rule, a brief summary of the Gospel precepts Francis selected to guide his eleven initial companions. Although the pope rebuked Francis's first overtures, he was moved to sanction the order and its activities by a dream in which he saw Francis upholding the tottering Lateran basilica. Francis later wrote a more thorough rule based on the three core vows of obedience, chastity, and, above all, poverty. This rule, the *Regula Bullata,* was approved in 1223 by Pope Honorius III.

Van Os identifies the scene with Innocent's confirmation of Francis's first rule while Boskovits classifies it as Honorius's confirmation of Francis's second rule. Lloyd bolsters Van Os's hypothesis by labeling the cardinal dressed in black robes as the Dominican Giovanni di San Paolo, the cardinal-bishop of Sabina, who sup-ported the Franciscan cause at the papal court. However, Weppelmann (in Israëls) lends support to Boskovits's identification, observing that the robes were not black originally but have darkened over time owing to conservation issues, thus perhaps negating the figure's Dominican designation. Weppelmann also notes that cardi-nals countersigned papal documents, so their prominence in the panel supports the idea that it depicts the confirmation of the later, more formal rule. But when Francis drew up the first rule, he had only eleven companions, who also accom-panied him to Rome in 1209; here, note that Spinello included precisely eleven friars in the scene, which may further support the idea that the panel depicts the earlier event.

This small panel once belonged to a larger cycle of scenes from the life of Saint Francis, the most famous of which were the frescoes in the Upper Church at San Francesco in Assisi. After its completion around 1300, the Assisi cycle quickly became regarded as Francis's definitive pictorial vita. A scene of Innocent's approval of the first rule is included in the Assisi cycle while Honorius's approval of the second one is not. Spinello's panel follows the Assisi scene closely: in both, the action proceeds from left to right, the walls are hung with textiles decorated with geometric patterning, and the scene is viewed through an opening in the architectural framework. These similarities add further weight to the argument that the panel depicts Innocent's approval of the first rule.

Whatever the case, the panel likely belonged to a now dismembered altarpiece, although thinning and cradling have obliterated any evidence of how it might have been incorporated into such a complex. Van Os argues that it is the only remaining

1 See catalogue 15 for more information on the
altarpiece.

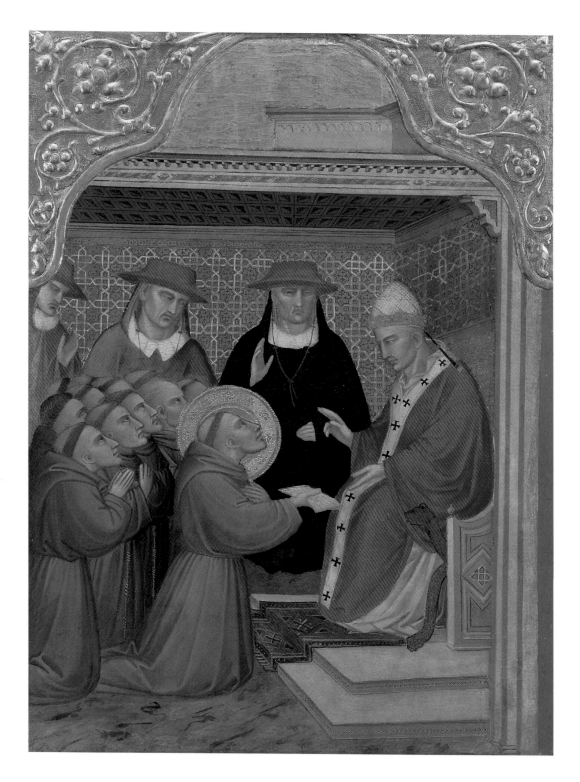

fragment of an altarpiece once in the church of San Francesco in the Umbrian town of Borgo San Sepolcro (present-day Sansepolcro) that was later replaced by Sassetta's great altarpiece of about 1437–44.[1] Cooper and Weppelmann suggest instead that the work belonged to an altarpiece made for the church of San Francesco in Città di Castello, although they disagree as to which altarpiece. The attribution of the panel has not been disputed since it was first published by Perkins. VB

Saint Francis before Christ on the Cross

c. 1437–44
Sassetta
Italian, Siena, active by 1427–died 1450
Tempera and gold on wood
80.8 × 40.2 cm (framed)
The Cleveland Museum of Art, Mr. and
Mrs. William H. Marlatt Fund, 1962.36

INSCRIPTION
I.N.R.I. [abbreviation of *Iesus Nazarenus,
Rex Iudaeorum*, "Jesus of Nazareth, King of
the Jews" (John 29:19)] (on the tablet of
the cross).

PROVENANCE
High altar of San Francesco, Borgo San
Sepolcro, by 1444; following the disassembly
of the altarpiece, side altar of San Francesco
dedicated to the Virgin of the Snow, Borgo
San Sepolcro, by 1583; Johann Georg von
Sachsen, Prince of Saxony (1869–1938); with
Gerhard Freiherr von Preuschen, Stuttgart
and Lugano, by 1950; Paul Drey Gallery,
New York, by 1962.

REFERENCES
Israëls 2009, 2: pp. 534–37.
Christiansen and Israëls 2008, pp. 179–80.
Gardner von Teuffel 2005, p. 447.
Boskovits 2003, p. 621.
Gordon 2001, p. 352.
CMA 1974, pp. 121–24.

BETWEEN 1437 AND 1444, Siena's most important painter, Stefano di Giovanni, known since the eighteenth century as Sassetta, created a great altarpiece for the Franciscan church of San Francesco in the small Tuscan town of Borgo San Sepolcro (present-day Sansepolcro). The altarpiece was decorated on the front and back with sixty paintings. In a crypt below the altar lay the remains of the Blessed Ranieri, whose miracles Sassetta recounted in the altarpiece, alongside other episodes. The altarpiece was removed from the altar for liturgical reasons and dismantled between 1578 and 1583. Today only twenty-seven paintings survive, distributed among twelve museums. The present panel appeared on the front of the altarpiece in the center of its upper tier, concluding the Passion narrative that unfolded on the front of the predella (the long horizontal structure at the base of an altarpiece often decorated with narrative scenes). The panel was cut down at some point during its history; Christ's hands are awkwardly chopped off mid-palm, and documentary evidence states that the panel showed the Virgin and Saint John mourning at either side of the cross, suggesting that the panel was once wider.

The panel shows Christ hanging on the cross on the barren hill of Golgotha. Blood flows from the wound in his side and from the nails piercing his hands and feet; it runs down the bottom part of the cross and pools beneath it. At Christ's feet, in the place typically occupied by Mary Magdalene, Saint Francis of Assisi kneels, clasping the cross in his right hand and holding his left to his breast in a gesture of grief and devotion. In his hands are his stigmata, the wounds he received in imitation of Christ's. Above, a pelican's nest surmounts the cross. The mother bird pecks at her breast and feeds her young with her blood, a symbol of Christ's sacrifice for mankind; according to medieval legend, the bird killed her young and restored them to life three days later by sprinkling them with her own blood.

In addition to leading an exemplary life of poverty, humility, and penance, Francis was fiercely devoted to Christ's Passion and the Cross. Portrayals of Francis at the foot of the cross may be found in painted crosses made in Umbria throughout the thirteenth century—perhaps from as early as 1236—and the motif appears in the most prominent depiction of the saint's life executed at the turn of the thirteenth century in the Upper Church at San Francesco in Assisi. The image may be associated not only with the growing cult of the cross during this period of pilgrimage and crusade but also with the notion of *Imitatio Christi* (the imitation of Christ) advocated by Francis and his followers. Moreover, it alludes to both his stigmatization and to his conversion, when a painted crucifix spoke to him. VB

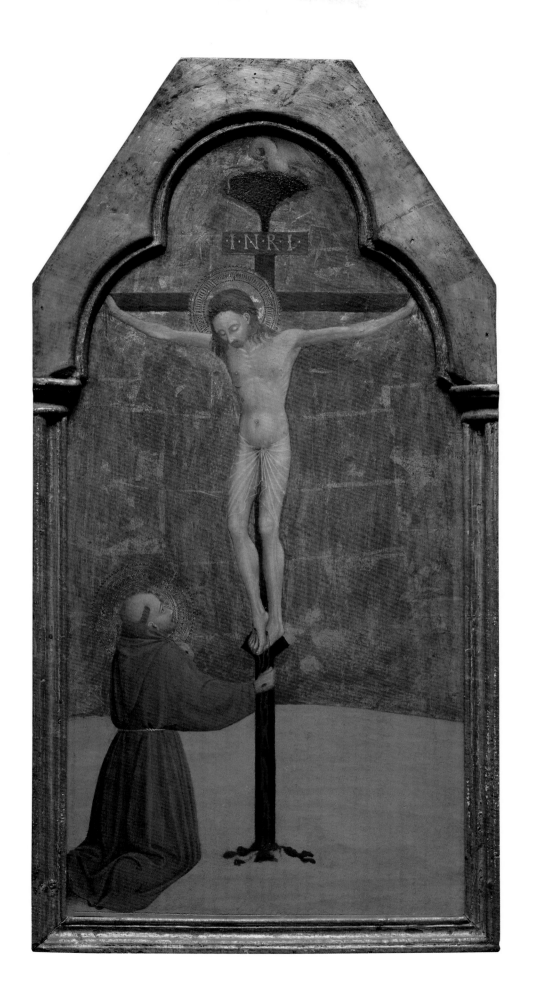

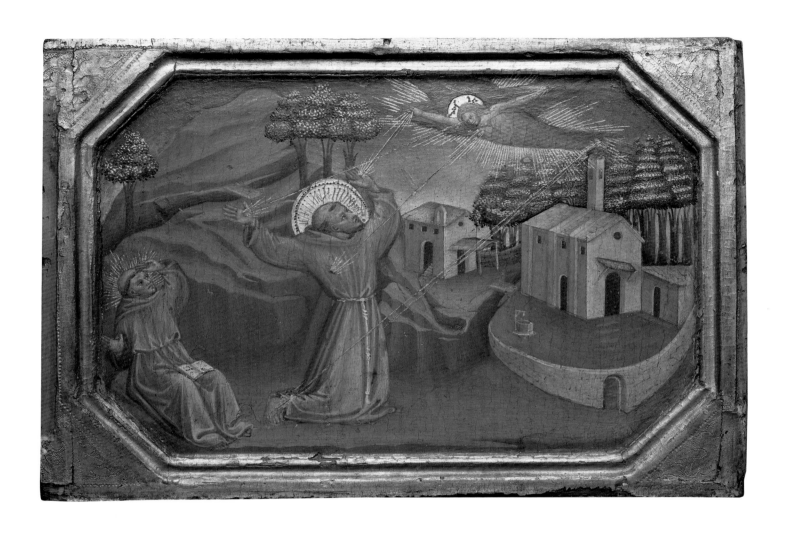

The Stigmatization of Saint Francis

c. 1430
Bicci di Lorenzo
Italian, Florence, 1373–1452
Tempera and gold on wood
21.7 × 32 cm (framed)
The Cleveland Museum of Art, Holden
Collection, 1916.787

PROVENANCE
James Jackson Jarves (1818–1888); sold to
Mrs. Liberty E. Holden, Cleveland, 1884.

REFERENCES
CMA 1991, p. 46.
Volbach 1987, cat. 15.
CMA 1974, pp. 48–49.
Fredericksen and Zeri 1972, pp. 147, 399, 573.
Rubinstein 1917, no. 18.
Burroughs 1912, p. 176.
Berenson 1907, p. 2.
Jarves 1883, cat. 5 (as Fra Angelico).

ACCORDING TO Tomaso da Celano and Bonaventura da Bagnoregio, thirteenth-century sources for the life of Francis of Assisi, the saint's stigmatization took place in 1224 during the forty days he spent fasting and in prayer on Mount Verna, near Arezzo. During the retreat, Francis thrice asked his companion, Brother Leo, to open the Gospels to a random page. Each time the book fell open to the passage describing Christ's Agony in the Garden, which was interpreted by Francis as a call to emulate Christ's last days. One morning, deep in prayer, Francis had a vision of a seraph embracing the crucified Christ, together descending from heaven; the apparition miraculously impressed onto Francis's body the wounds in Christ's hands, feet, and torso. These wounds signified Francis's transformation into another Christ through his intense spiritual fervor.

In any depiction of the saint's life, the episode of the stigmatization was a sine qua non. Here, Francis prays in a mountainous landscape. At the right a small chapel is enclosed within a wall, and a bridge across a chasm in the rocks leads to another building. His hands raised, Francis looks up at the apparition of Christ, arms outstretched as if on the cross and surrounded by the seraph's six red wings and a mandorla of light. Thin golden lines emanate from Christ's wounds and strike Francis's body in bursts of light, impressing Christ's wounds upon the saint. At the left Brother Leo witnesses the vision; although Francis was said to be alone at the event, Leo is usually included in scenes depicting it. His outstretched hands mirror Francis's while the book on his lap alludes to the Gospel falling open to the Agony. A second small bridge behind Francis's right hand also appears in many other stigmatization scenes; perhaps this motif is a metaphor for this moment's miraculous union of the earthly and divine.

This panel by the Florentine artist Bicci di Lorenzo comes from the predella of an unidentified altarpiece; thus it was once part of the long horizontal structure at the base of an altarpiece usually painted with narrative scenes related to the subject of the larger images above. It is similar in size and shape to two panels by Bicci in the Vatican Museums: *Saint Anthony of Padua Feeding the Poor* and *Saint Francis at the Deathbed of the Miser of Celano*. These three panels may have been part of the predella of an altarpiece made for a Franciscan church. Many altarpieces were dismembered during the dissolution of religious institutions in the eighteenth and nineteenth centuries, and their fragments were sold to collectors who became increasingly interested in early Italian paintings throughout this period; small, precious, and charming in their profusion of narrative detail—a contrast to the stern, iconic saints of altarpieces' upper regions—panels from predelle were especially favored by collectors. This panel was purchased in Italy by James Jackson Jarves, who first brought large numbers of "primitive" paintings to America before the Civil War. Jarves sold 119 paintings to Yale College in 1867 and a second collection in 1884 to Delia Holden of Cleveland; she presented the works to the Cleveland Museum of Art in 1916. Jarves optimistically ascribed the painting to Fra Angelico, but by the early twentieth century, this attribution was changed to "fifteenth-century Florentine." Fredericksen and Zeri gave the work to Bicci di Lorenzo.

VB

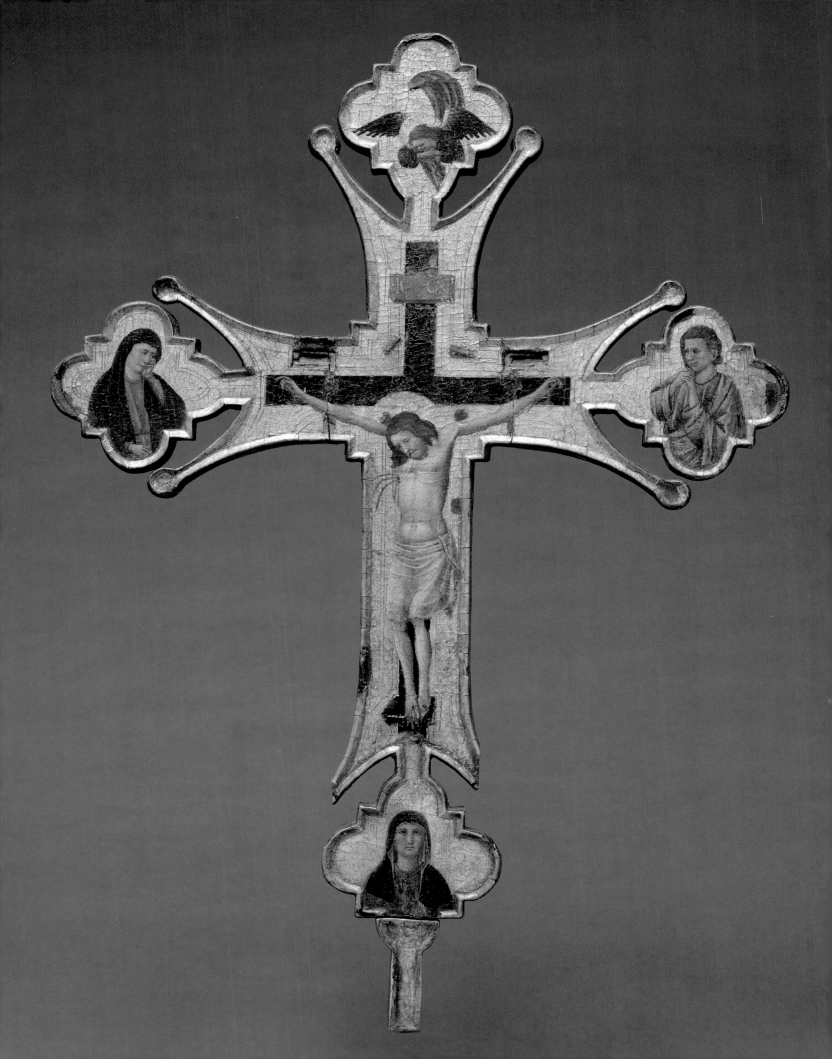

Double-sided Processional Cross

First decade of the 1300s
Expressionist Master of Santa Chiara
Italian, Umbria, c. 1290–c. 1330
Tempera and gold on wood
61.3 × 44.2 cm
The Cleveland Museum of Art, Purchase from
the J. H. Wade Fund, 1943.280

PROVENANCE
Charles A. Loeser (1864–1928), Florence;
Achille de Clemente, Florence; sale, American
Art Association, Anderson Galleries, Inc.,
New York, January 10–17, 1931, cat. 491;
William Randolph Hearst, New York; sale,
Hammer Galleries, New York, March 25, 1941,
lot 552–2; Adolphe Loewi, Los Angeles.

REFERENCES
Cook 1999, pp. 85–86.
Morello and Kanter 1999, pp. 86–87.
Todini 1989, 1: p. 138; 2: p. 80.
Cole 1987, pp. 196–97.
CMA 1974, pp. 138–39.
Boskovits 1968, pp. 126–27.
Offner 1956, pp. 166–67, no. 1.
Francis 1945, pp. 3–5.

CROSSES LIKE THIS ONE are carried at the head of church processions, usually mounted on long staffs or handles so that they can be held aloft. They are painted on both sides so that they may be viewed most effectively in the round. The pope is always entitled to have the cross borne before him, while legates and bishops enjoy this honor in their own territories only. Nearly all parishes possess such crosses; with parishioners marshaled behind them, they act as a sort of standard during festive processions. The same is true of religious orders as well. While the monastic orders almost invariably owned crosses made of silver or other metals, the mendicant orders like the Franciscans, to whom this cross belonged, preferred ones fashioned from more humble wood. Christ can appear on both sides, as with the present cross, or only on one. In the latter case, Christ faces the direction the procession moves, but when the cross precedes one or more prelates, Christ is turned toward them.

Here, the crucified Christ appears on both sides of the cross, as do the half-length figures of the Virgin and John the Evangelist, who mourn the Crucifixion in the cross's left and right quadrilobe terminals, respectively. A half-length figure of Saint Francis appears in the bottom terminal on the front while a half-length figure of Saint Clare is depicted in the same space on the back. Angels contorted with grief are situated in the upper terminal on both sides; on the front an angel shown in profile flies up and away from Christ while the angel on the back, rendered in dramatic and steep foreshortening, looks downward. The Cleveland cross and another similar piece in the Yale University Art Gallery are the first of their kind to show saints—other than the Virgin and the Evangelist—in their terminals.

In 1968 Boskovits assigned the work to the Expressionist Master of Santa Chiara, an artistic personality identified only in 1963 by Roberto Longhi. The Master takes his name from his extremely theatrical frescoes of the life of the Virgin and the burial of Saint Clare in the church of Santa Chiara in Assisi. Assisi was the birthplace of Saint Francis and his religious order, the Franciscans. It was also the place where Saint Clare, Francis's female counterpart, established a female branch of the Franciscan order called the Poor Clares. The presence of both saints on this cross suggests that it was made for one of Assisi's Franciscan or Clarissan institutions.

VB

Left column

...pmogentū morbem
terre: die et adorent
eum: cz angli di. Et
ad angelos quidē die.
Qui facit angelos suos
spiritus: et ministros suos i
flammā ignis. Ad fi
lium ait. Thronus
tuus ds i seclm seculi:
uirga equitatis uirga
regni tui. Dilexisti iu
stitiam et odisti iniqui
tatem: ppterea unxit
te ds deus tuus oleo
exultationis. pre par
ticipibus tuis. Et tu i
principio dnie terram
fundasti: et opa ma
nuum tuarum st celi. Ipsi
peribut: tu aut pmane
bis: et omnes ut i
uestimentu ueteras
cent. Et uelud amictu

Right column

...deficient. Viderunt
omnis fines terre salutare
dei nri. iubilate deo omnis
terra. Notum fecit dns sa
lutare suum. ante cospectu
gentiu reuelauit iustitia
suam. Allā. V. Dies sācifica
tus illuxit nobis uenite gē
tes et adorate dnm. quia
hodie descendit lux mag
na sup terram. Initium
sancti euangelij. Secdm
Ioh. In principio Ioh.
erat uerbum. et uerbum erat
apud deum: et
deus est uerbum.
Hoc erat i prin
cipio: apud deu.
Omnia per ipsum
facta sunt: et sine ipso
factum est nichil. Quod
factum ē: in ipso uita erat

Appendices

APPENDIX A

Caporali Missal: Illustrated List of Folios with Illumination

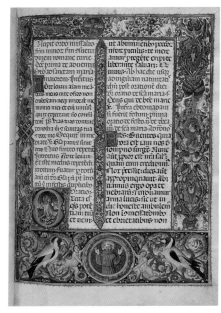

FOLIO 9 Introit for the first Sunday in Advent (full borders with *alter Christus* roundel)

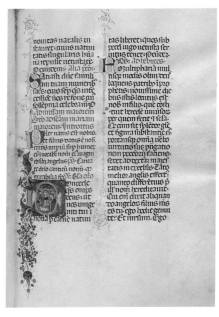

FOLIO 22 Nativity

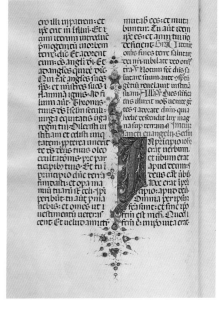

FOLIO 22V Foliage with fish

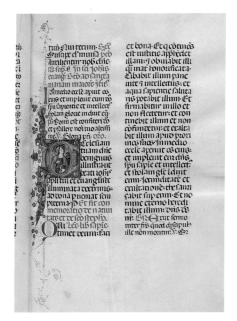

FOLIO 25 Saint John the Evangelist

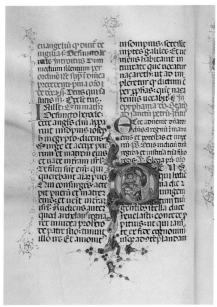

FOLIO 30V Adoration of the Magi

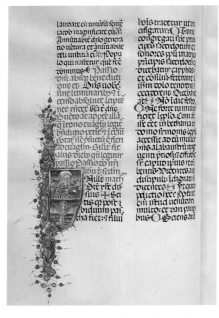

FOLIO 116V Saint Matthew with angel

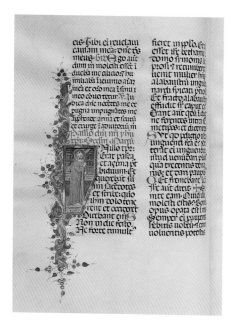

FOLIO 124V Christ holding the cross

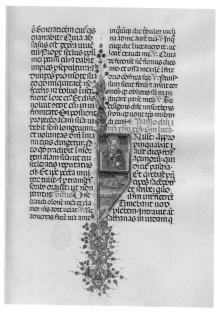

FOLIO 131 Saint Luke with bull

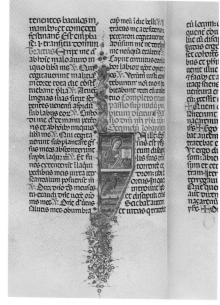

FOLIO 141V Saint John with eagle

FOLIO 183 Foliage decoration

FOLIO 183V Cross with foliage

FOLIO 184 Foliage

FOLIO 184V Cross with foliage

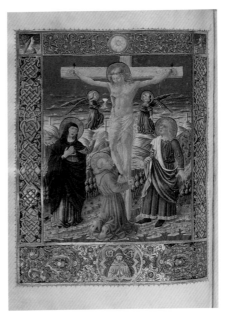

FOLIO 185V Crucifixion with borders
(full page)

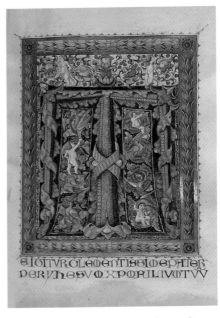

FOLIO 186 Decorated initial *T[e igitur]*
(full page)

FOLIO 192V Resurrection of Christ

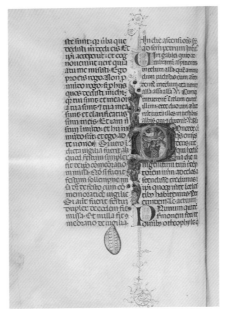

FOLIO 208V Ascension of Christ

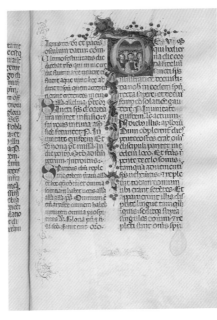

FOLIO 214 Pentecost

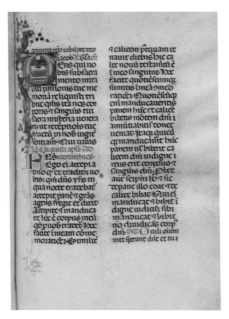

FOLIO 225 Chalice with Host

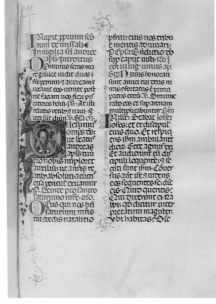

FOLIO 259 Saint Andrew

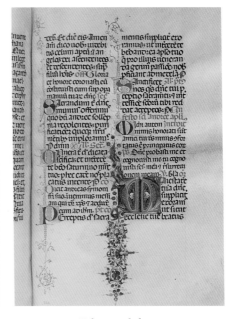

FOLIO 260 Foliage with fruit

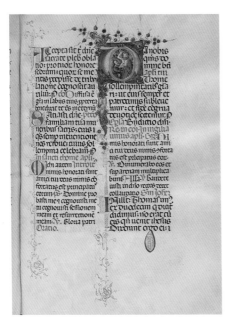

FOLIO 262 Saint Thomas

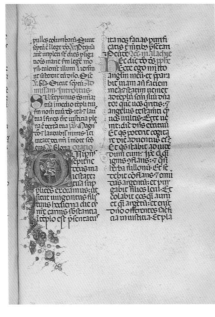

FOLIO 270 Presentation of Christ to Simeon

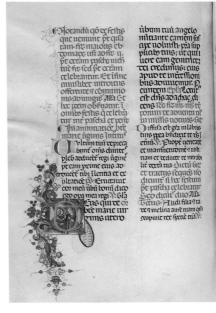

FOLIO 275V Annunciation

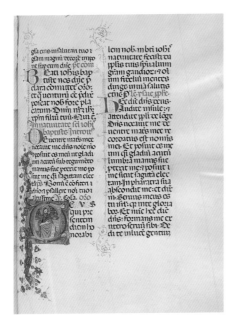

FOLIO 287 Saint John the Baptist

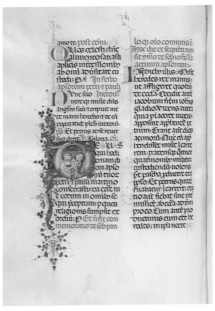

FOLIO 290V Saints Peter and Paul

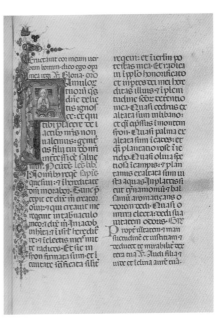

FOLIO 306 Assumption of the Virgin

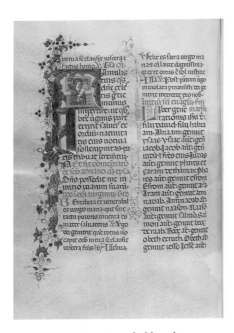

FOLIO 311V Saint Anne holding the
newborn Virgin

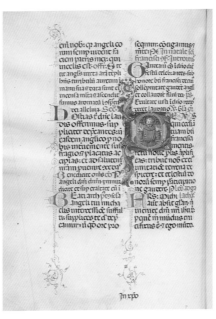

FOLIO 318V Saint Francis *(alter Christus)*

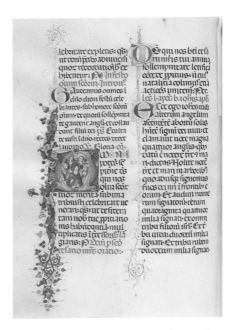

FOLIO 322V The Virgin among the apostles
and saints

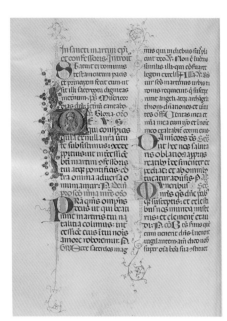

FOLIO 324V Saint Martin

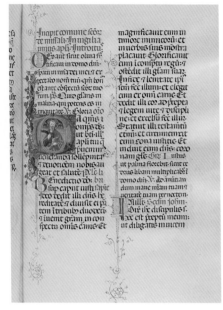

FOLIO 327 Saint Bartholomew

FOLIO 387V Death represented as a
skeleton with a sickle

FOLIO 400 Colophon

filio simul adoratur et cui glo
rificatur. qui locutus é per p̄
phetas. Et unam scām ca
tholicam et aplicā ecclesiam
Confiteor unum baptisma
in remissioez peccatorum. Et
expecto resurrectioez mortu
orum. Et uitam uenturi
seculi. ✠ ⁊ · M · ẼN

mariam glām. Qui sedes
ad dexteram p̄ris miserere
nob. Qui tu solus sanct.
Mariam sānficans. Tu so
lus dr̄is. Mariā gubnans
Tu solus altissimus. Ma
riam coronans yhū xp̄e.
Cum sc̄o sp̄u i gloria dei pa
tris. Amē.

G̃Loria in excelsis deo.
Et in terra pax hoib; bone
uoluptatis. Laudamus te.
Benedicimus te. Adoramus
te. Glorificamus te. Gratias
agimus t p̄ magnā glām
tuam. Dr̄ie deus rex celesti
ds pat ōmp̄ns. Dr̄ie fili u
nigenite yhū xp̄e. Sp̄s ⁊ al
me orphanorum parach
te. Dr̄ie dū agnus dei filiu'
patris. Primogenit' maē
uirgis matris. Qui toll'
peccta mundi miserere nob
Qui toll' peccta mundi sus
cipe deprecatioez nr̄am. ⁊d

C̃onsūmtū ⁊ cōpletū feliciter p
me henricū haring alma
nū scriptorē pn̄tis opis. Sub
ān̄s dō. M̄. cccc̄. lxviii.
die qr̄ta octobr̄s. Quo tp̄e
fuit guardian' cōuēt' mo
tom. Venā' pr. fr. Stephs
camby. Et pr̄iurēs dei cō
uēt' fuert bōn. uiri. ... fra
tr cs suis. S̃. Johis dō aurelk.
Et pc̄r paul' dō miraluk. Q̃
Jnape ⁊ finire feterit sol
lēpn̄t. pn̄is op. ⁊d laudē
⁊ honorē ōip̄tēntis dei glō
sec̄q̄. v. M̄. b̄tiq̄ fiā̄m' ⁊ oiū
scōr q̄ sit bn̄dcā iss. Amē.

Caporali Missal: Transcription and Translation of the Colophon on Folio 400

Finitu(m) (et) co(m)plet(um) feliciter p(er) me henricu(m) haring almanu(m) sc(ri)ptore(m) p(re)(se)ntis op(er)is. S(u)b a(n)nis do(min)i M°·cccc°·lxviiii°· die q(ua)rta Octob(ri)s· Quo t(em)p(or)e fuit guardian(us) co(n)ve(n)t(us) mo(n)toni· Ven(er)a(bilis) p(rio)r· F(rate)r Steph(anu)s cambij· Et p(ro)cur(ator)es d(i)c(t)i c(on)ue(n)tus fuer(un)t hon(orabi)ⁱⁱ uiri s. fra(n)ciscus S. Ioh(anni)s de Ciurell(is): Et Petr(us) Paul(us) d(e) miracul(is)· Qui Incip(er)e et finire feceru(n)t solle(m)p(ni)t(er)· p(re)(se)ns op(us) Ad laude(m) (et) honore(m) O(mn)ipote(n)tis Dei gl(ori)oseq(ue) Vi(rginis) M(ari)e b(ea)tiq(ue) Fran(cis)ᶜⁱ (et) o(mn)ium s(an)c(t)or(um) qui si(n)t b(e)n(e)d(i)c(t)i i(n) s(ecula) s(eculorum) Am(en)

Finitum et completum feliciter per me Henricum Haring Almanum scriptorem presentis operis sub annis[1] domini millesimo quadringentesimo sexagesimo nono die quarta Octobris· Quo tempore fuit guardianus conuentus Montoni[2]· Venerabilis prior frater Stephanus Cambii et procuratores dicti conuentus fuerunt honorabili[3] uiri Ser[4] Franciscus Ser Iohannis de Ciurellis: et Petrus Paulus de Miraculis· Qui incipere et finire fecerunt sollempniter· presens opus ad laudem et honorem Omnipotentis Dei glorioseque Virginis Marie beatique Francisci et omnium sanctorum qui sint benedicti in secula seculorum Amen

Finished and completed with good fortune by me, Heinrich Haring, German, the copyist of the present work in the years [sic] of Our Lord 1469, on the fourth day of October [Feast of Saint Francis]; at which time the guardian of the convent at Montone was the venerable prior Fra Stefano di [= son of] Cambio and the procurators of the said convent were the honorable men Ser Francesco di Ser Giovanni de'Cirelli and Pierpaolo de'Miraculi, who solemnly [= in due form] caused the present work to be begun and ended to the praise and honor of Almighty God and the glorious Virgin Mary and the blessed Francis and all the saints; may they be blessed forever and ever. Amen.

Profound gratitude to Professor Leofranc Holford-Strevens, Oxford, UK, for providing the above transcription and translation of the colophon.

1 One would have expected the singular *anno.*

2 Altered from *montom* by insertion of a dot before the last descender, but one would have expected *Montonensis.*

3 Fusion of Latin *honorabiles* with Italian *onorevoli.*

4 Even in Latin, it would have been *Ser . . . Ser* not *Senior . . . Senioris.*

Genealogical Table of Bartolomeo Caporali

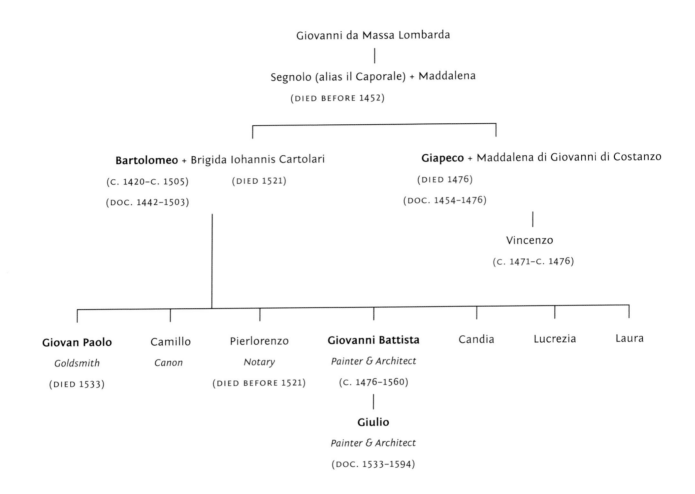

Giovanni da Massa Lombarda

Segnolo (alias il Caporale) + Maddalena

(DIED BEFORE 1452)

Bartolomeo + Brigida Iohannis Cartolari

(C. 1420–C. 1505) (DIED 1521)

(DOC. 1442–1503)

Giapeco + Maddalena di Giovanni di Costanzo

(DIED 1476)

(DOC. 1454–1476)

Vincenzo

(C. 1471–C. 1476)

Giovan Paolo

Goldsmith

(DIED 1533)

Camillo

Canon

Pierlorenzo

Notary

(DIED BEFORE 1521)

Giovanni Battista

Painter & Architect

(C. 1476–1560)

Candia

Lucrezia

Laura

Giulio

Painter & Architect

(DOC. 1533–1594)

Reference List

Acidini Luchinat 1994
Acidini Luchinat, Cristina. *Benozzo Gozzoli*. Antella: Scala, 1994.

Aeschlimann 1940
Aeschlimann, Erardo. *Dictionnaire des miniaturistes du Moyen-âge et de la Renaissance dans les différentes contrées de l'Europe*. Milan: U. Hoepli, 1940.

Ahl 1996
Ahl, Diane Cole. *Benozzo Gozzoli*. New Haven, CT: Yale University Press, 1996.

Alexander 2010
Alexander, J. J. G. "The City Gates of Perugia and Umbrian Manuscript Illumination of the Fifteenth Century." In *The Medieval Book: Glosses from Friends & Colleagues of Christopher de Hamel*, edited by Richard A. Linenthal, James H. Marrow, and William Noel. Houten, Netherlands: Hes & De Graff, 2010.

Alexander 1994
——, ed. *The Painted Page: Italian Renaissance Book Illumination 1450–1550*. Exh. cat. Munich and New York: Prestel, 1994.

Berenson 1909
Berenson, Bernard. *Florentine Painters of the Renaissance*. 3rd ed. London: G. P. Putnam's Sons, 1909.

Berenson 1907
Berenson, Mary Logan. "Dipinti Italiani in Cleveland." *Rassagna d'arte* 7 (1907): p. 2.

Berenson 1897
Berenson, Bernard. *The Italian Painters of the Renaissance*. New York, 1897.

Boskovits 2003
Boskovits, Miklòs. *Italian Paintings of the Fifteenth Century*. Washington, DC: National Gallery of Art, 2003.

Boskovits 1975
——. *Pittura fiorentina alla vigilia del Rinascimento, 1370–1400*. Florence: Edam, 1975.

Boskovits 1968
——. "Un pittore 'espressionista' del trecento umbro." In *Storia e Arte in Umbria nell'età Comunale*. Perugia: Facolta di lettere e filosofia dell'Universita degli studi di Perugia, 1968.

Burroughs 1912
Burroughs, Bryson. "Early Italian Paintings Lent by Mrs. Liberty Emery Holden." *Bulletin of the Metropolitan Museum of Art* 7, no. 2 (1912): p. 176.

Bury 1990
Bury, Michael. "Bartolomeo Caporali: A New Document and Its Implications." *Burlington Magazine* 132, no. 1048 (July 1990): pp. 469–75.

Caleca 1969
Caleca, Antonino. *Miniatura in Umbria. I. La Biblioteca Capitolare di Perugia*. Florence: Marchi & Bertolli, 1969.

Cavallo 1960
Cavallo, Adolph S. "A Newly Discovered Trecento Orphrey from Florence." *Burlington Magazine* 102, no. 693 (December 1960): p. 515.

Christiansen and Israëls 2008
Christiansen, Keith, and Machtelt Israëls. "Sassetta, St. Augustine, 1444." In *From Gothic Tradition to the Renaissance: Italian Painting from the 14th and 15th Centuries*. Exh. cat. Paris: G. Sarti, 2008.

Cioni 1998
Cioni, Elisabetta. *Scultura e Smalto nell'Oreficeria Senese dei secoli XIII e XIV*. Florence: Studio per edizioni Scelte, 1998.

CMA 1991
Handbook of the Cleveland Museum of Art. Cleveland: Cleveland Museum of Art, 1991.

CMA 1974
The Cleveland Museum of Art: European Paintings before 1500. Cleveland: Cleveland Museum of Art, 1974.

Cole 1987
Cole, Bruce. *Italian Art 1250–1550: The Relation of Renaissance Art to Life and Society*. New York: Harper & Row, 1987.

Cook 1999
Cook, William R. *Images of St. Francis of Assisi in Painting, Stone, and Glass from the Earliest Images to ca. 1320 in Italy*. Italian Medieval and Renaissance Studies 7. Florence: L. S. Olschki; Perth: Department of Italian of the University of W. Australia, 1999.

Cooper 2005
Cooper, Donal. "Le tombe del Beato Ranieri a Sansepolcro e del Beato Giacomo a Città di Castello: Arte e santità francescana nella terra altotiberina prima di Sassetta." In *Il Beato Ranieri nella storia del francescanesimo e della terra altotiberina*. Sansepolcro: Comitato per le celebrazioni del VII centenario della morte del beato Ranieri dal Borgo, 2005.

Cooper 2001a
——. "Franciscan Choir Enclosures and the Function of Double-sided Altarpieces in Pre-Tridentine Umbria." *Journal of the Warburg and Courtauld Institutes* 64 (2001): pp. 21, 25.

Cooper 2001b
——. "The Lost Model for Sassetta's Sansepolcro Polyptych." *Apollo* 154 (April 2001): pp. 23–24, 27–29.

Fliegel 2007a
Fliegel, Stephen N. *Sacred Gifts and Worldly Treasures: Medieval Masterworks from the Cleveland Museum of Art*, edited by Holger Klein. Exh. cat. Cleveland: Cleveland Museum of Art, 2007.

Fliegel 2007b
——. "The Caporali Missal." *Cleveland Museum of Art Members Magazine* 47, no. 9 (November 2007): pp. 5–7.

Francis 1945
Francis, Henry S. "A Fifteenth-Century Florentine Processional Cross." *Bulletin of the Cleveland Museum of Art* 32 (1945): pp. 3–5.

Fredericksen and Zeri 1972
Fredericksen, Burton B., and Federico Zeri. *Census of Pre-Nineteenth-Century Italian Paintings in North American Public Collections*. Cambridge, MA: Harvard University Press, 1972.

Gardner von Teuffel 2005
Gardner von Teuffel, Christa. *From Duccio's Maestà to Raphael's Transfiguration: Italian Altarpieces and Their Settings*. London: Pindar Press, 2005.

Garibaldi 1998
Garibaldi, Vittoria, ed. *Beato Angelico e Benozzo Gozzoli: Artisti del Rinascimento a Perugia; itinerari d'arte in Umbria*. Exh. cat. Cinisello Balsama: Silvana, 1998.

Garibaldi and Mancini 2008
Garibaldi, Vittoria, and Francesco Federico Mancini, eds. *Pintoricchio*. Exh. cat. Milan: Silvana, 2008.

Gordon 2001
Gordon, Dillian. *The Fifteenth Century Italian Paintings*. London: National Gallery Co., 2001.

Grohmann 1981
Grohmann, Alberto. *Città e territoria tra Medioevo ed età moderna. Perugia, secc. XIII–XVI*. Vol. 1. Perugia: Volumnia, 1981.

Gronwaldt 1989
Gronwaldt, Ruth. "An Unknown Trecento Embroidery." *Textile History* 20, no. 2 (1989): pp. 245–47.

Guardabassi 1872
Guardabassi, Mariano. *Indice-guida dei monumenti pagani e cristiani riguardanti l'istoria e l'arte esistenti nella provincia dell'Umbria*. Perugia, 1872.

Hague 1933
Hague, Marian. "Notes on Some Fourteenth Century Embroideries in Judge Untermyer's Collection." *Bulletin of the Needle and Bobbin Club* 17, no. 2 (1933): pp. 38–49.

Israëls 2009
Israëls, Machtelt, ed. *Sassetta: The Borgo San Sepolcro Altarpiece*. 2 vols. Florence: Villa I Tatti, the Harvard University Center for Italian Renaissance Studies, 2009.

Jarves 1883
Jarves, James Jackson. *Handbook for Visitors to the Hol-lenden Gallery of Masters: Exhibited at the Boston Foreign Art Exhibition in 1883-84*. S.l.: J. J. Jarves, 1883.

Kanter and Palladino 2005
Kanter, Laurence, and Pia Palladino, eds. *Fra Angelico*. Exh. cat. New York: Metropolitan Museum of Art; New Haven, CT: Yale University Press, 2005.

Kurth 1931
Kurth, Betty. "Florentiner Trecento Stickereien." *Pantheon* 8 (1931): pp. 455-62.

Lloyd 1993
Lloyd, Christopher, ed. *Italian Paintings before 1600 in the Art Institute of Chicago: A Catalogue of the Collection*. Chicago: Art Institute of Chicago in association with Princeton University Press, 1993.

Lunghi 1984
Lunghi, Elvio. *Per la miniature umbra del Quattrocento*. Atti dell'Accademia Properziana del Subasio, 6th ser., no. 8. Assisi: Accademia Properziana del Subasio, 1984.

Morello and Kanter 1999
Morello, Giovanni, and Laurence B. Kanter, eds. *The Treasury of Saint Francis of Assisi*. Exh. cat. New York: Metropolitan Museum of Art, 1999.

Muzzioli 1954
Muzzioli, Giovanni, ed. *Mostra storica nazionale della miniatura*. Exh. cat. Florence: Sansoni, 1954.

Offner 1956
Offner, Richard. *A Critical and Historical Corpus of Florentine Painting*, sec. 3, vol. 6. New York: Institute of Fine Arts, New York University, 1956.

Padoa Rizzo 1992
Padoa Rizzo, Anna. *Benozzo Gozzoli: Catalogo completo dei dipinti*. Florence: Cantini, 1992.

Perkins 1918
Perkins, Frederick Mason. "Una tavola d'altare di Spinello Aretino." *Rassegna d'arte* 18 (1918): pp. 5-6.

Perrott 1934
Perrott, Emilia. "Un Messale umbro del Quattrocento." *Bibliofilia* 36 (1934): pp. 173-84.

Rowe 1979
Rowe, Donald F. *The First Ten Years: Notable Acquisitions of Medieval, Renaissance, and Baroque Art*. Chicago: Martin D'Arcy Gallery of Art, The Loyola University Museum of Medieval and Renaissance Art, 1979.

Rubinstein 1917
Rubinstein, Stella. *Catalogue of a Collection of Paintings, etc. Presented by Mrs. Liberty E. Holden to the Cleveland Museum of Art*. Cleveland: Cleveland Museum of Art, 1917.

Salmi 1957
Salmi, Mario. *Italian Miniatures*. London: Collins, 1957.

Salmi 1933
——. "Bartolomeo Caporali a Firenze." *Rivista d'arte* 15 (1933): pp. 253-72.

Salmi 1930-31
——. "Il Paliotto di Manresa e l'Opus Florentinum." *Bollettino d'arte* 24 (1930-31): pp. 385-406.

Santi 1985
Santi, Francesco. *Galleria Nazionale dell'Umbria: Dipinti, sculture e oggetti dei secoli XV-XVI*. Cataloghi dei musei e gallerie d'Italia. Rome: Istituto poligrafico e Zecca dello Stato, Libreria dello Stato, 1985.

Scarpellini and Mancini 1987
Scarpellini, Pietro, and F. F. Mancini. "Miniatura e ambiente artistico a Perugia fra XIII e XVII secolo." In *Carte che ridono*. Exh. cat. Perugia: Editoriale Umbra, 1987.

Seidel 2000
Seidel, Linda. *Pious Journeys: Christian Devotional Art and Practice in the Later Middle Ages and Renaissance*. Exh. cat. Chicago: David and Alfred Smart Museum of Art, The University of Chicago, 2000.

Silvestrelli 1997
Silvestrelli, Maria Rita. "Bartolomeo Caporali." In *Museo Comunale di San Francesco a Montone*, edited by Giovanna Sapori. Perugia: Editori umbri associati, 1997.

Thurman and Batty 2003
Thurman, Christa C. Mayer, and Jessica Batty. "Two Bands and Four Fragments from an Orphrey Band." *Art Institute of Chicago Museum Studies* 29, no. 2 (2003): p. 94.

Todini 1989
Todini, Filippo. *La pittura umbra dal Duecento al primo Cinquecento*. 2 vols. Milan: Longanesi, 1989.

Toscano and Capitelli 2002
Toscano, Bruno, and Giovanna Capitelli, eds. *Benozzo Gozzoli: Allievo a Roma, Maestro in Umbria*. Exh. cat. Milan: Silvana, 2002.

Van Fossen 1968
Van Fossen, David. "A Fourteenth-Century Embroidered Florentine Antependium." *Art Bulletin* 50, no. 2 (June 1968): pp. 141-52.

Van Os 1974
Van Os, Henk. "St. Francis of Assisi as a Second Christ in Early Italian Painting." *Simiolus* 7 (1974): pp. 125, 127.

Volbach 1987
Volbach, Wolfgang Fritz. *Monumenti Musei e Gallerie Pontificie: catalogo della Pinacoteca Vaticana. Vol. II: il Trecento a Firenze e Siena*. Vatican City, 1987.

Wardwell 1982
Wardwell, Anne E. "On the Dating of a Dismantled Trecento Altar Frontal." *Bulletin de liaison du Centre International d'etude des textiles anciens* 55/56 (1982): pp. 141-53.

Wardwell 1979
——. "A Rare Florentine Embroidery of the Fourteenth Century." *Bulletin of the Cleveland Museum of Art* 66, no. 9 (December 1979): pp. 322-33.

Weber 1904
Weber, Siegfried. *Fiorenzo di Lorenzo: eine kunsthistorische Studie*. Strassburg, 1904.

Weppelmann 2003
Weppelmann, Stefan. *Spinello Aretino und die toskanische Malerei des 14. Jahrhunderts*. Florence: Edifir, 2003.

Wickhoff 1908
Wickhoff, Franz. "Die Sammlung Tucher." *Müncher Jahrbuch der Bildenden Kunst* 3 (1908): pp. 21-30.

Wixom 1999
Wixom, William D., ed. *Mirror of the Medieval World*. Exh. cat. New York: Metropolitan Museum of Art, 1999.

Index

Page numbers in *italic type* indicate illustrations.

Contributors

DB Dilys Blum is the Jack M. and Annette Y. Friedland Senior Curator of Costume and Textiles at the Philadelphia Museum of Art.

DC Donal Cooper is a professor of art history at the University of Warwick, United Kingdom.

JC Jonathan Canning is the Martin D'Arcy Curator of Art at Loyola University Museum of Art in Chicago.

MRS Maria Rita Silvestrelli is a lecturer at the Università per Stanieri di Perugia, Italy.

SB Silvia Braconi is an independent historian in Umbertide, Italy.

SNF Stephen N. Fliegel is the curator of medieval art at the Cleveland Museum of Art.

VB Virginia Brilliant is the curator of European art at Ringling Museum of Art in Sarasota, Florida.

Translation management: The Art of Translation

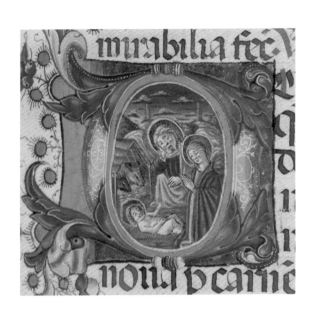